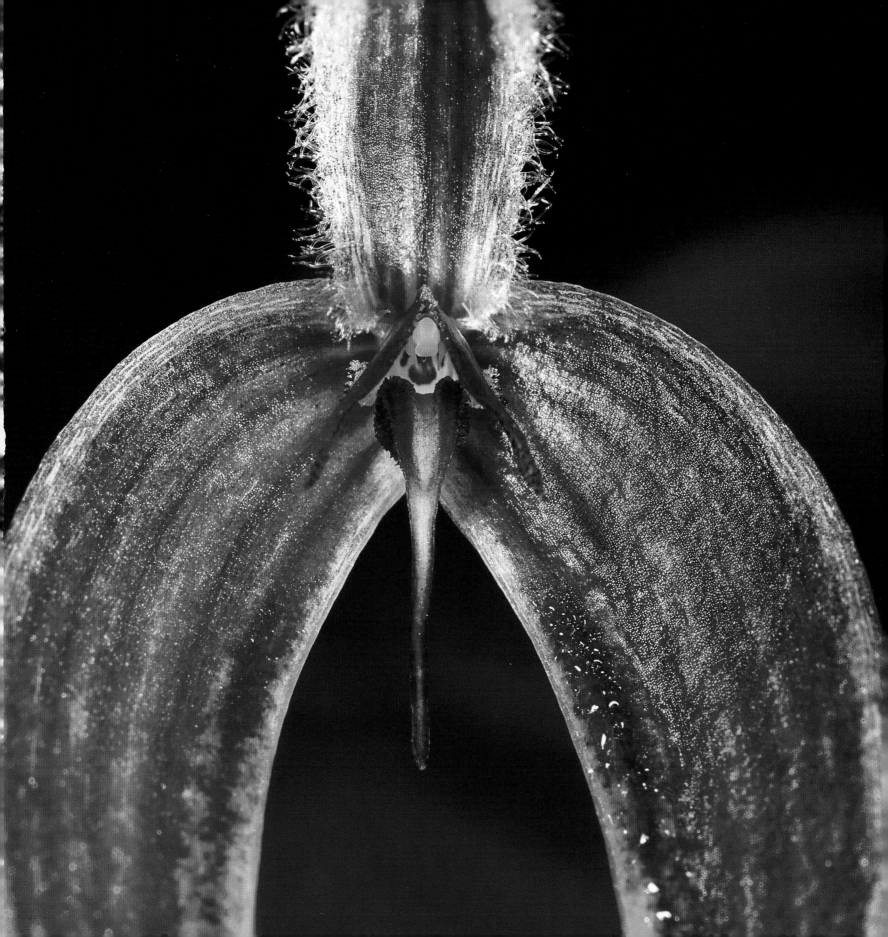

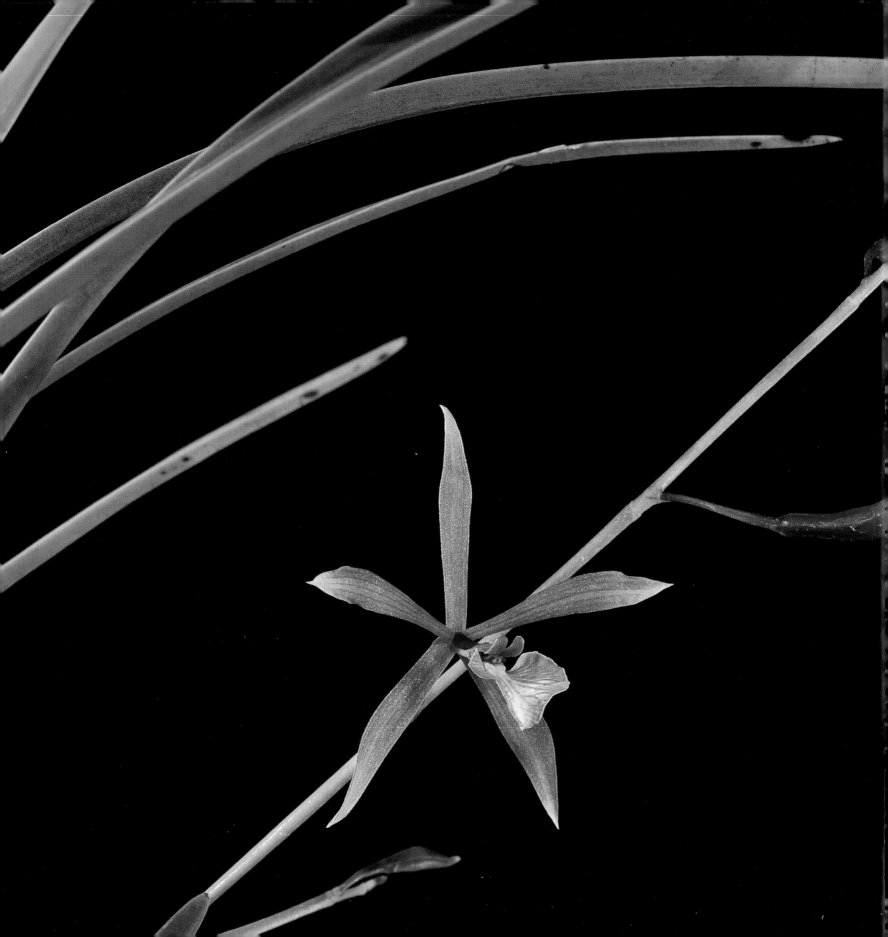

DECEPTIVE BEAUTIES

The World of Wild Orchids

CHRISTIAN ZIEGLER

FOREWORD BY Natalie Angier

INTRODUCTION BY Michael Pollan

THE UNIVERSITY OF CHICAGO PRESS

CHICAGO AND LONDON

Dedicated to Janeene
—CZ

HALF TITLE: Bulbophyllum blumei.
Sabah, Borneo

PRECEDING PAGES: Encyclia bractescens.
Chilibre, central Panama

RIGHT: Ophrys speculum. *Each orchid*
species in the Ophrys *genus attracts a different*
bee species as its pollinator. They do this by
producing perfect imitations of the pheromones
of the appropriate female bees. Sexual
deception is a technique used by a number of
different orchids to attract pollinating insects.
Sardinia, Italy

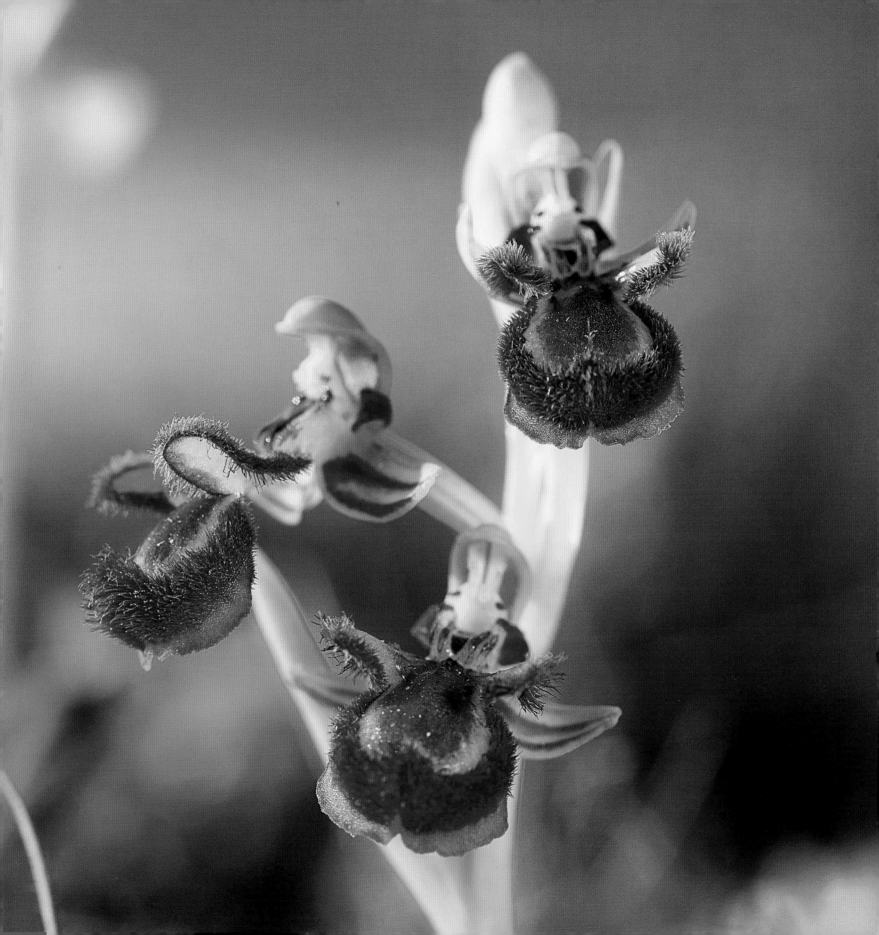

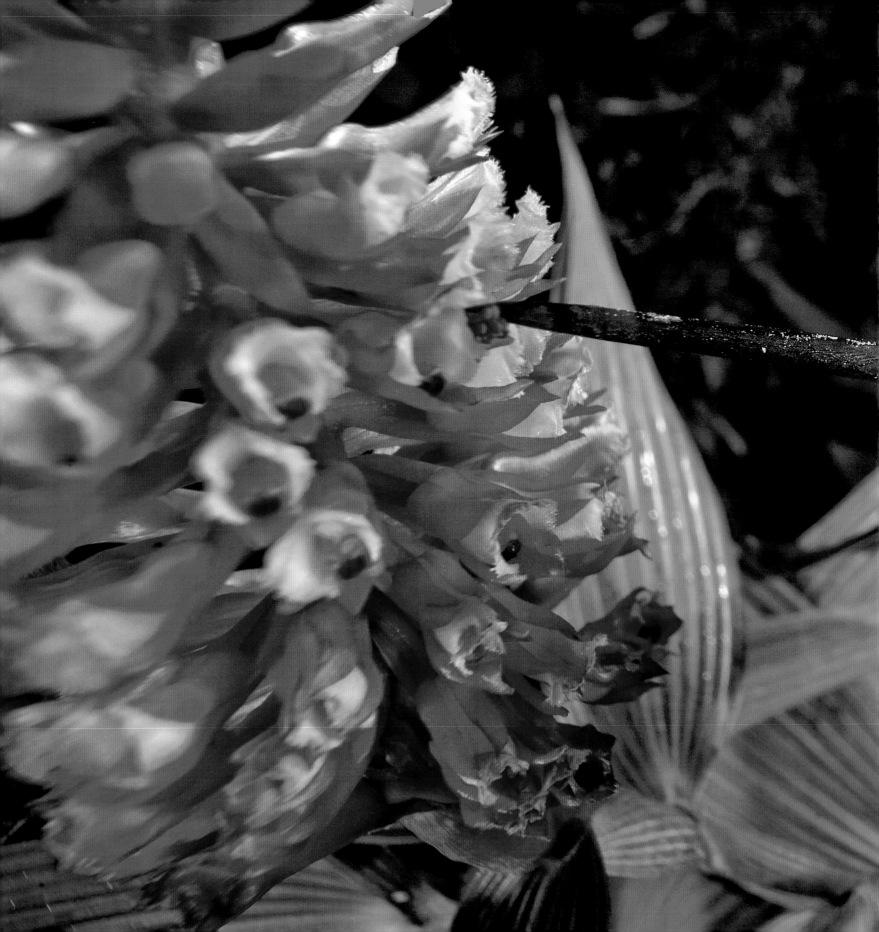

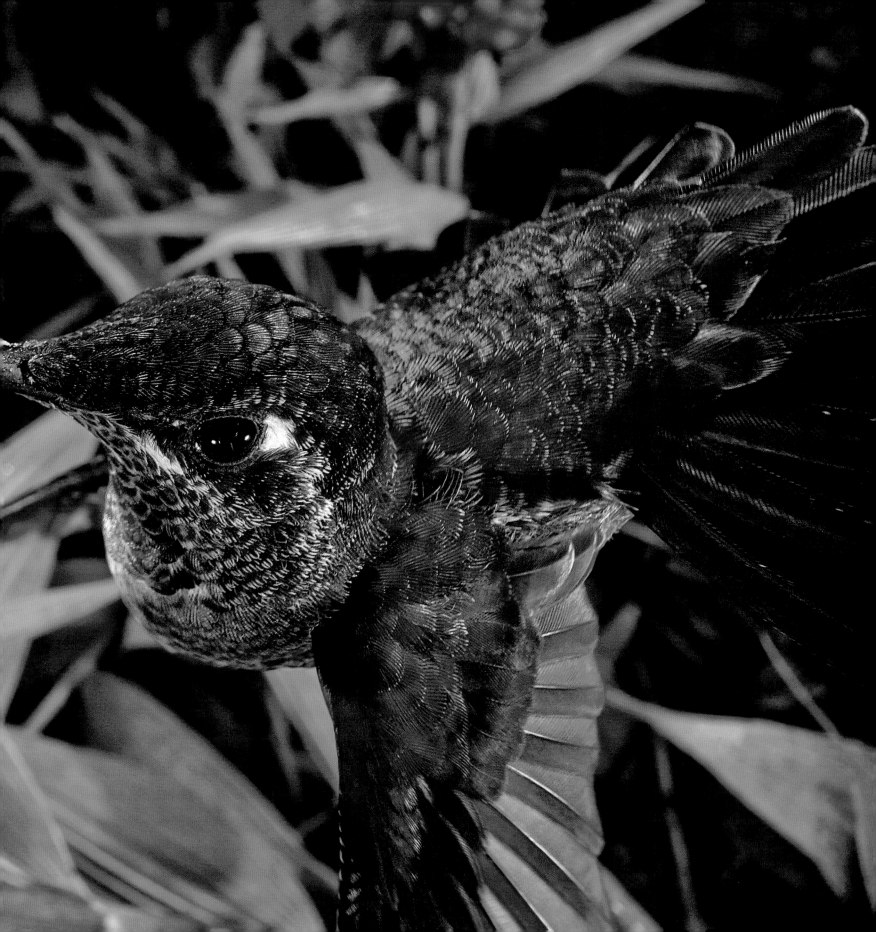

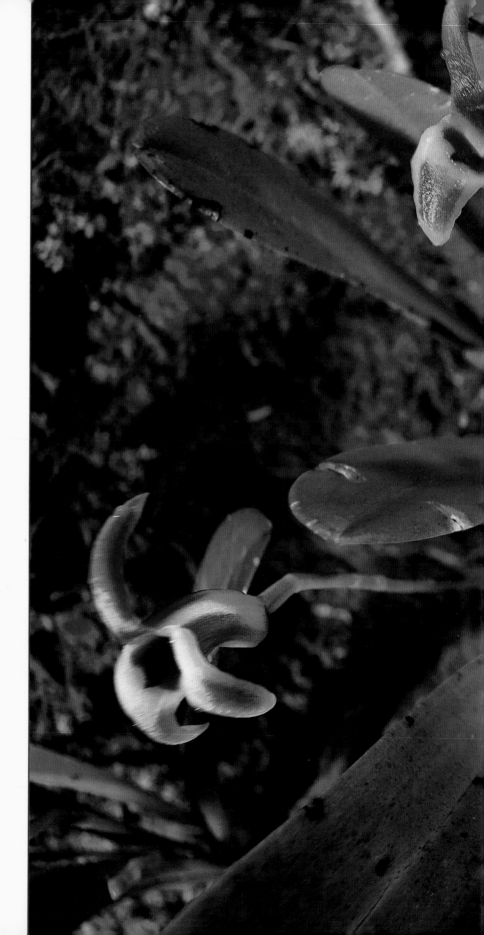

RIGHT: Masdevallia livingstoneana *flowering high in the canopy of a moist lowland rain forest. Fort San Lorenzo National Park, Panama*

PRECEDING PAGES: Eleanthus sp. *being pollinated by a male magnificent hummingbird. The orchid's violet-colored pollen package lies on top of the hummingbird's beak. Most bird-pollinated orchids have evolved dark pollinia because the usual yellow ones would be easily seen and probably groomed off by the birds. Finca Dracula Orchid Sanctuary, western Panama*

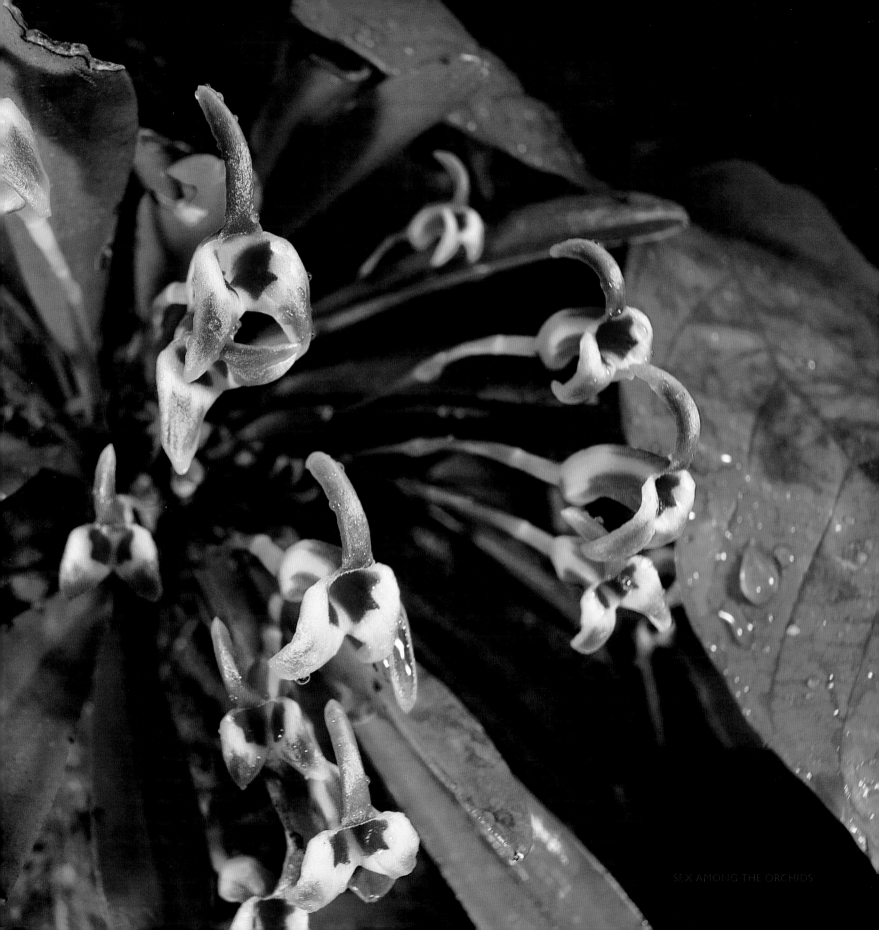

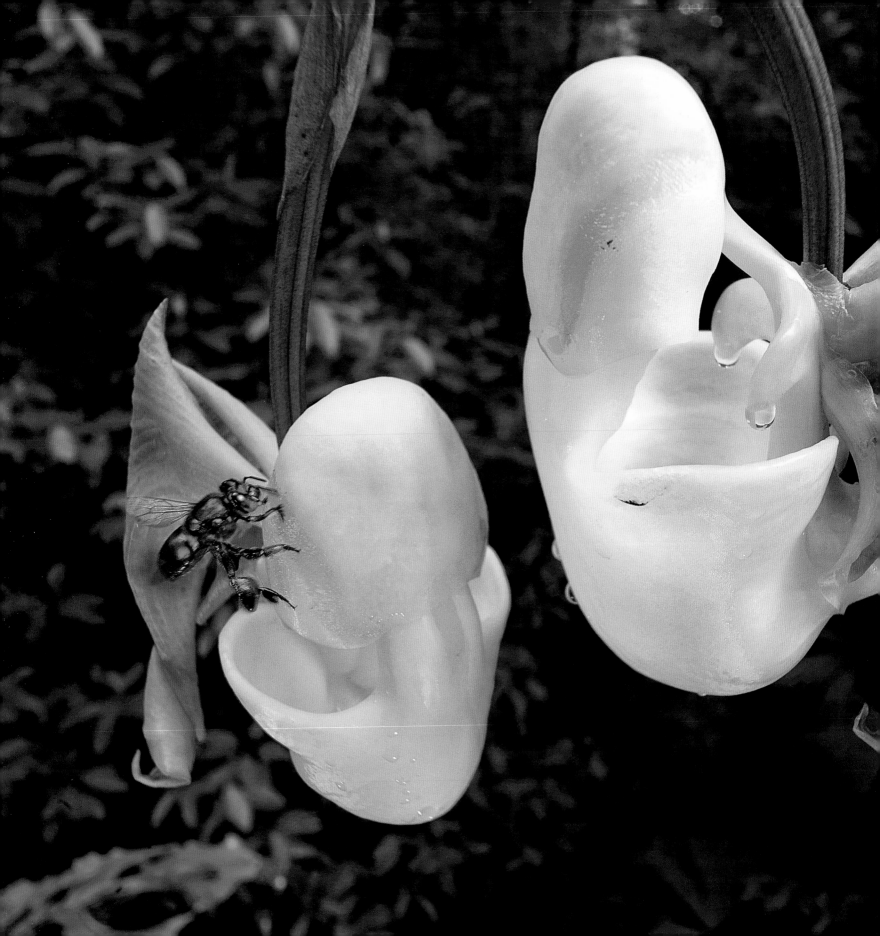

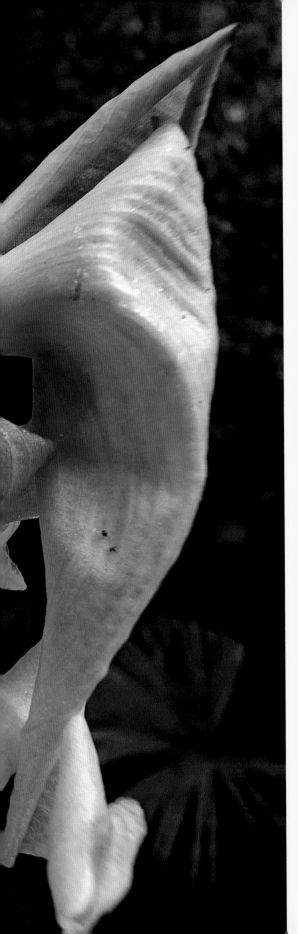

contents

Coryanthes panamensis. *The impressive flower of the bucket orchid offers its pollinator, a male euglossine bee, ingredients to make the perfume it needs to attract a female bee. Gamboa, central Panama*

foreword

THE ancient chinese believed that travelers venturing into a forest should first pin orchids in their hair, for only orchids packed enough power to repel evil spirits. To the samurai warriors and nobility of pre-industrial Japan, the *Neofinetia falcata* orchid was so sacred that desecrating the pale, slender-petaled flowers brought a sentence of death. Besotted Victorian collectors paid up to $150,000 for the finest orchid blooms.

Botanists often decry the public's "plant blindness," the ease with which people dismiss the plant world as so much fuzzy green infrastructure that, for all they know, may not even be quite alive. Yet if any chlorophyllated tribe reliably escapes consignment to wallflower status, it is the orchid. How can you ignore an orchid? Even those species that are not pig-drunk in Moulin Rouge pigments or impeccably pinstriped like an Armani suit seem to be watching with human-shaped faces. Their blossoms are bilaterally symmetrical, their distinctive labellum—the modified, lowermost petal that serves as a landing strip for pollinators—looks here like a pouting lip, there like Popeye's bulging jaw; their side petals and sepals are ruffled like windblown hair or springing outward goofily, like a commedia dell'arte hat. How can you ignore the family's multifarious success? At 25,000 known species and more than 100,000 hybrids, Orchidaceae is by far the world's most diverse floral phylum. "Orchids are found in every environment imaginable, from the Arctic Circle to Tierra del Fuego," says Marc Hachadourian, the orchid curator at the New York Botanical Garden. "They can be vines 45 feet long

to plants that, in their entirety, are smaller than your pinkie, with flowers the size of a comma to flowers six feet across." Orchids, he says, "have conquered the Earth."

They have also conquered our myths, our metaphors, and our medicine cabinets. The Chinese and other Asian cultures have long been particularly attentive to their orchids, as much for the graceful arch and variegated shapeliness of the orchid's leaves as for the saturated flaunt of the blossoms. Confucius compared the true gentleman with an orchid: noble, refined, pure of heart, unbowed even by poverty. At the same time, orchids were associated with the ideal woman: elegant and modest, yet decidely alluring. Orchids embodied love. "When two people understand each other in their innermost hearts," said the *I Ching*, "their words are sweet and strong, like the fragrance of orchids." Orchids were also fair in war. After the Mongolian conquest of 1279, artists still loyal to the fallen Sung dynasty depicted their resistance as *Cymbidium* orchids sprouting defiantly from cracks in a rock.

Orchids have been on the ingredients list of many traditional nostrums, reputed to cure arthritis, cholera, intestinal distress, headaches, fever, cough, a sick elephant. When Hernán Cortés entered Mexico in 1519, the Aztec emperor Moctezuma treated him to a convivial sample of his favorite fortifying potion, a cacao beverage flavored with extract of the *Vanilla planifolia* orchid. The friendship didn't take, but the Western taste for vanilla did, and today the world's supply of vanilla is still derived,

painstakingly and expensively, from cultivars of *V. planifolia*.

Orchids often served as fertility fetishes, because the twinned swollen tubers at the base of many European orchids, where starchy nutrients are stored, were thought to resemble a man's reproductive organs. And who knew how far that visual similitude might extend? Expectant parents in ancient Greece were advised to eat big, fresh orchid tubers if they wanted a boy; small, dried tubers for a girl. In truth, the early Greeks were flummoxed by orchid fecundity. Orchids have the tiniest seeds in the botanical kingdom—each no bigger than a speck of dust—and the Greek naturalists simply couldn't find them. If orchids didn't grow from seeds, well, then, they could be the souvenirs of highly sexed spirits, the fruit of the bawds, springing up wherever nymphs and satyrs may play. Only later did researchers begin decoding the orchidean game plan and learn that these master strategists keep their seeds small and cheap by relying on cooperative fungi in the soil to provision their "young" with the sugars needed for germination.

The Victorians were smitten by orchids on a near-industrial scale, as technological advances yielded soaring urban greenhouses of steel and glass, and Charles Darwin and other pan-sampling naturalists brought back exotic floral specimens from remote apses of the globe. Yet even as they prided themselves on being enlightened realists who accepted the biological world on its own terms, the Victorians couldn't help imbuing orchids with a titillating sexual mystique:

Have you read Mr. Darwin's description of the orchid whose labellum tube is so deep it requires a pollinator with a tongue the length of a gentleman's…hand? Critics called the flowers a form of "horticultural pornography" that no proper woman should associate with, which only guaranteed that proper and sufficiently monied women wanted nothing but: Orchid cultivation became a symbol of wealth and status among the landed gentry and the strivers just behind them.

Today, orchids and orchid cultivation are more wildly popular than ever before. The orchid show at the Tokyo Dome, where orchid breeders compete for a grand prize of $25,000—and where the "lights and pomp and circumstance," said Hachadourian, "are outlandish beyond extreme"—attracts a million visitors a year.

Not everybody is orchidophilic. Some call the flowers gauche. Others concur with the famous line from the Humphrey Bogart movie *The Big Sleep*, in which the wealthy and wheelchair-bound General Sternwood complains of orchids, "Their flesh is too much like the flesh of men, and their perfume has the rotten sweetness of corruption."

Yet I'm convinced that even the most contrarian orchid skeptic would be swayed by the sight of orchids as they are meant to be seen. Not in hothouses, not en masse in domes, but as Christian Ziegler shows them here: in their native splendor and rarity, springing up from a lowland forest floor or dangling from an alpine tree, quietly yet insistently demanding to be seen.

—Natalie Angier

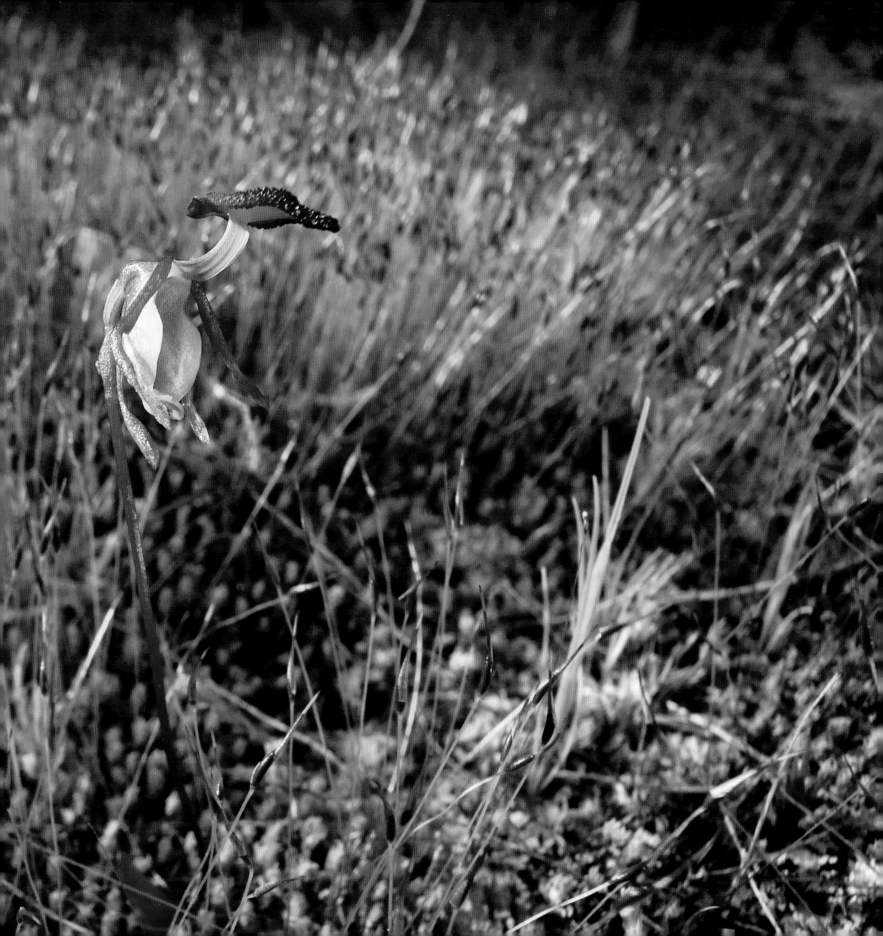

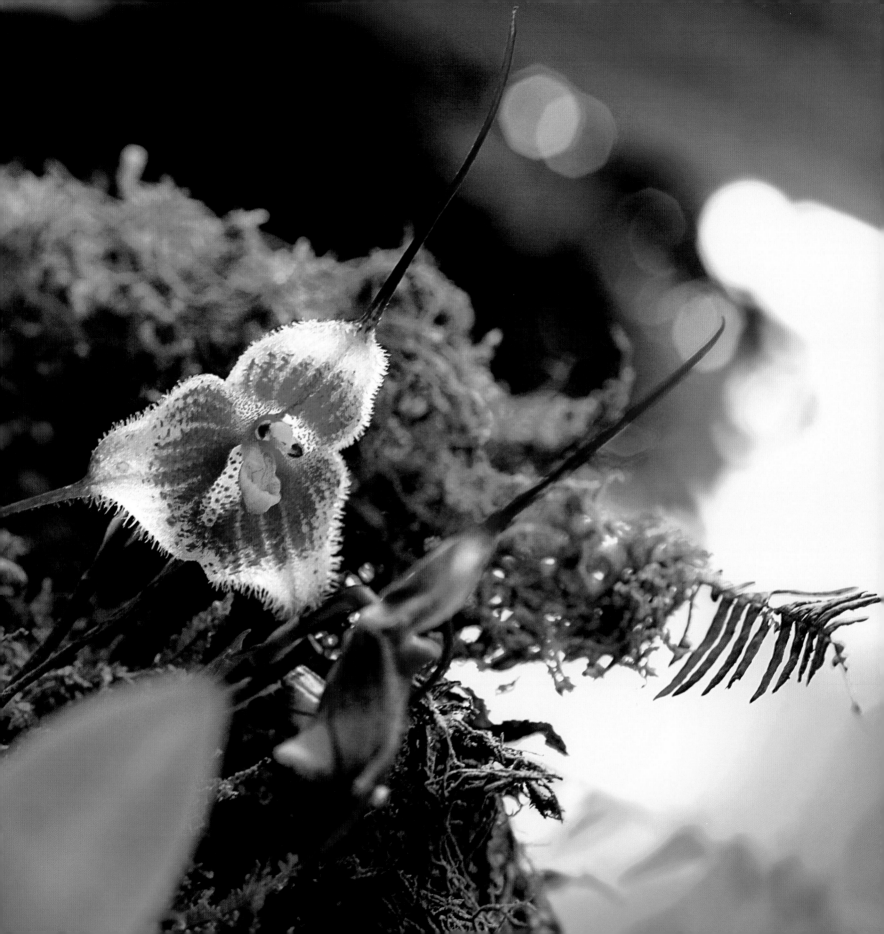

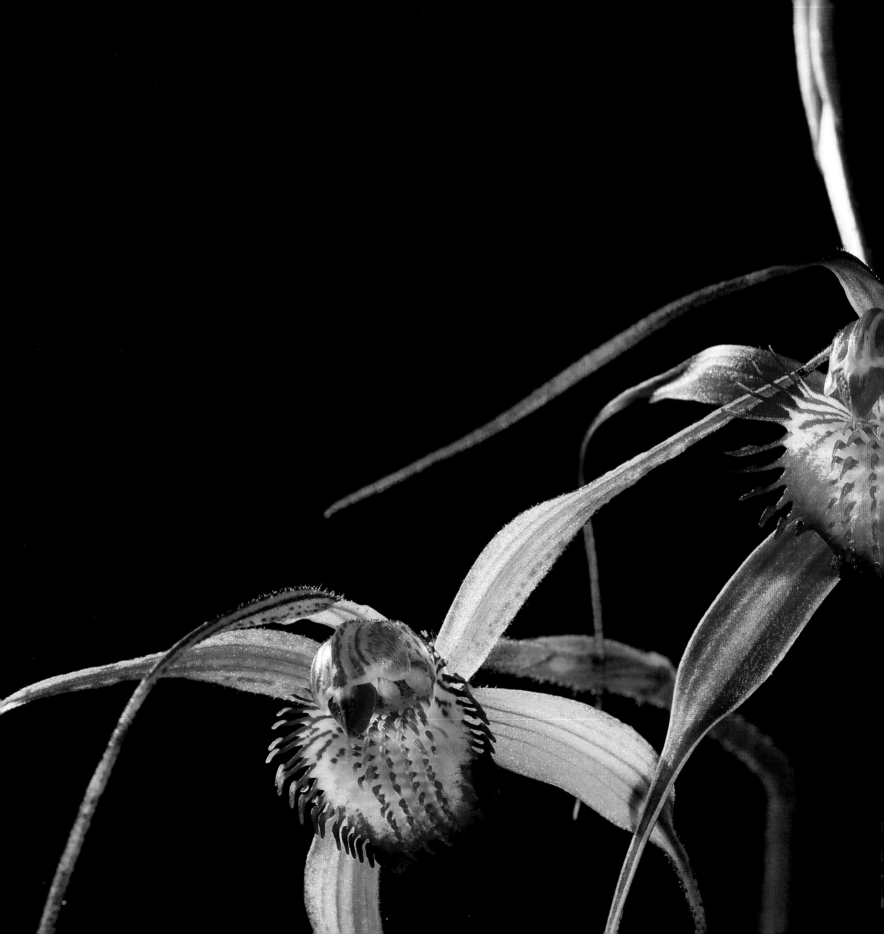

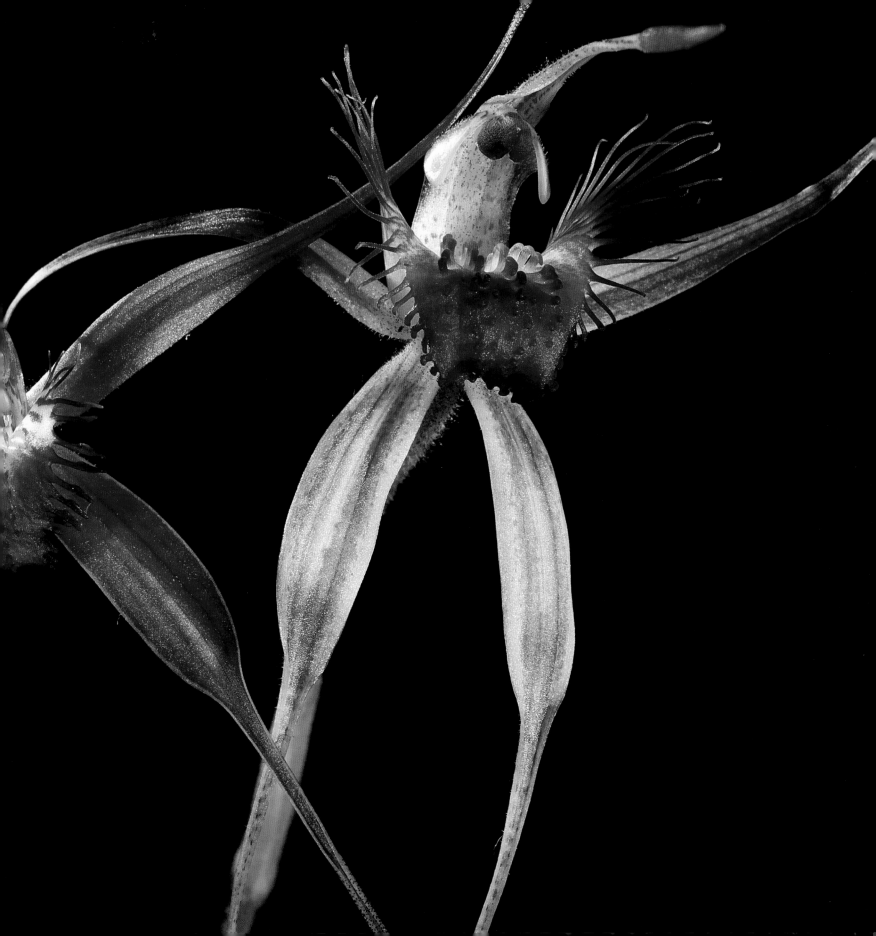

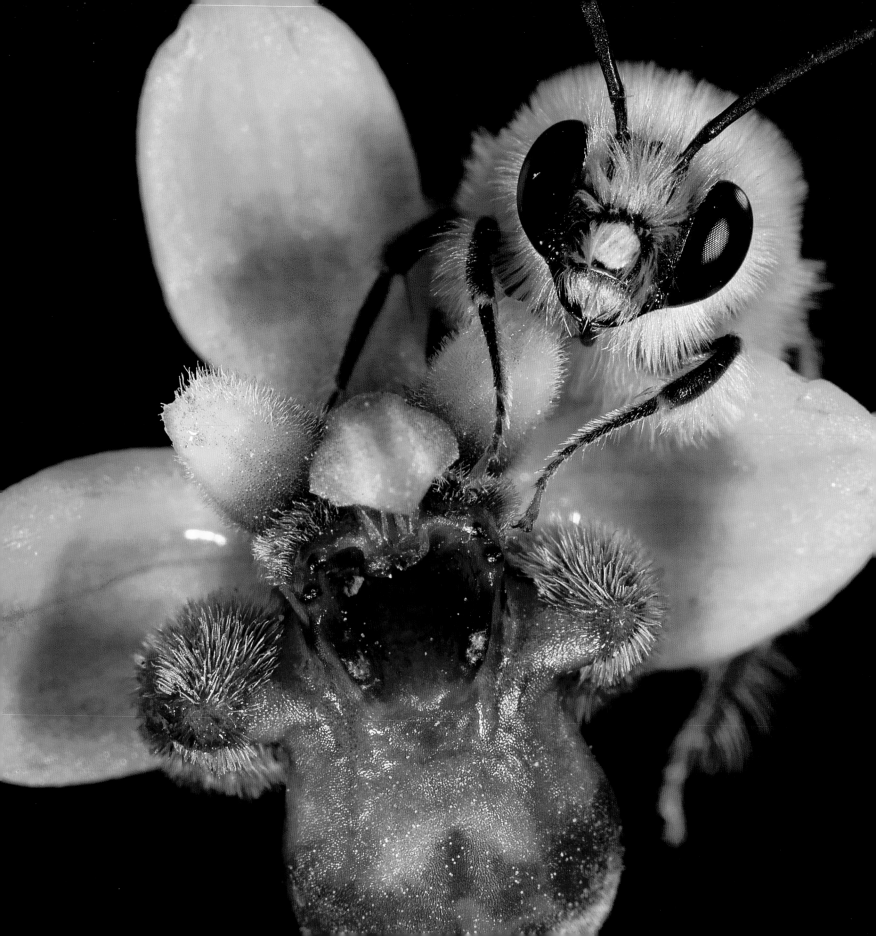

MICHAEL POLLAN

SEX AMONG THE ORCHIDS

"It has always pleased me to exalt plants in the scale of organized beings."
CHARLES DARWIN

We animals don't give plants nearly enough credit. When we want to dismiss a fellow human as ineffectual or superfluous, we call him a "potted plant." "A vegetable" is how we refer to a person who has been reduced to a condition of utter helplessness, having lost most of the essential tools for getting along in life. Yet plants get along in life just fine, thank you, and had done so for millions of years before we came along. True, they lack such abilities as locomotion, the command of tools and fire, the miracles of consciousness and language. To animals like ourselves, these are the tools for living we deem the most important, or "advanced," which is not at all surprising since they have been the shining destinations of our evolutionary journey. But the next time you're tempted to celebrate human consciousness as the pinnacle of evolution, stop for a moment to consider exactly where you got that idea. Human consciousness. Not exactly an objective source.

Tools are tools, or, as Darwin called them, adaptations—and in evolution there is always more than one way to get a job done. So while we were nailing down locomotion, consciousness, and language, plants were hard at work developing a whole other bag of tricks to advance their interests. All of those tricks take account of the key existential fact of plant life: rootedness. How do you spread your genes around when you're stuck in place? How do you defend yourself? You get really, really good at things like biochemistry, at engineering, design, and color, and, in the case of the flowering plants, at the art of manipulating the allegedly higher creatures, up to and including animals like us.

PRECEDING SPREADS

PAGES 14-15: Paracaleana nigrita *(flying duck orchid) uses a sexual deception strategy to attract its wasp pollinator. Once the wasp is inside the flower, a sophisticated mechanism catapults it onto the reproductive parts of the orchid. Denmark, western Australia*

PAGES 16-17: Dracula erythrochaete. *Finca Dracula Orchid Sanctuary, western Panama*

PAGES 18-19: *Two* Caladenia *species with their natural hybrid in between. Albany, western Australia*

LEFT: Ophrys bombyliflora *and its pollinator, a male solitary bee from the genus* Eucera. *Sardinia, Italy*

So let us celebrate some other pinnacles of evolution, the kind that would get a lot more press if natural history were written by plants rather than animals (I suppose an essay by a biped named Pollan will have to do). I'm thinking specifically of the flowering plants, and in particular of one of the largest, most diverse families of flowering plants: the 25,000 species of orchids that, over the past 80 million years, have managed to colonize six continents and almost every conceivable terrestrial habitat, from the deserts of western Australia to the cloud forests of Central America, from the forest canopy to the underground, from remote Mediterranean mountaintops to living rooms, offices, and restaurants the world over. The secret of their success? In a word, sex. But not exactly normal sex. Really weird sex, in fact.

Hoping to observe some of this plant sex, said biped recently journeyed to one of those remote Mediterranean mountains in search of one of the most ingenious and diabolical of these orchids: the *Ophrys*, or, as it is sometimes called, the bee orchid. (Some botanists, less politely, call it the prostitute orchid.) I'd been eager to lay eyes on this orchid and meet its hapless pollinator ever since reading about its reproductive strategy, which involves what my field guide called "sexual deception" and "pseudocopulation." What I learned of these prostitute orchids forced me to radically revise my estimation of what a clever plant is capable of doing to a credulous animal.

In the case of this particular *Ophrys*, that animal is a relative of the bumblebee. The orchid in question offers the bee no nectar reward or pollen meal; rather, it seduces the male bee with the promise of bee sex, then insures its pollination by frustrating precisely the desire it has excited. The orchid accomplishes its sexual deception by mimicking the appearance, scent, and even tactile experience of a female bee. The flower, in other words, traffics in something very much like metaphor: *This stands for that.* Not bad for a vegetable.

Finding these bee orchids proved easier than finding the bees. In the company of Christian Ziegler, I journeyed to Sardinia, an island 120 miles off the west coast of Italy. Windswept, mountainous, and lightly populated, it is perhaps best known for its floral biodiversity and human kidnapping. (Deceit is evidently very much in the air.)

Orchid hunting sounds arduous, and in many places it is, but in the mountains of Sardinia *Ophrys* orchids grow like roadside weeds. Though they're only eight inches or so high, when they bloom in April you can spot them from a moving car. We found orchids growing amid a veritable garden of richly scented Mediterranean plants, including rosemary, Astrantia, lilies, geranium, curry plants, and fennel.

Even close up, the lower lip, or labellum, of these diminutive orchids bears an uncanny resemblance to a female bee as viewed from behind. This pseudobee, which in some *Ophrys* species comes complete with fake fur and what appear to be elbows and folded iridescent wings, looks as though she has her head buried in a green flower formed by the actual flower's sepals. To reinforce the deception, the orchid gives off a scent that, though imperceptible to us, has been shown to closely match the pheromones of the female bee. Blooming in the middle of a lively crowd of other aromatic plants, the orchid would have to get the scent exactly right to attract the hapless male bee.

We staked out a patch of orchids for a few hours, hoping to catch some pseudo-copulation, but no luck. Only a tiny percentage of these orchids succeed in getting pollinated, which makes you wonder just how clever a strategy sexual deception really is (more on that later). But when it does work, it works like this: The male bee alights on the beelike labellum and attempts to mate, or, in the words of one botanical reference, begins "performing movements which look like an abnormally vigorous and prolonged attempt at copulation." In the midst of these fruitless exertions, the bee jostles the orchid's column (a structure unique to orchids that houses both the male and female sexual organs) and two yellow sacs packed with pollen (called the pollinia, another structure unique to orchids) are stuck to his back with a quick-drying gluelike substance. Frustration mounts until eventually it dawns on the bee that he has been had. He abruptly flies off, pollinia firmly attached, in frantic search of more authentic female companionship.

There was something poignant about the solitary bee I spotted, flying around madly with what looked like a chubby pair of yellow oxygen tanks strapped to his back.

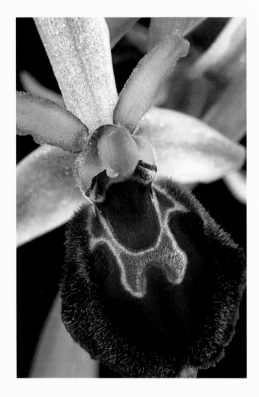

Ophrys morisii. *Sardinia, Italy*

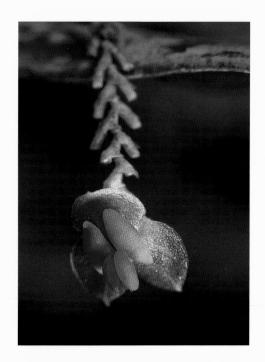

Lepanthes sp. *Finca Dracula Orchid Sanctuary, western Panama*

He'd been deluded by the promise of sex—bee sex—when in fact all that was really on offer was plant sex. Botanists have been known to refer to pollen-carrying bees as "flying penises," but of course most of the world's bees perform that role unwittingly, with food rather than sex on the brain. Not so for the poor, deluded orchid bee.

In fact, the sexual frustration of the bee turns out to be an essential part of the orchid's reproductive strategy, which is to favor outcrossing, or mixing one's genes with distant mates. (Preferable, since inbreeding decreases fitness.) When a bee has been discombobulated by sexual frustration, it's much less likely to mate with a flower on the same or a nearby plant. Determined not to make the same mistake again, the bee travels some distance and, if things work out for the orchid, ends up pseudocopulating (and leaving his package of pollen) with an orchid a ways off. That distant orchid is likely to look and smell ever so slightly different from the first, and some botanists believe these subtle variations from plant to plant are part of the orchid's strategy to prevent bees from learning not to fall for the same flower twice. "Imperfect floral mimicry" is the botanical term for this adaptation. Think of it: The very imperfection of the orchid's mimicry may itself be part of the perfection of its reproductive strategy.

THE POLLINATION STRATEGY of the *Ophrys* is, like that of so many orchids, ingenious, intricate, wily, and seemingly improbable—so much so that proponents of intelligent design sometimes point to orchids as proof that the hand of a higher intelligence must be at work in nature. (And a rather sadistic intelligence at that.) Though some orchids offer conventional food rewards to the insects and birds that carry their pollen from plant to plant, roughly a third of orchid species figured out long ago—unconsciously, of course—that they can save on the expense of nectar and increase the odds of outcrossing by evolving instead a clever deceit, whether that ruse be visual, aromatic, tactile, or, in the case of the bee orchid, all three at once.

The deception and exploitation of animals has become something of an orchid family specialty. There are orchids in the genus *Orchis* that lure pollinators with the promise of food by mimicking the appearance of nectar-producing flowers, or, in the

case of fly-pollinated *Dracula* orchids, by producing an array of nasty scents running the scales of putrefaction, from fungus and rotten meat to cat urine and baby diaper. (Believe me, I've sniffed them.) Other orchids, like the *Serapias*, promise shelter by deploying floral forms that mimic protective insect burrows or brood rooms. Some of the *Oncidiums* mimic the appearance of male *Centris* bees in flight, hoping to incite territorial combat resulting in pollination. And then there are the many orchids that hold out the promise of romance.

In one way or another, orchids have evolved reproductive strategies that play on an animal's three most urgent needs: for food, for shelter, for sex. Has the plant world produced any more brilliant students of animal desire? I doubt it. Orchids are nature's meta-flowers, improvising on what has come before. For orchid deception can only succeed in a world where most things in nature really are what they seem: Where the smell of rotting meat signals rotting meat, where flowers really do offer nectar and where they don't dress up as bugs.

The orchids' baroque pollination strategies raise challenging questions for the evolutionist, however. Since natural selection seldom rewards the unnecessary complication, why haven't orchids stuck with more straightforward pollination strategies based on nectar reward? And how in the world did their sexual practices get so elaborate? As for the hoodwinked pollinators, what, if anything, do they gain from their relationships with these flowers? If the answer is "nothing but frustration," then why wouldn't natural selection eventually weed out insects so foolhardy as to spend their time mating with nature's version of the inflatable love doll? Many of these deceptions are so specific they fool only a single (albeit extremely dedicated) pollinator and, as for the *Ophrys*, they don't work all that often. So what possible advantages could there be in depending so absolutely on a single pollinator, and one you can't even count on fooling all the time?

Botanists and evolutionary biologists have come up with fascinating answers to all these questions; indeed, the peculiarities of orchid sex offer one of the great case studies of natural selection, as Darwin himself understood. Darwin was fascinated

by orchid pollination strategies, and, though he was puzzled by the purpose of *Ophrys* orchids' uncanny resemblance to bees (pseudocopulation wasn't observed until 1916), he taught us much of what we know about these plants in *The Various Contrivances by Which Orchids Are Fertilised by Insects*, the volume he published immediately after *The Origin of Species*. Indeed, some scientists believe that had he published his orchid book first, the theory of natural selection might have encountered considerably less skepticism than it did. Why? Because Darwin called the orchids' floral structures "as perfect as the most beautiful adaptations in the animal kingdom." He painstakingly demonstrated how even the most improbable features of these flowers serve a reproductive function. Many of their structures are so perfectly adapted, both to the plants' requirements and the morphology of their pollinators, that they offered Darwin elegant proofs of his outlandish theory.

Darwin demonstrated how orchid sexual organs were perfectly adapted to promote cross-pollination by conducting some simple experiments with a bristle and *Orchis* orchids, a genus found across Europe that often practices food deception. Darwin described a pair of ridges on the flower's labellum that guided the slender proboscis of a moth, like a "thread into the fine eye of a needle," to a precise point directly beneath a sticky disc holding the pollinia deep inside the flower's faux nectary. When the proboscis—or, in Darwin's experiment, the tip of a bristle—is withdrawn, the disc, which resembles a little saddle, comes with it, bearing the pollen sacs on upright stalks at a 90° angle. Curiously, at this angle the pollinia cannot make contact with the stigma of another *Orchis*, should the moth immediately pay one a visit. But Darwin discovered that after 30 seconds, the glue binding the pollen structure to the moth contracts in such a way as to lower the angle of the stalks to 45°, which happens to be the perfect angle for nailing another orchid's stigma. What this means is that the orchid's pollen must travel for at least 30 seconds before being successfully introduced to a stigma, thereby guaranteeing the plant doesn't waste its genes on another of its own flowers or on that of a close relative. (When Darwin demonstrated this trick for his friend and fellow biologist Thomas Huxley, Huxley reportedly said,

"You can't expect me to believe that, can you?")

More recently, biologists have developed theories to explain why some orchids have evolved away from a simple nectar reward for their pollinators. The energy saved in producing nectar is one possibility, yet orchids put lots of energy into their deceptions, too. John Alcock, an evolutionary biologist and author of *An Enthusiasm for Orchids*, proposes two more intriguing explanations. When botanists experimented by adding a nectar reward to a normally nectarless orchid, they found that the pollinators hung around longer, happily visiting other blooms on the same and nearby plants. This does not suit the orchid's interests, however, since inbreeding results in lower-quality seeds. By comparison, mixing one's genes with more distant mates increases vigor and variation in one's offspring, maximizing fitness. As with the bee orchid, pollinator frustration works to the advantage of the plant, since the insect is apt to leave quickly and travel farther. Other studies suggest that a thwarted pollinator will thrust himself more deeply into a flower and thrash about in search of promised food, improving the odds that he'll crash into the pollinia and then leave in a huff.

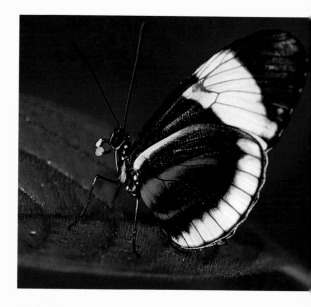

Epidendrum radicans. *A pollinating butterfly carries pollinium on its proboscis. Gamboa, central Panama*

Another reason so many orchids have gotten out of the restaurant business may have to do with the benefits of developing a relationship with a single, highly devoted pollinator. Nectar, beloved by so many different animals, attracts all sorts of riffraff that may not deliver your pollen to the right target. But if instead you produce a scent that attracts only the males of one particular species of bee, then you can insure that your pollen will end up precisely where you want it: on the stigma of a far-flung orchid of your own kind. So over time, orchids that produce chemicals akin to specific insect pheromones leave behind more offspring than orchids that indiscriminately feed everyone in the neighborhood.

The exactitude of the perfume business (and of sexual deception strategies in general) may also help explain the astounding biodiversity of the orchid family. A mutation producing even a slight change in an orchid's scent could, strictly by chance, turn out to be the key that unlocks the sexual attentions of a new pollinator, while at the same time completely turning off the original pollinator. In this way, variations in

the chemistry of floral scent can function much as geographic isolation does in the creation of new species: by preventing new mutant flowers from being pollinated by older ones. The novel orchid can evolve in genetic isolation from its forebears—a prerequisite for creating a new species.

Orchids excel at spinning off new species. In fact, one of the curiosities of the orchid family is the fact that there are so very many species and yet at the same time relatively few orchid plants—remarkably little biomass, compared with other important plant families. The rarity of orchids in the landscape argues for highly customized pollination strategies to deploy their pollen as efficiently as possible—unlike grasses, for instance, which can simply broadcast their pollen in the wind. Yet the orchids' small numbers ensure their survival. If deceptive orchids were much more common, their ruses would no longer work, since they depend on the ubiquity of honest flowers.

There is one more characteristic of orchids that helps to explain their extraordinary diversity of form as well as the ingenuity of their pollination strategies. Flowers, in general, come in two types: the radial symmetry of the daisy or sunflower, or the bilateral symmetry of the lily or orchid. The second way of structuring a flower is more complex and therefore offers many more possibilities for variation. (This becomes immediately clear as soon as you put both types side by side and see how much more information the bilaterally symmetrical flower offers; just think how many more words you need to describe it.) Without bilateral symmetry, you don't get the labellum and all the extraordinary forms that the protruding labellum has evolved. But one of the most important options opened up by bilateral symmetry is the possibility of mimicking the morphology of your pollinator—since the symmetry of all the higher animals happens also to be bilateral.

IT SEEMS FAIR to say that, when it comes to sex, orchids have opted for quality rather than quantity. For while it is true that sexual deception doesn't fool all of the pollinators all of the time, it does fool some of them some of the time, and for an orchid that is quite enough. That's because each pollinium contains a stupendous number of pollen grains

and, once delivered, a fertilized flower contains thousands of seeds. So while sex among the orchids may be a rare and intricately choreographed affair, reflecting scrupulous attention to the fate of one's genes, what happens after the match is made is all about profligacy and chance.

Borne on the wind, orchid seeds are so tiny and minimalist they don't even contain a source of food for the developing embryo. For this, the orchid must (once again) count on the kindness of strangers—in this case, that of an endophytic fungus. If all goes right (and, here again, it seldom does), the tendrils of the fungus infiltrate the orchid seed and provide the sugars that the developing embryo needs to grow. What does the fungus get out of the relationship? Don't be so sure it gets anything—these are orchids, after all. For all we know, the poor fungus has been deceived into thinking the orchid's seed is some dead microbe or other fungus lunch. And once the fungus has outlived its usefulness, the orchid simply eats it.

If it is starting to sound as though I don't trust orchids, that's because I've seen what they can do to some of my fellow animals.

The Australian tongue orchids (*Cryptostylis* species) lure their pollinators by deploying a scent closely resembling the pheromone of the female *Lissopimpla excelsa* wasp. The male wasp alights on the tonguelike labellum, tail first, and commences to copulate with the flower, probing its interior with the tip of its abdomen until it bumps into the sticky pollinia, which attach themselves to the insect's posterior like a pair of yellow tails. But having to play pin the tail on the pollinator is only the beginning of the wasp's humiliation. For with the tongue orchids we have passed beyond pseudocopulation into a realm even more perverse: More often than not, the wasp—referred to in the scientific literature rather pathetically as the "male orchid dupe wasp"—in the throes of his misguided sexual exertions actually ejaculates onto the flower.

Surely this represents the height of maladaptive behavior, and natural selection could be expected to deal harshly with a creature foolish enough to squander its genes having sex with a flower ("costly sperm wastage," is how the literature describes it). But as with so much else in the bizarre world of orchid sex, the matter is not quite so

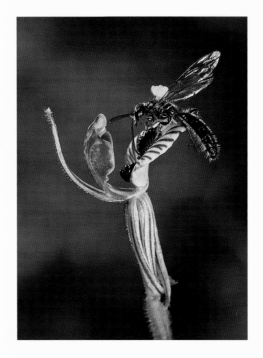

Caladenia cairnsiana *with its pollinator, a male wasp. Near Denmark, western Australia*

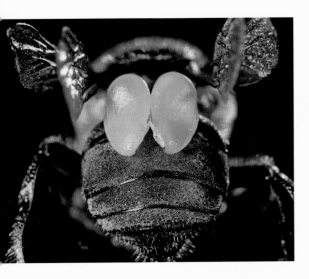

A male orchid bee with orchid pollinium attached to its back. Barro Colorado Island, Panama

simple. It seems that in a haplodiploid insect species such as *Lissopimpla excelsa*, females can reproduce with or without sperm from a male. With it, they produce the usual ratio of male and female offspring; without it, they produce only male offspring. How convenient! For the tongue orchids, that is. By inducing wasps to waste their sperm on its flowers, tongue orchids are decreasing the amount of sperm available to female wasps, thereby assuring themselves an even larger population of pollinators. Not only that, but the overpopulation of male wasps increases competition for females, which makes the desperate males less picky in their choice of mates and more likely to fall for a flower. This is very good news indeed for the tongue orchid, which through this strategy is manipulating not just individual pollinators but also whole populations of them.

TO LEARN ALL this about orchids is to admire them more but perhaps love them less. And to wonder if we too haven't fallen prey to their deceptive charms. That thought occurred to me the first time I saw the notorious Central American bucket orchid, a *Coryanthes*. I was visiting the nursery of Gaspar Silvera, an orchid hunter and breeder in Panama. Gaspar is a debonair Panamanian given to wearing straw fedoras and married to a woman named Flor. An agronomist by training, Silvera has, since retiring from government service, devoted himself to rescuing orchids from the threat of development and to the painstaking work of propagating them. "I suppose you could say that I, too, am manipulated by orchids," he explained with a twinkle in his eye, as he finished telling a shaggy tale about the great lengths to which he has gone to secure particularly choice specimens.

Christian and I had been hunting orchids deep in the cloud forest of Panama, enduring extremes of heat and cold, torrential rains and sliding mud, when Gaspar phoned to report that one of his *Coryanthes*, a genus notoriously difficult to keep happy in captivity, had bloomed. We immediately flew to Gaspar's nursery in Chilibre, hoping to witness what I'd heard was one of nature's most dramatic PG-rated pollination scenes.

By the time we got there, the canary yellow flower, a surprisingly ungainly Rube Goldberg contraption, was already fading, though it still gave off a powerful perfume of apricots and eucalyptus. The flower had thrown open its elaborately engineered petals a few days before, and the spicy-sweet scent had summoned out of the surrounding woods a band of euglossine bees—sleek, iridescent relatives of bumblebees, stingless and solitary. The bees jostled one another for space on the slick curves of the intricately sculpted flower, directly above a labellum that formed a deep bucket into which the flower dripped a clear, slightly viscous liquid.

Nectar it was not.

The bees busied themselves scraping oils from the waxy surface of the flower using their front legs, then transferred the oils to tibia sacs carried on their rear legs like little wallets. Exactly what they were collecting, and why, wasn't understood until 1966, when a botanist named Stefan Vogel figured out that the bees were collecting the chemical building blocks needed to create a scent.

Most animals that rely on a scent to attract a mate produce it themselves, but not the euglossine bee. Each male gathers ingredients from not only orchids but also certain leaves and fungi, then the male mixes the perfume by "hand," each euglossine species according to a different formula. Once a male bee has concocted his particular scent, he spreads it on his wings, then flaps them to release the aroma into the air and summon a female.

A few days before, I'd trapped one of these bees with the help of David Roubik, the world's leading authority on euglossines, in the woods behind his house in eastern Panama. Roubik snipped off a leg and told me to pinch the tibia sac between my fingers. A captivating perfume of camphor and flowers filled the moist forest air.

The bucket orchid exacts a steep price for its contribution to this perfume, however. As the bees jostle one another for scents, one or more of them is apt to lose his footing on the slickened petal and plunge into the bucket. This wouldn't be a problem, except that the viscous liquid in the bucket renders the bee's wings temporarily useless. So the bee struggles mightily to clamber up the slippery walls of the bucket until he eventually

stumbles upon a series of steps, which conduct him up and out of the pool through a narrow passageway leading out the back of the flower. As the dazed and sopping bee squeezes himself through the tight tunnel, he passes beneath a spring-loaded device that (you guessed it!) claps a pair of yellow pollinia onto his back. If all goes according to (orchid) plan, the bee dries off his wings, flies to another *Coryanthes*, splashes into the bucket again and, on his way out through the tunnel, unwittingly snags his yellow backpack on tiny hooks adapted for precisely that purpose. Pollination accomplished, the bucket orchid closes up shop, collapsing its extravagantly engineered structure of petals into a wad of crumpled yellow tissue.

Well, at least the euglossine bee escapes with his wallet full of scents, which is a lot more than you can say for the poor male dupe wasp.

Here's what occurred to me as I studied Gaspar's *Coryanthes*: That the relationship of these bees to the bucket orchid, so easy for us to smile at, is not so very different from our own relationship to a flower like the orchid. Like the euglossine bees, we gather ingredients for our perfumes from flowers. And we, too, use flowers to communicate our romantic intentions and lure mates. What is a corsage, after all, but a signifier of romantic intent and receptiveness?

The very name of the orchid comes from the Greek word for testicle, referring not to the plant's flowers but its bulbs, organs that have long been endowed with aphrodisiac properties. But it doesn't take a Freudian to discern a strong sexual subtext in the passion for these flowers, especially among men, who, as any visit to an orchid show will tell you, suffer disproportionately from "orchidelirium"—the Victorians' term for the madness these flowers inspire. Victorians were offended by the "blatant sexuality" of orchids, according to Eric Hansen, the author of *Orchid Fever*; he wasn't referring to plant or insect sexuality either. "Prurient apparitions" is how Victorian critic John Ruskin described these flowers.

Prurient? Is it possible that humans can look at an orchid and, like the deluded orchid bees or male dupe wasps, see an apparition of female anatomy? (Georgia O'Keeffe certainly did.) Could it be that plant sex and animal sex have gotten their

wires crossed in human brains, just as they have in bug brains? That accident of evolution has proved another happy one for the orchid, for look how much we humans now do for these flowers: the prices paid, the risks to life and limb endured searching for them in the wild, the laws broken, the pains taken.... Haven't we, too, fallen into this flower's seductive trap?

Those at least were my thoughts, as I watched Gaspar Silvera deploy a pair of slender forceps to remove a pollinium from a bucket orchid that had failed to entrap a euglossine bee. Working with the steady hand and patience of a jeweler, Gaspar touched the tip of his forceps to the sticky pollinium and then pressed it to a slit in the column of another bloom. Five years from now, but only after a great deal of toil and trouble, Gaspar may find himself with a new and possibly precious flower—and this orchid will find itself with offspring it would otherwise not have had.

Ever since the first human-hybridized orchid bloomed (the earliest in the Western world was recorded in 1856), we humans have become important orchid pollinators—more deliberate perhaps than the orchid bees but lured into advancing the orchid's interests just the same, assisting it in its quest for world domination. Today, there are some 100,000 registered hybrid orchids, most of them the offspring of improbable marriages among far-flung plants arranged by—and literally inconceivable without—us.

Not that any of this was ever in the orchid's plan. In evolution there is no plan, of course, only blind chance. But what *are* the chances that a flower deemed sexy by a handful of witless insects would also be so deemed by us? The moment that the orchid stumbled upon one of the keys to human desire and used it to unlock our hearts, it conquered a whole new world—our world—and enlisted a vast new crew of credulous animals more than happy to do its bidding. Let's face it: We're all orchid dupes now.

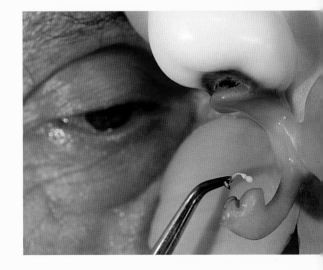

A human pollinator, orchid breeder Gaspar Silvera, hand-pollinates the flower of Cychnoches warscewiczii. *Chilibre, central Panama*

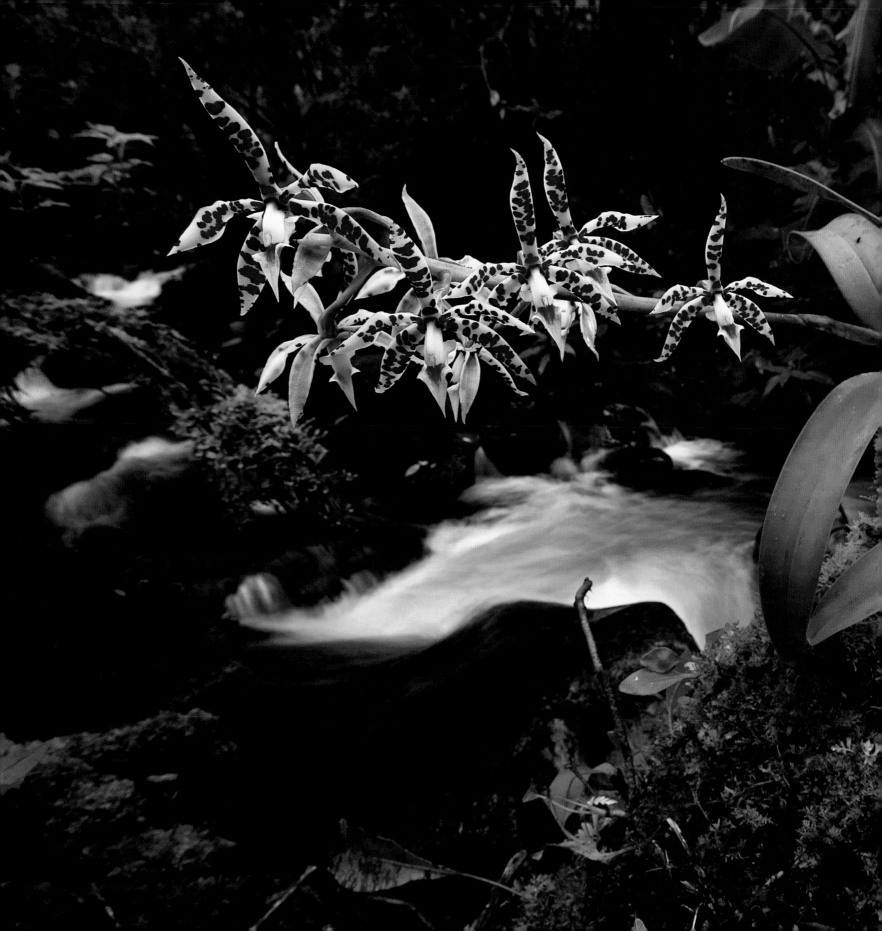

CHAPTER 1

ADAPTATION

They captivate with their beauty and seeming fragility, yet orchids belong to one of the hardiest, most adaptable plant families on Earth. With some 80 million years of evolution in their past, they've evolved to survive and thrive in a host of habitats, from semideserts to humid mangrove marshes, from the high hot canopy of tropical forests to the barren coldness of arctic tundra.

Prosthechea prismatocarpa. *The tropical montane and cloud forests from 3,000 to 6,000 feet (1,000 to 2,000 meters) are hot spots of orchid diversity worldwide. La Amistad National Park, western Panama*

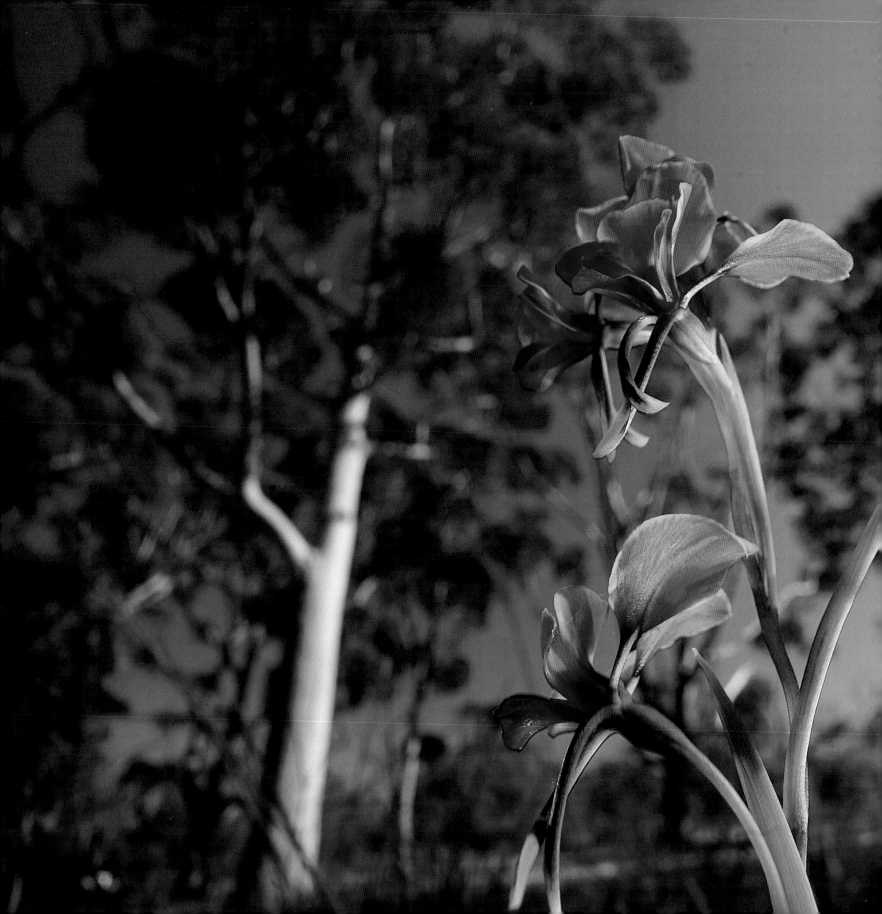

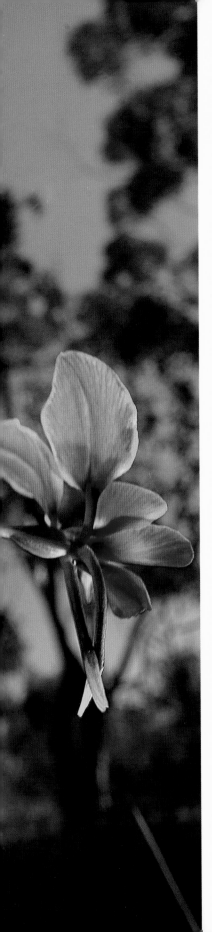

AN EVOLVING STORY

As a young naturalist growing up in southwest Germany, I was enthralled by orchids. To me, they were wondrous, exotic, and rare. When I roamed the early summer hills in search of wildlife and plants, spotting an orchid was always a particular thrill. I had learned where to look for them from a neighbor who was very botanically inclined. He knew the exact places along roadways where little patches of orchids flourished, despite the fact that they had no business being there. He guessed that they had arrived at their particular spot when the road was being built and a bit of limestone soil containing orchid seeds had found its way into the road margins. Since many of these terrestrial orchids need limestone, I would also look for them in sward—sparse, poor meadowland that drains well. Orchids, I soon realized, had flowers that didn't look like other flowers, and various species of these lovely, delicate works of nature could thrive in almost any environment, from rocky barren sward to shady wetlands.

I clearly remember a college field trip to a rolling grassland not far from my university. We had come at exactly the right week in late May and found a good dozen species of pink orchids of the genus *Orchis* in the south-facing sward. Then we walked up the meadow toward the vast Palatinate Forest, which runs all the way to the border with France, and there in the half-shade of the beeches along the forest edge were the delicate orchids called little white forest birds. Going deeper into the Palatinate, we found swamp orchids by a creek and in dark patches of woodland, brown orchids with none of the chlorophyll that gives most plants their greenness. This variety, called the bird's-nest orchid, lives off the nutrients it receives from a symbiotic fungus.

No other plant family held quite the same fascination for me as orchids did, maybe because of their relative rareness in northern Europe and certainly because of their

Diuris magnifica (pansy orchid) in a eucalyptus forest. Perth, western Australia

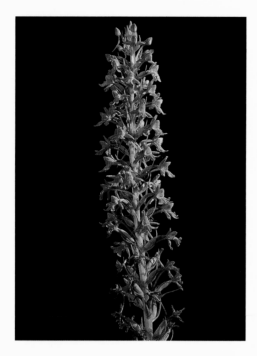

Gymnadenia conopsea growing in a shady fir forest. Near Lake Constance, southern Germany

unusual appearance—their delicate shapes and configuration, the deep spurs that hide their nectar. They weren't structured like any other flowers, and they seemed somehow special in a mysterious way.

As the radius of my wanderings expanded, I had the opportunity to see some amazing orchid habitats across Europe. On a backpacking trip into the Swiss Alps I saw orchids in abundance for the first time. I was astonished at the profusion of their blooms across the high mountain meadows, their pink spikes glowing amid dozens of other summer flowers and all of it backdropped by snow-capped peaks. It was breathtaking. There were at least a dozen species in those meadows, including the pyramid orchid that Charles Darwin had studied and written about. An orchid enthusiast himself, Darwin gathered wild orchids near his home in Kent and propagated them. In fact, orchids inspired some of his most critical thinking on natural selection. In his book *The Various Contrivances by Which Orchids Are Fertilised by Insects,* he explains the co-evolution of insects and orchids and calls them "amongst the most singular and most modified forms in the vegetable kingdom."

I shared Darwin's enthusiasm for these "singular" creatures, and on hikes I took into the Pyrenees, southern Italy, and Greece, I discovered a whole new realm of orchid species that I had not seen before. Some of them were oddly shaped, mimicking bees and other insects, while others grew to amazing sizes and had a sweet, honeyed scent.

In graduate school, on botanical research expeditions in the tropics of Asia, Africa, and Panama, I began to realize how narrow the European range of orchids was. Tropical orchids seemed nothing like the ground-based European varieties I had known. Almost all orchid species in the warm rain forests lived as epiphytes, growing from other plants, often high up in the canopy. The shapes, colors, and, in many cases, the scents, were out of this world. Their diversity seemed endless; hardly ever would I find two individuals of the same species.

My experience with orchids mirrors the global patterns of orchid distribution. While temperate areas tend to have fewer species and predominantly terrestrial ones, tropical orchids are much more diverse and most are epiphytic. Central Europe has about 250 species of orchids, yet Panama, barely one-tenth the size, has more than 1,300 known species, with many newly discovered ones being reported every year.

That's typical of the difference between tropical and temperate places worldwide, and the explanation for this lies deep in the Earth's past, in its geology and weather patterns.

KEEPING AHEAD OF CLIMATE CHANGE

For the 3.5 billion years that life has existed on Earth, this has been a warm planet, meaning most life probably evolved under conditions even warmer than what now exists in tropical areas. The giant fern and horsetail forests that prevailed some 360 to 300 million years ago in the Carboniferous period evolved and flourished in a hot, moist climate. Over the course of many millions of years the organic deposits from these plants created the carbon fossil fuels—coal and oil—that we rely on today.

Modern flowering plants began to emerge about 140 million years ago in the Cretaceous period. By 100 million years ago, they had diversified widely, probably co-evolving with insects—the insects pollinating the flowers and the flowers feeding the insects. The first orchids are thought to have appeared around 80 million years ago, among the flowering plants of the tropical forests. It's amazing to think of orchids as co-existing with dinosaurs and yet the two shared the planet for a good 15 million years.

The tropical forests of today have existed and evolved without major interruptions for millions of years. Some, like the rain forests in parts of Africa and South America, date back an astonishing 65 million years. Of course they started with a different and less diverse set of species, but these ancient, persisting habitats are more likely to preserve species over time. That's why the majority of orchid species still inhabit the tropics. And the greater number of potential pollinator species in these forests has probably added to the orchids' evolutionary potential, accounting for the species richness closer to the Equator, while the numbers drop off sharply toward the poles.

In contrast, temperate habitats are much younger and have been subject to more intense temperature variations that can occur even yearly. Orchids have survived only as terrestrial species, so they can retreat underground during inclement seasons.

Climatic changes have occurred throughout the Earth's history, and they've never been evenly distributed, always affecting the poles much more than areas close to the Equator. Today, in fact, the polar regions of Earth are warming up at an alarming rate, while the increase in temperature is happening at a much slower pace closer to

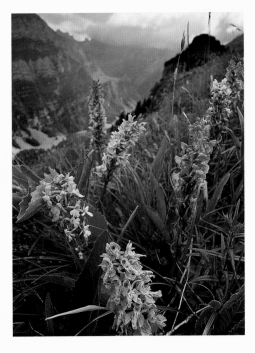

Dactylorhiza maculata *flowers in abundance in montane meadows on the slopes of Santis Mountain. northern Swiss Alps*

the Equator. During past periods of cooling, large areas of the temperate zone—a good part of which lies in the present-day United States, northern and western Europe, and China—also cooled down significantly and were often covered with huge glaciers. Most species could cope with the gradual cooling of the planet, but the glaciation events were far more challenging, driving species and whole ecosystems south. In the past 500,000 years alone, there have been five such periods of glaciation, and once each ended, life had to start virtually from scratch in the north.

Central Europe, the region that I grew up in, has been hit especially hard by glaciation-induced extinctions, even by temperate zone standards. Fossils from Messel, a famous site close to Frankfurt in central Germany, point to the existence of a very diverse tropical forest there about 50 million years ago. Similar to what we find in Borneo today, this species-rich community included a wide variety of plant life, as well as crocodiles, monkeys, and many bat, bird, and large insect species. Since then, the entire planet has cooled and, due to the movement of tectonic plates, Europe has glided north about 800 miles (1,300 kilometers). Over time, the ecosystems and many of the species of tropical Europe have migrated toward the Equator.

These European migrants faced a serious challenge as they moved south: the Alps. Other continents have north-south-running mountain systems, but this east-west barrier often proved fatal for species on the retreat from approaching glaciations. Time and again, species got pushed against the Alps, and only the ones that could move fast enough to escape the ice and cold survived.

In plants these kinds of migrations require different processes than they do in animals. While animals for the most part can move as individuals under their own steam—walking, flying, swimming—plants have to find different solutions. The movement of plants takes place across generations, with each generation taking a single step, if the conditions are right. The movement phase in the life of plants is not in the adults, who are firmly set in a single place, but in the seeds. Seeds can cover amazing distances, many miles sometimes. The agents of transport can be abiotic, such as wind or water. More often animals take the role of dispersers, and seeds can travel long distances in the fur, feathers, or guts of animals. Wherever the seed is transported, it will attempt to germinate. But only those that end up in a habitat with just the right

conditions become successful individuals of the next generation.

Imagine that a colder period is descending on the Northern Hemisphere. Over several hundreds or thousands of years, the average temperature slowly drops. For the plants of any given species adapted to that ecosystem, conditions keep getting worse on the northern edge of the area, while they keep getting better toward the south. Seeds that have been dispersed northward are less likely to be successful than the ones that end up toward the south. So the distribution of the species in this ecosystem is slowly, step by step with each generation, shifting toward the south.

It's obvious under this scenario that different plant species will have very different travel speeds, depending mostly on how long it takes them to produce a new generation and on their average seed-dispersal distance. While annuals disperse every year from their first year on and thus are able to respond quickly to climate changes, trees might have a generation time of ten or more years and can take a step only that often. This generally means that trees are slower responders to climate change than annuals, but in fact some trees make up for the long generation time by having efficient long-distance seed dispersal. In the case of epiphytic orchids, the plants bear huge quantities of minute, almost microscopic seeds that can be dispersed great distances by the wind. That allows for rapid transit and the opportunity to colonize new habitats.

Plants and plant communities flow north and south over time, following the ever changing climate. If climate change is very rapid, as it is now, some or even many species might not be able to move fast enough. They'll get run over by the changing conditions and sink into extinction.

The glaciations of the last million years have significantly influenced all Earth's temperate ecosystems. After all, a mere 15,000 years ago large areas of North America and Europe were covered with ice sheets. The temperate species of today either migrated up from the south or originated from protected habitat islands that were not ice-covered. The orchids of Europe and North America seem to be a mix of both.

As to the long-lived tropical forests, the periods of Earth's cooling had far less impact on them, manifesting mostly as a reduction in rainfall rather than a drop in temperature. In fact, the periods of cooling may have acted as "species pumps"— encouraging new species to evolve. Here's how it worked: Reduced rainfall turned

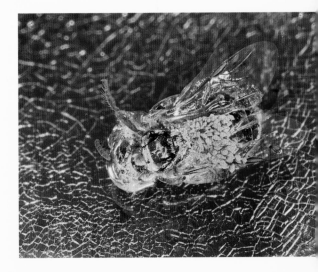

Preserved in amber, this roughly 20-million-year-old sweat bee carrying an orchid pollen package helped scientists determine the general age of the orchid family as 100 million years old.

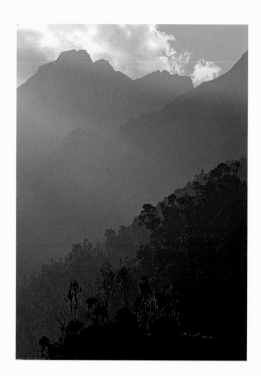

At an elevation of 6,000 feet (2,000 meters), the heather forests of the Rwenzori Mountains provide superb orchid habitat. Uganda

parts of the jungle into savannah, interrupted by "islands" of forest. The habitat fragmentation isolated plant and animal species in these island communities, where they evolved new species. That helps explain the richness of flora and fauna in the tropics today and the vast diversity of orchids found there.

THE HIGH LIFE

The orchid family is exceptional, probably uniquely so, in its ecological diversity and its ability to tolerate environmental stresses of various kinds, especially a lack of nutrients and water. Members of the orchid family are able to live in a range of habitats—from semideserts to the moistest forests. Some species inhabit swamps and can even live as floating aquatic plants, while others flourish in alpine meadows and arctic tundra. Even when shrubs and trees have petered out in the harsher northern temperate zone or at high altitude, there are orchid species that hang on. In fact, orchids thrive in extreme habitats, pushing the edges of where plant life can exist on the planet.

Many orchids have evolved into epiphytes, plants that use others for structural support without being parasitic. Epiphytes have no connection to the ground and must therefore cover all their nutritional needs while attached to another plant. An estimated 72 percent of orchids, or 15,000 to 20,000 species, live in the canopies of rain forests, making them the plant family with the highest number of epiphytic members.

The epiphytic life form probably evolved in the orchid family many times independently, because the ancestral orchids had a set of important pre-adaptations that equipped them for life in the treetops and in other marginal habitats. Among these pre-adaptations were their drought resistance; their low nutrient requirements; their special, more water-efficient type of photosynthesis; and their ability to produce huge numbers of tiny, easily dispersed seeds. The big disadvantage of the epiphytic existence is the disconnection from the ground and thus from a steady and reliable supply of nutrients and, most crucially, water.

Despite the fact that tropical rain forests receive abundant rain, the living environment of an epiphyte high in the canopy can resemble a desert, with the stress of extreme heat, radiation, and photo bombardment from the sun. All epiphytic orchids have evolved a number of adaptations to cope with these conditions. Most have leathery

leaves with a thick outer wax layer that reduces water loss and also protects the plant from the intense UV that could destroy proteins and DNA. They also have a modified root system, the roots covered with a spongelike layer of dead tissue called velamen. When it rains, the epiphytes' velamen captures water and stores it—an adaptation to the rare, short, and heavy downpours that occur in the dry seasons of tropical rain forests. Another water-storage adaptation among orchids is their thickened stems, called pseudobulbs, which store enough water to get the plant through a dry season. Orchids that produce pseudobulbs grow new ones each year.

While living high up in the canopy can have its stresses, this place in the sun is also the greatest advantage of the epiphytes. With very little investment in a stem, these plants have access to sunlight and can concentrate on gathering it with almost all their tissue. A tree, in contrast, has to invest a lot more to get its own leaves into the sun. Abundant sunshine is very beneficial for the process of photosynthesis, in which carbon (from atmospheric carbon dioxide) is captured by the plant. Probably the most important and sophisticated adaptation in orchids is their way of doing photosynthesis—a process called CAM, for Crassulacean Acid Metabolism. The defining feature of CAM is the ability to take CO_2 from the atmosphere at night and store it until day, when the energy of sunlight is available to turn carbon into sugars. On a molecular level, this happens when electrons are knocked free by the light and stored in energy-transporting molecules—much like the process in a solar panel. These molecules then provide the energy to build sugars from CO_2 and water. So CAM allows orchids to keep their leaf openings closed in the daytime, thus significantly reducing the loss of water.

Many scientists see these adaptations as a major reason for the impressive diversification of the orchid family. Drought resistance and low nutrient requirements enabled the terrestrial orchids of the temperate zones to colonize such difficult habitats as rocky, porous karst landscapes or nutrient-poor meadows and to diversify there. As to the tropical epiphytes, the ancestral orchid forms were able to conquer an almost empty habitat: the branches of the canopy. Over time, via mechanisms like the repeated fragmentation of the forest environment and co-evolution with pollinators, these ancestral forms radiated into the stunning array of orchids that we encounter today.

Fernandezia sp., a very rare orchid, flowers in an elfin cloud forest, where harsh conditions limit growth. La Amistad National Park, western Panama

ABOVE: Pterostylis sp. *(the long-beaked bird orchid) in an old growth oak forest. Near Denmark, western Australia*

RIGHT: *A large stand of* Diuris magnifica *(pansy orchids) in Kings Park. Perth, western Australia*

TEMPERATE FORESTS OF AUSTRALIA

The dry forests and woodlands of Western Australia harbor a rich diversity of terrestrial orchids. Many of these eucalyptus-dominated forests frequently experience fires that clear out the undergrowth and create ideal conditions for orchids to be found by their pollinators.

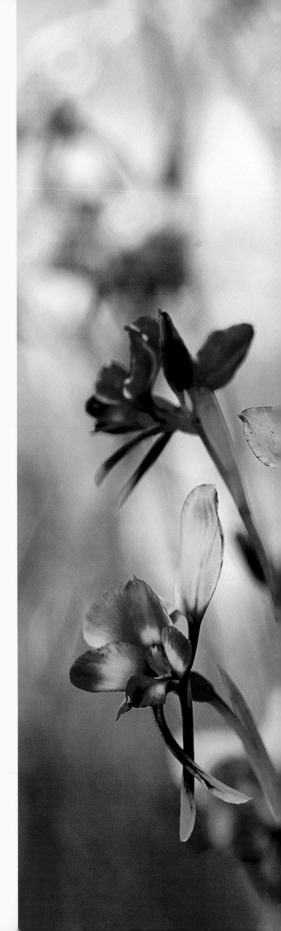

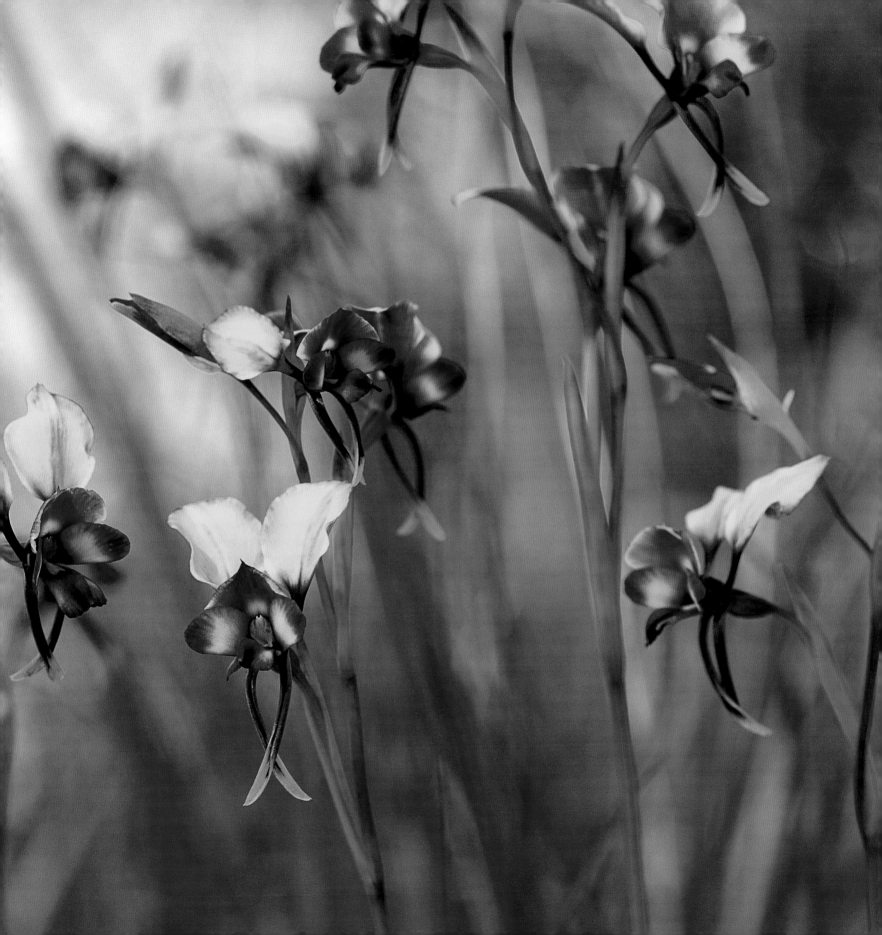

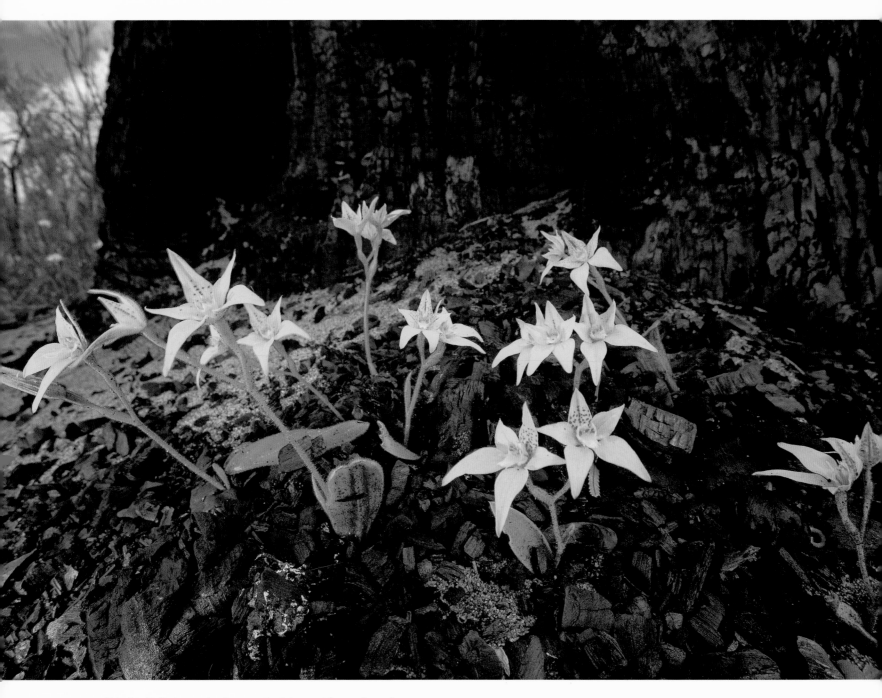

ABOVE: Caladenia flava *growing in a patch of charcoal from a forest fire.*

RIGHT: Cyanicula sericea *growing on the base of a tree burned by a recent forest fire.*

Both near Perth, western Australia

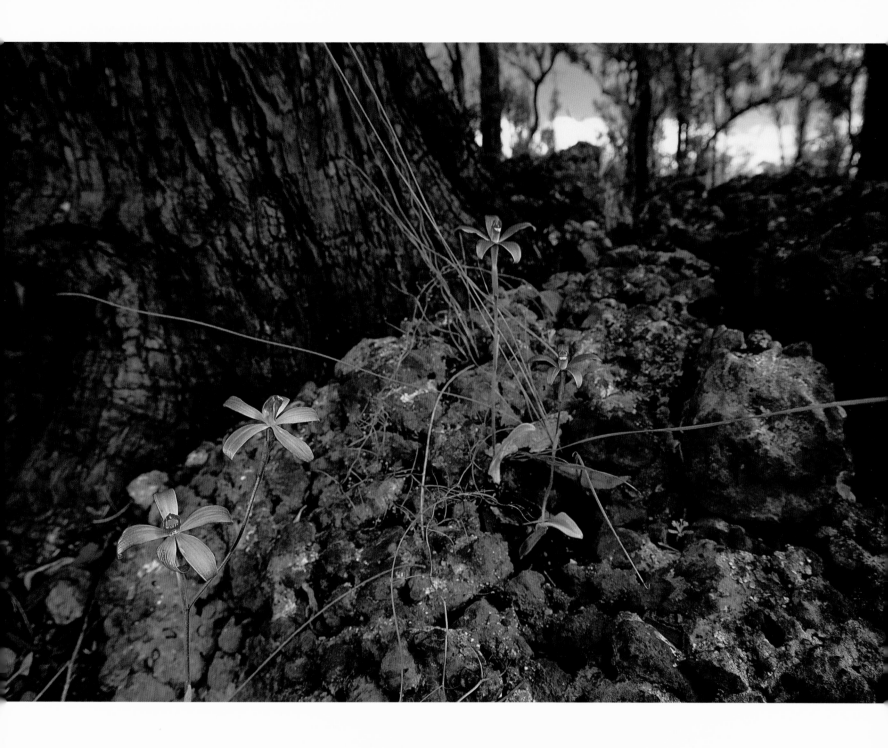

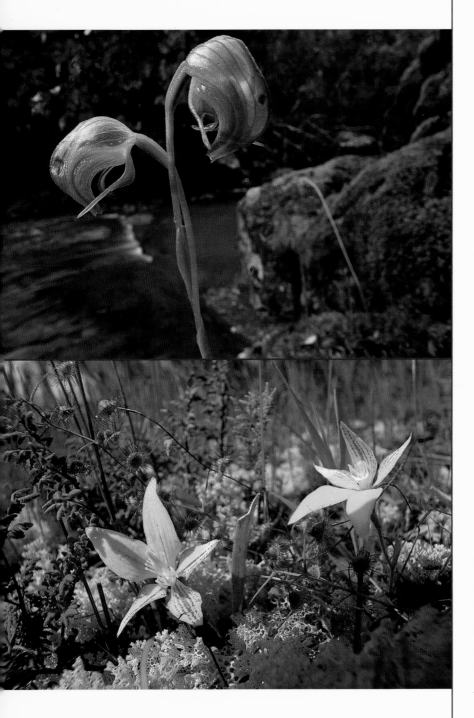

LEFT, TOP: Pterostylis nutans *growing next to a stream in a eucalyptus forest. South of Sydney, south Australia*

LEFT, BOTTOM: Caladenia flava *(cowslip orchid) on the edge of a granite outcrop. Near Perth, western Australia*

RIGHT: Caladenia polychroma *(spider orchid) flowers next to a sundew. The carnivorous sundew is ready to devour any pollinating insects attracted to it by the false promise of nectar. Albany, western Australia*

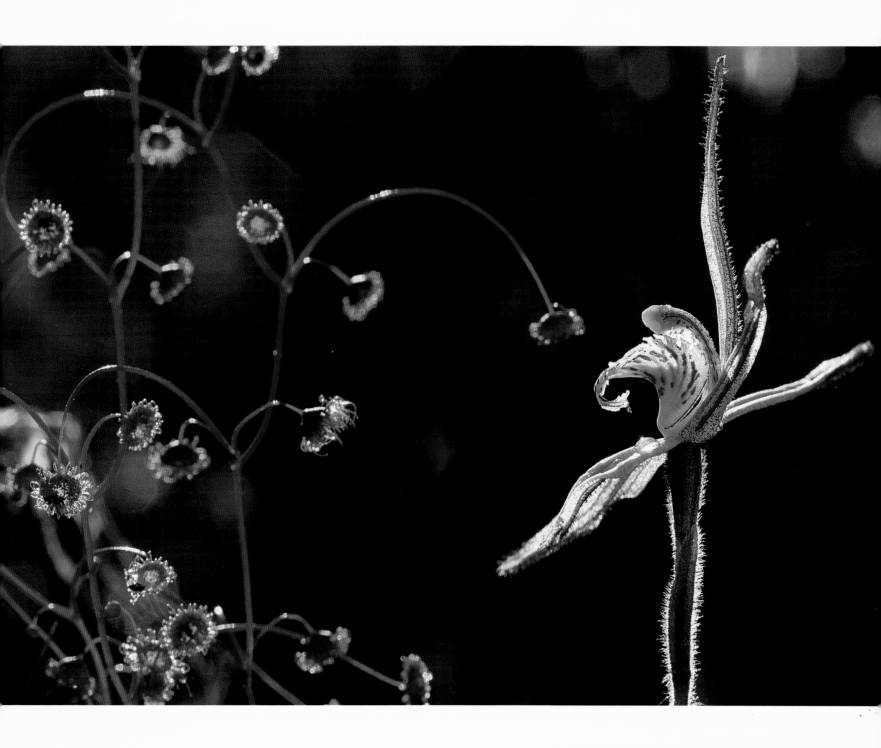

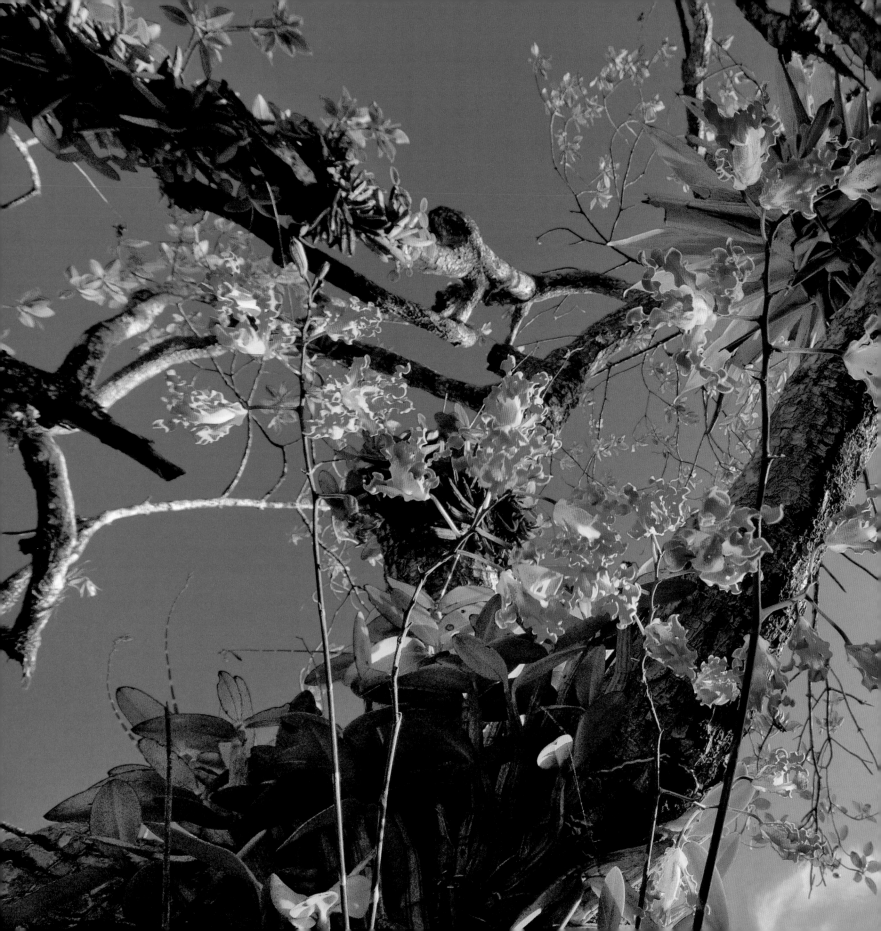

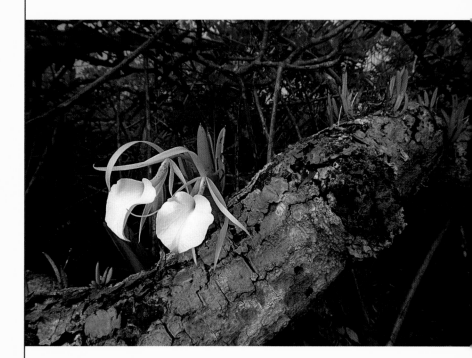

LEFT: Myrmecophila brysiana *blooming in a mangrove stand. Rio Platano, Honduras*

ABOVE: Brassavola nodosa *emits a sweet scent all night to attract its pollinator, the hawk moth. Southern Belize*

EXTreme TropICAL HaBITaTs

Along Caribbean coastlines, mangrove forests often define the transition from ocean to land. From an orchid's perspective, these forests present a very challenging habitat because of their high salinity and radiation and their limited freshwater. Still, some epiphytic orchids have conquered this special habitat and can be quite common in mangrove stands.

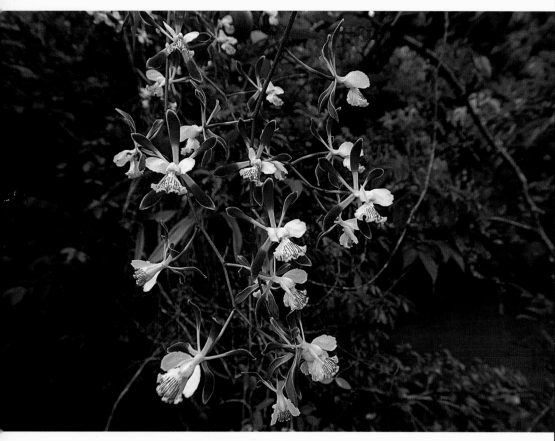

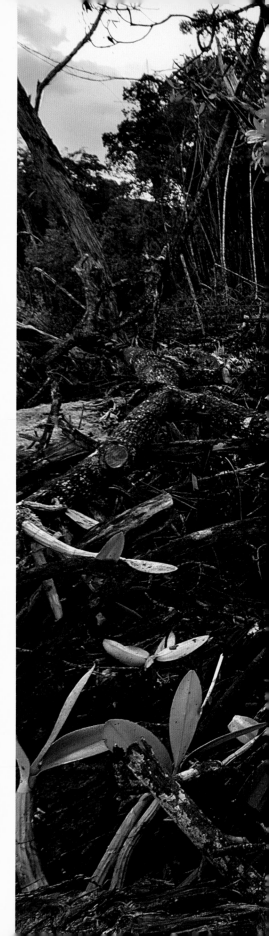

ABOVE: *An* Encyclia alata *flower spike hangs from a low tree. Rio Platano, Honduras*

RIGHT: *A mangrove stand in southern Belize being logged for vacation homes; many of these important forest habitats are disappearing at alarming rates worldwide, to make way for shrimp farms and touristic development.*

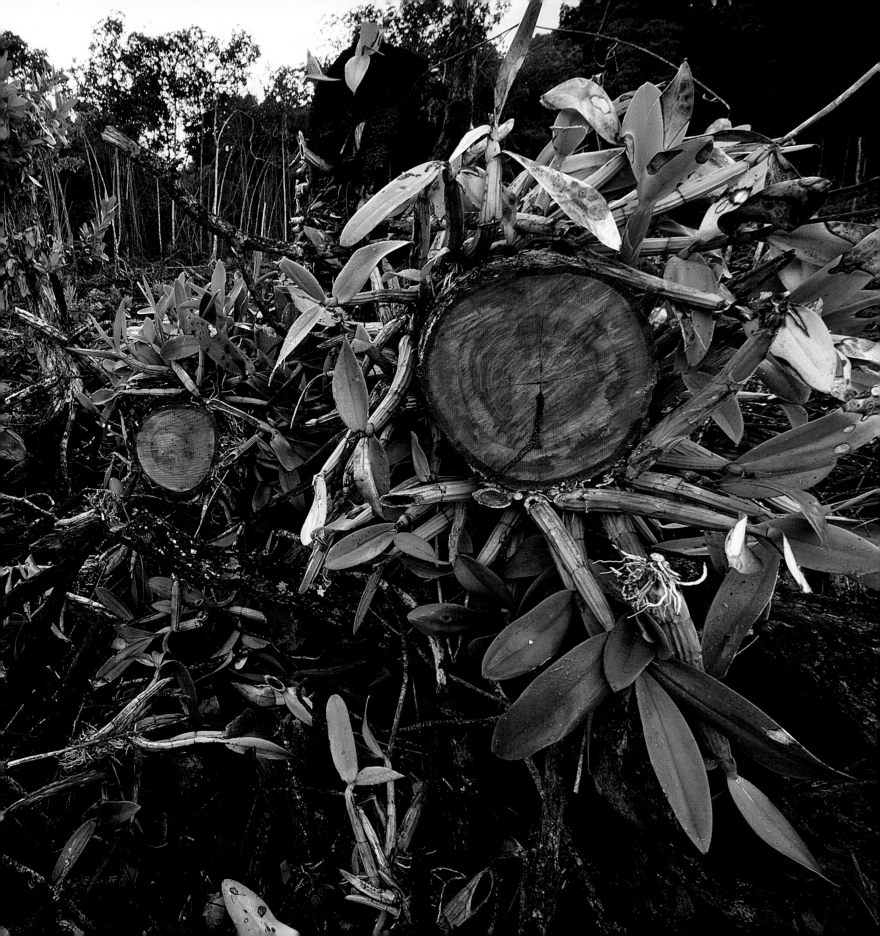

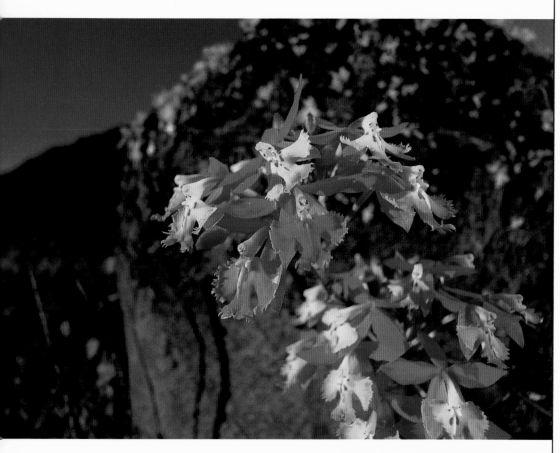

ABOVE: Epidendrum radicans *flowers in large numbers in an open grassland growing atop an old lava flow.*

RIGHT: Sobralia sp. *orchids in this location all flower together for only three days once a year, thus ensuring cross-pollination.*

Both in Volcano Baru National Park, western Panama

KARST HABITATS

Karst landscapes are difficult habitats for all plants. The Swiss cheese—like soils, composed of limestone or old lava flows, drain extremely fast, so water from rainfall runs off rather than being absorbed. Orchids, with their adaptations to drought, are especially suited to this kind of habitat and can thrive in karst grasslands.

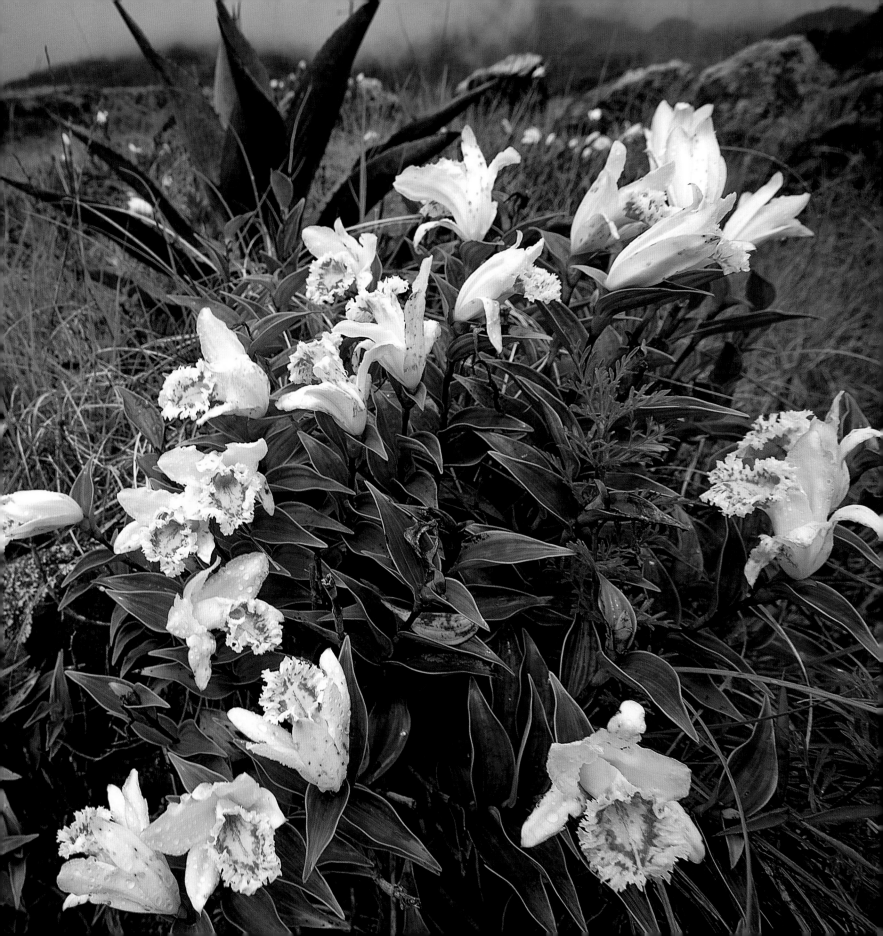

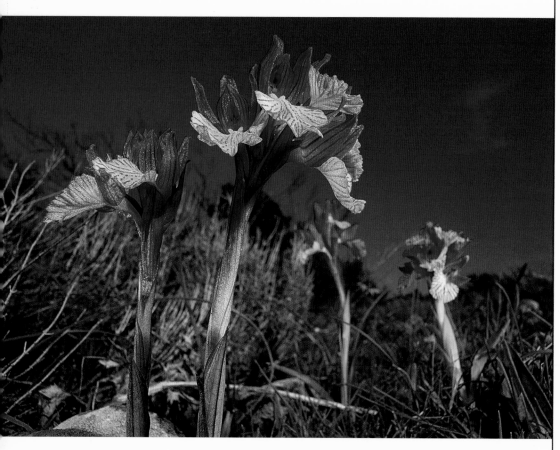

ABOVE: Anacamptis papilionacea *(butterfly orchid) amid the dense shrubs of a macchia landscape.*

RIGHT: Ophrys speculum *(mirror bee orchid) grows in abundance despite the low nutrients on these coastal limestone cliffs. The plant gets its name because it produces a faux female-bee pheromone and its flower resembles a female bee, both ploys to attract its pollinator, the male bee.*

Both in Sardinia, Italy

macchia habitat

Winter rains and summer heat blanket some areas around the Mediterranean in southern Europe, giving rise to a challenging plant habitat called macchia. Similar to the dense, low shrublands of North American chaparral, macchia has poor, often limy soil and limited water—ideal conditions for an impressive number of orchid species.

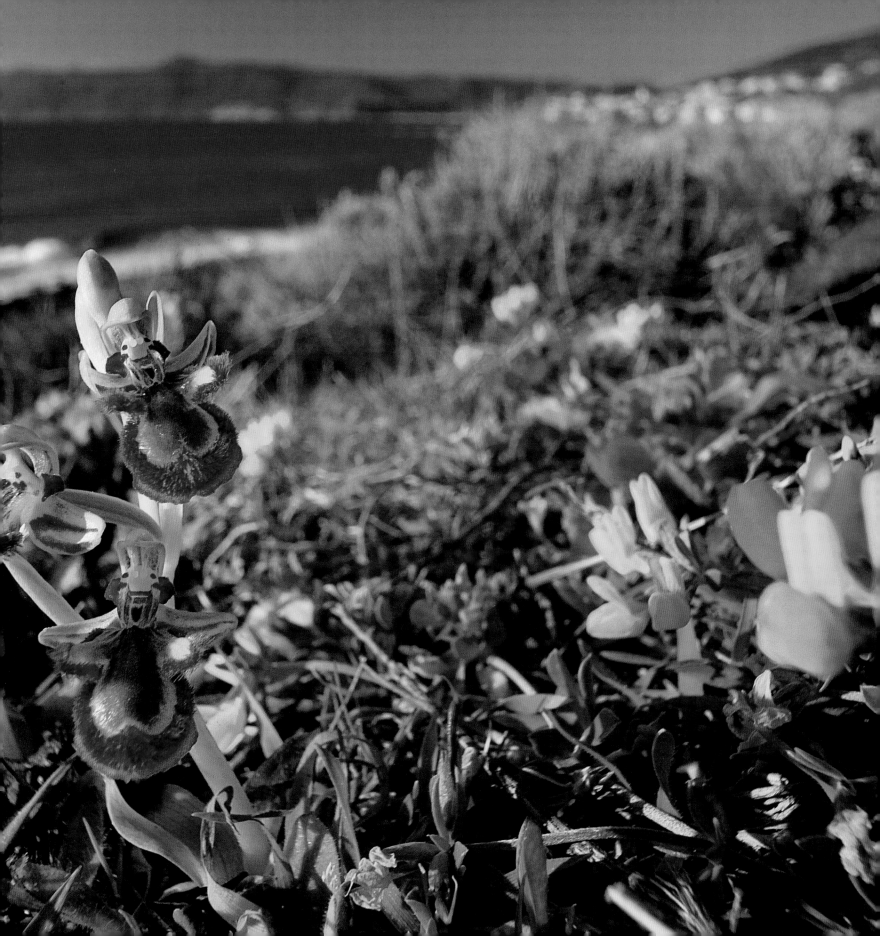

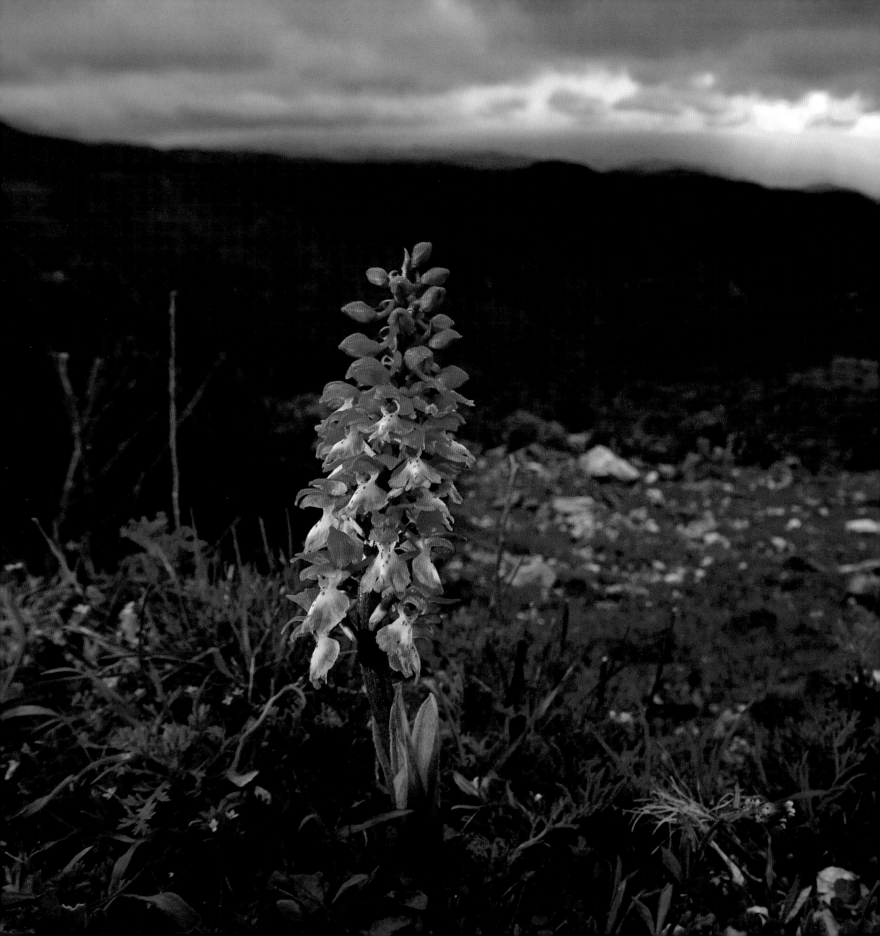

LEFT: Orchis mascula, *a widespread species in Europe, is a food-deceptive orchid. By looking like a nectar-rich flower, it attracts naive bees that transport its pollen.*

ABOVE: Anacamptis papilionacea *(butterfly orchid) flowering by a roadside.*

Both in Sardinia, Italy

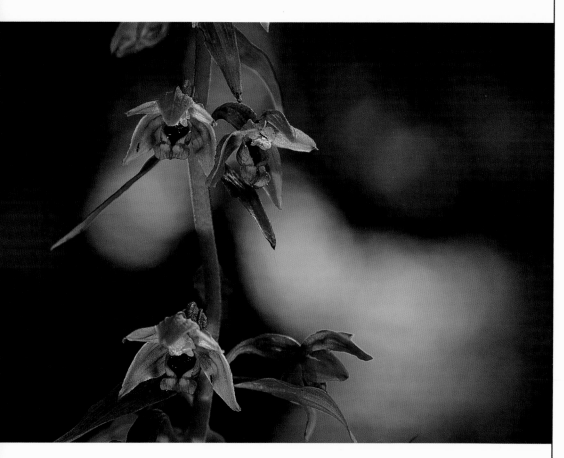

ABOVE: Epipactis helleborine *in a mixed hardwood forest.*

RIGHT: Neottia nidus-avis *(bird's-nest orchid), a chlorophyll-free species often found in shady forest areas.*

Both near Lake Constance, southern Germany

TEMPERATE EUROPE

The European flora north of the Alps is less diverse than elsewhere owing to relatively recent glaciations. Still, some orchid species have established themselves in nutrient-poor areas and in forest habitats that grow in limy soil.

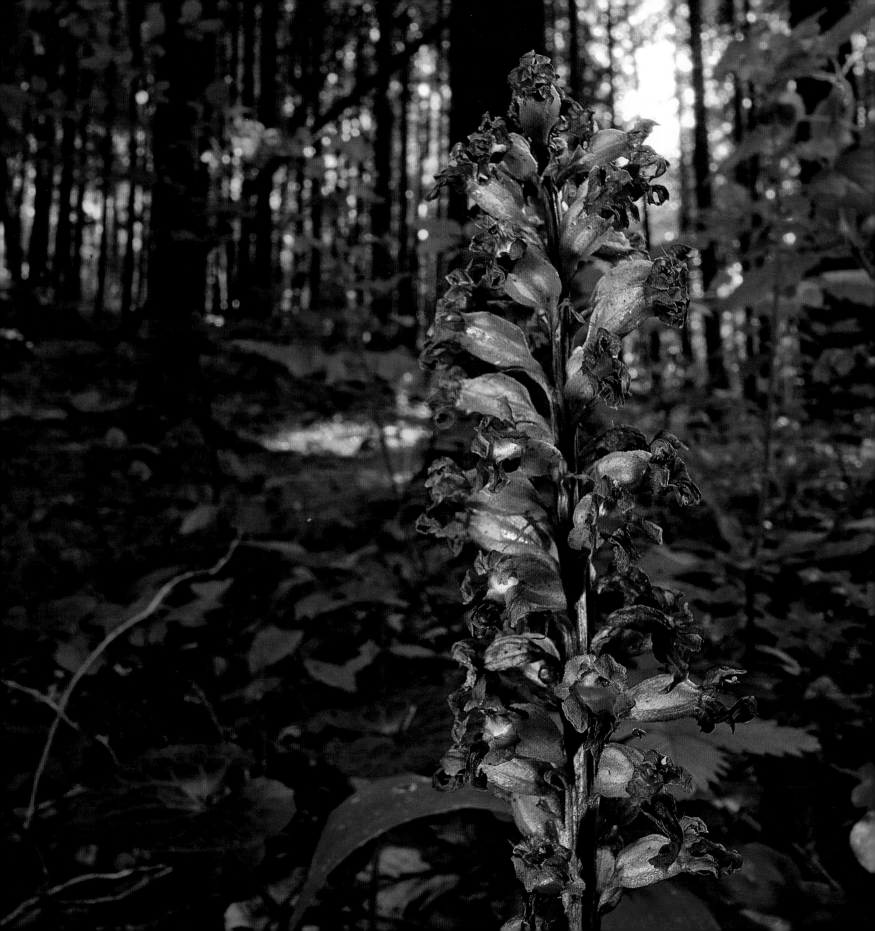

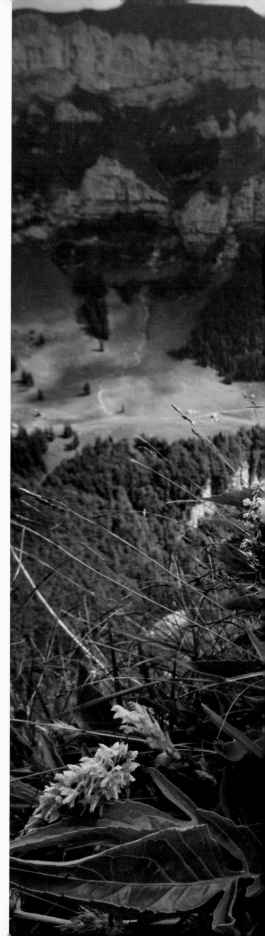

ABOVE: Gymnadenia conopsea *also flowers in montane meadows on these slopes.*

RIGHT: Dactylorhiza maculata *flowers in abundance on the slopes of Santis Mountain. Alpine meadows have a rich and diverse orchid community.*

Both on Santis Mountain, northern Swiss Alps

ALPINE MEADOWS

The Alps are home to a wide variety of orchid species; many inhabit the higher-altitude meadows, often far above tree line. Here, the harsh conditions—poor soils, limited water, and high radiation—suit orchids well.

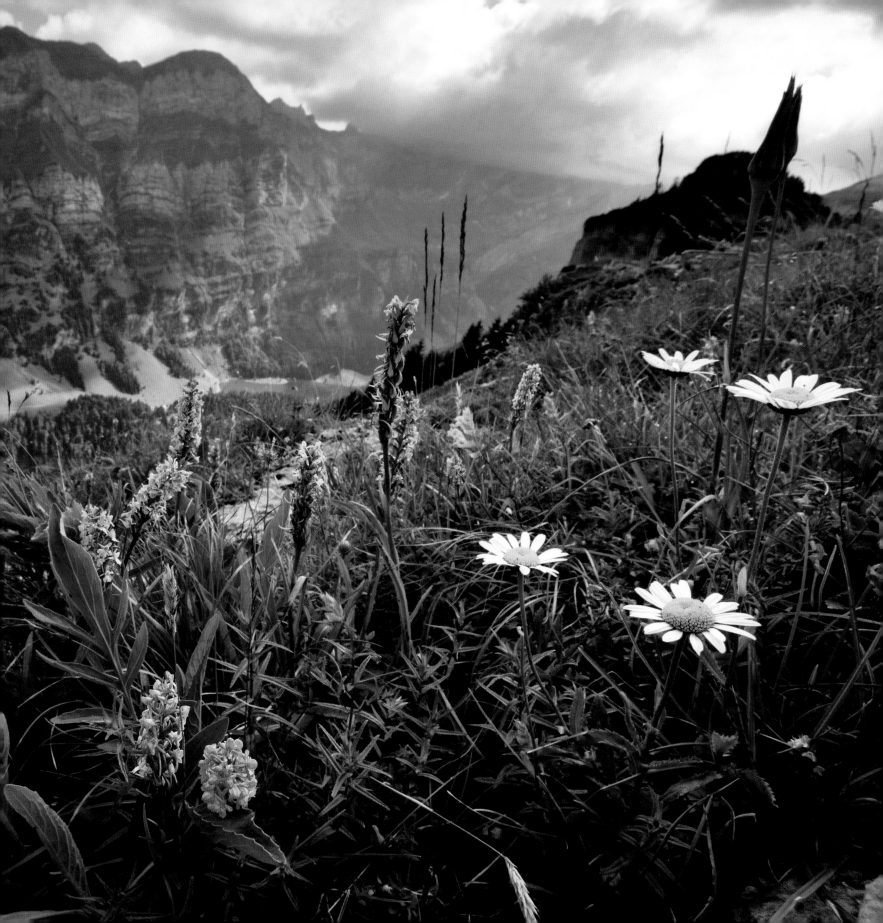

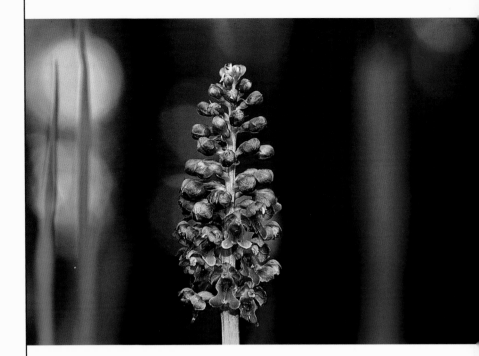

LEFT: *An old-growth stand of beeches on a Baltic island is home to a number of terrestrial orchid species.*

ABOVE: Neottia nidus-avis *(bird's-nest orchid), a non-photosynthetic orchid, gets its food from symbiotic relationships with fungi and parasitic relationships with green plants.*

Both in Jasmund National Park, Rügen Island, Germany

TEMPERATE LOWLAND FORESTS

Northern temperate Europe is not a very species-rich habitat. Covered by glaciers barely ten thousand years ago, the ecosystems here are still in flux. However, a healthy variety of orchid species has managed to colonize these young and changing forests.

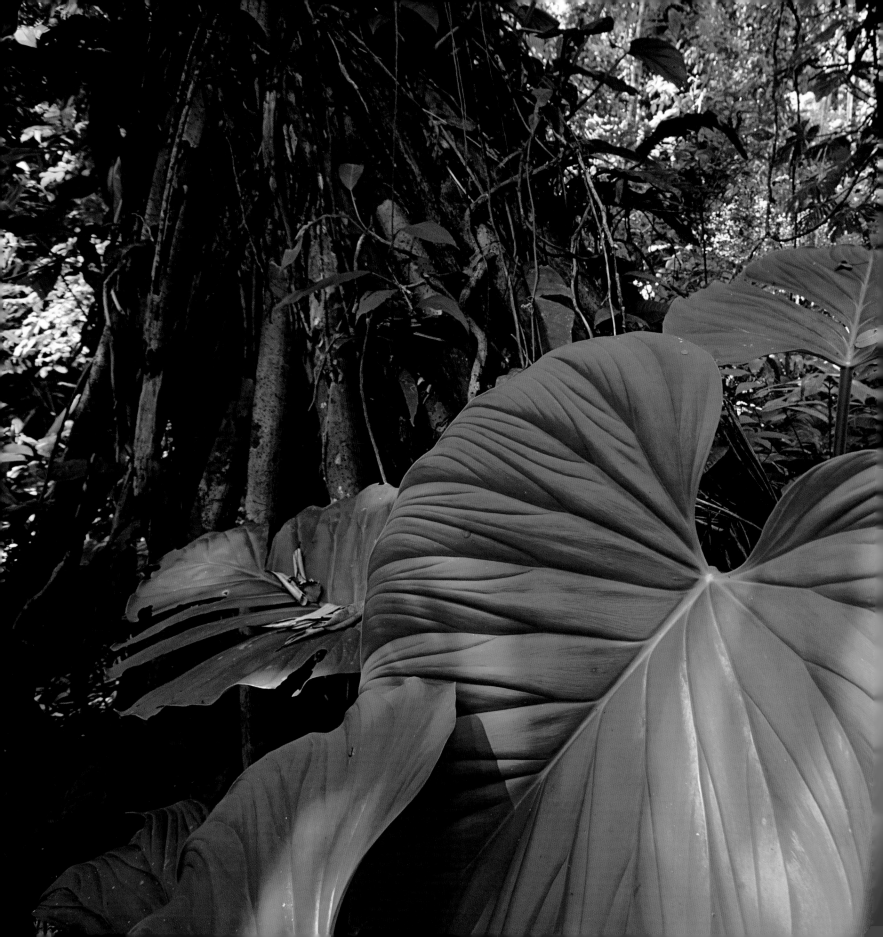

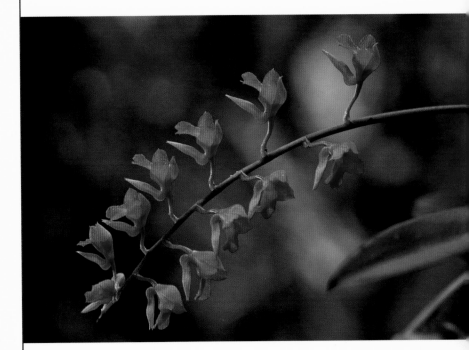

LEFT: *A philodendron with giant leaves thrives in the shady understory of this lowland rain forest, also an important orchid habitat. Bocas del Toro, Panama*

ABOVE: *Rodriguezia lanceolata (coral orchid) is typical of the orchid species found in the moist lowland forests of Central America. Barro Colorado Island, Panama*

TROPICAL LOWLAND FORESTS

The tropical lowland rain forests of Central America and Borneo are defined by an abundance of rainfall—at least four inches (a hundred millimeters) a month—and extremely high biomass. Because of the lack of sunlight on the forest floor, a vast majority of the orchids live as epiphytes in the canopy, which reaches 200 feet (60 meters) into the sky and offers a plentitude of ecological micro-niches. Here, sunlight is abundant but nutrients and sometimes water are scarce.

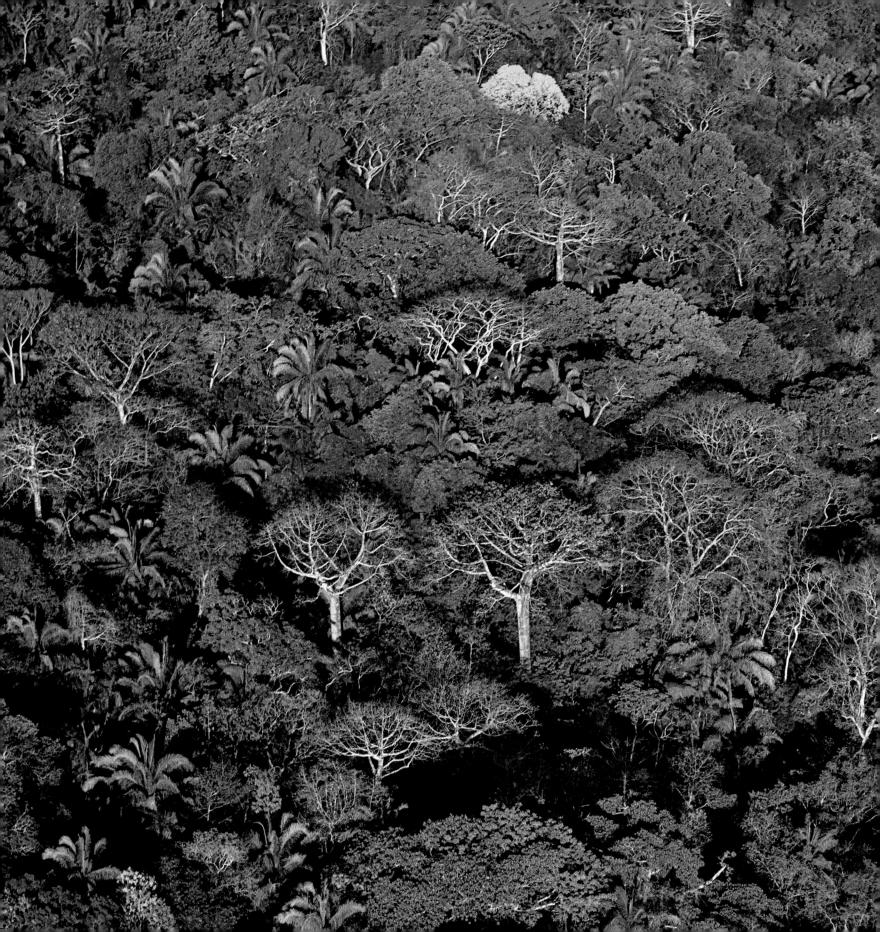

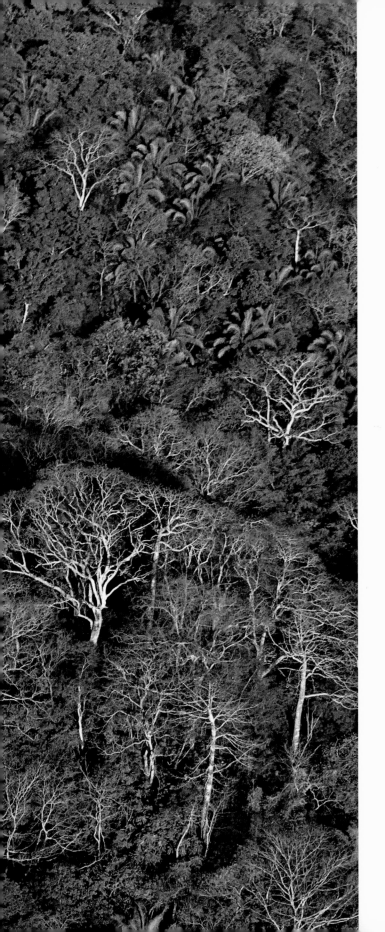

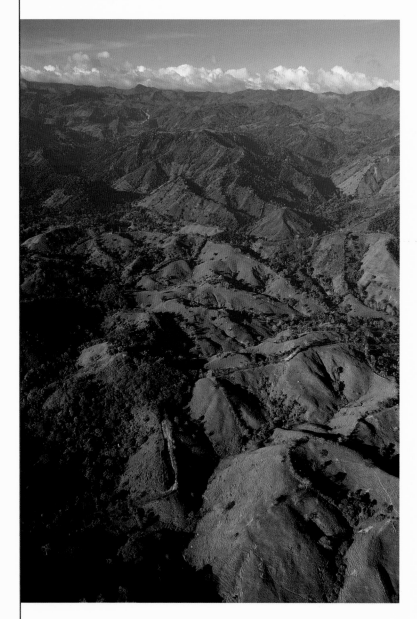

LEFT: *This lowland tropical forest in Soberania National Park is home to a large diversity of mainly epiphytic orchid species.*

ABOVE: *These rolling hills were covered in an orchid-rich rain forest just 20 years ago. But across Latin America huge tracks of forest have been destroyed in recent decades to make way for cattle farming, which often leaves the land depleted.*

Both in central Panama

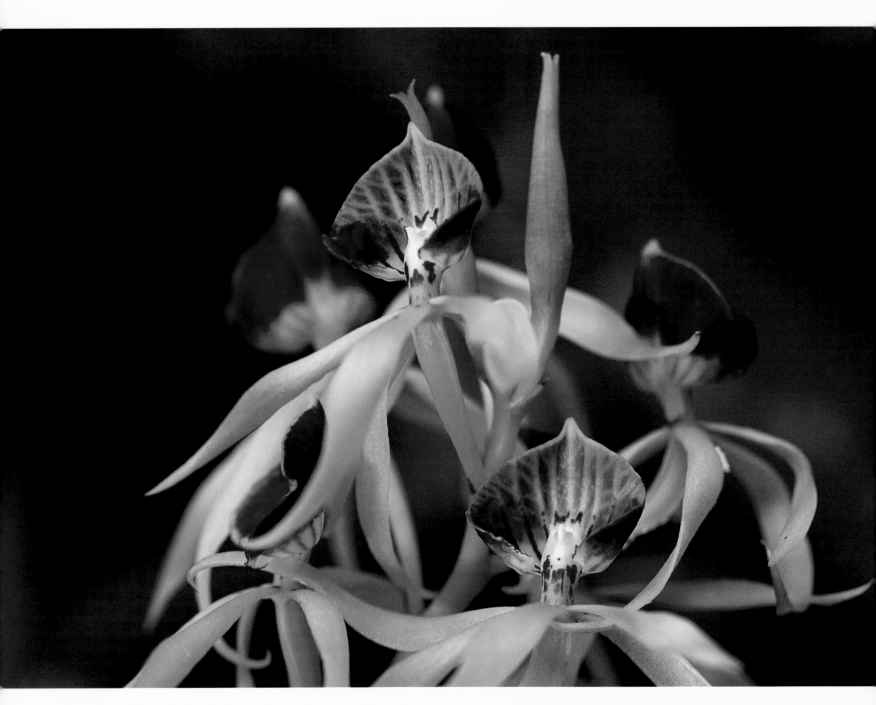

Encyclia cochleata (black orchid), an epiphyte, is the national flower of
Belize. The vast majority of tropical orchid species live as epiphytes in the
high canopies of rain forests.

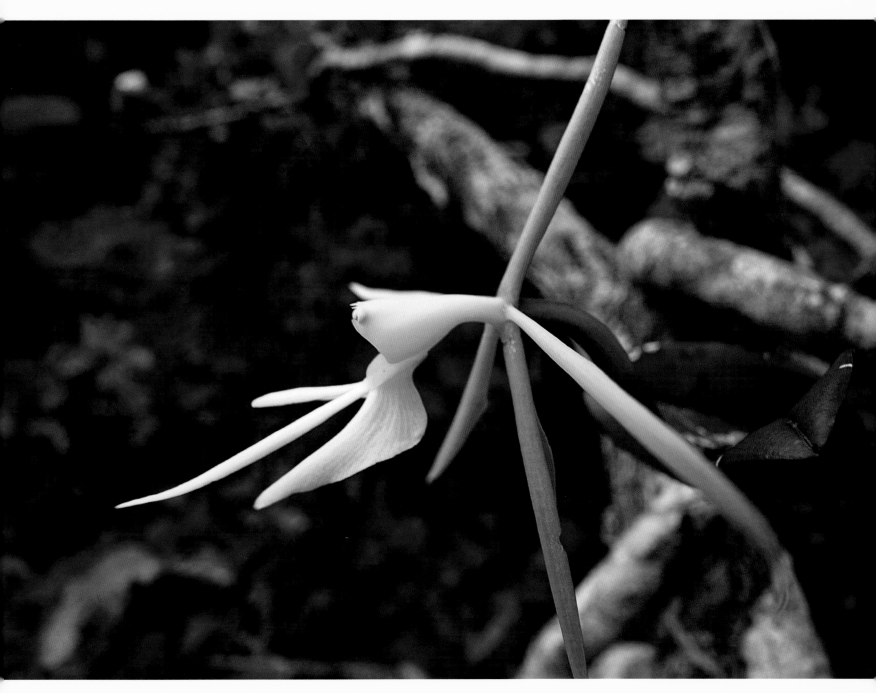

Epidendrum nocturnum *grows so high up that a canopy crane is required*
to photograph it. The crane used here was courtesy of the Smithsonian
Tropical Research Institute.

Both in Fort Sherman, Caribbean coast of Panama

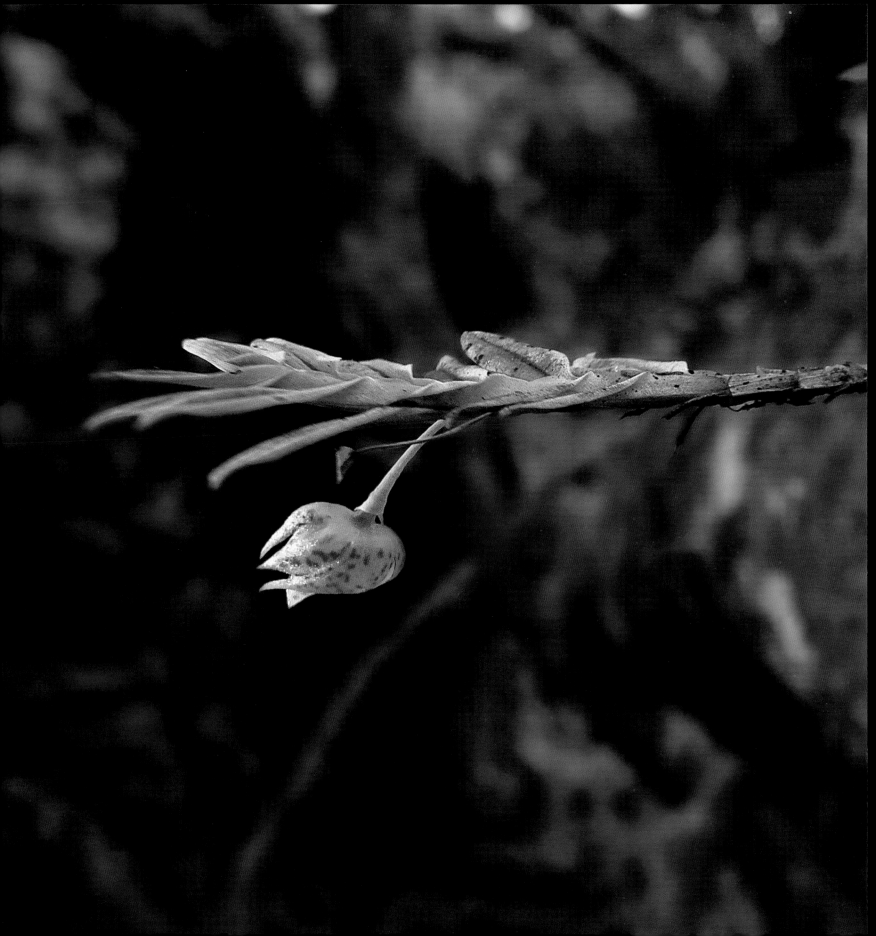

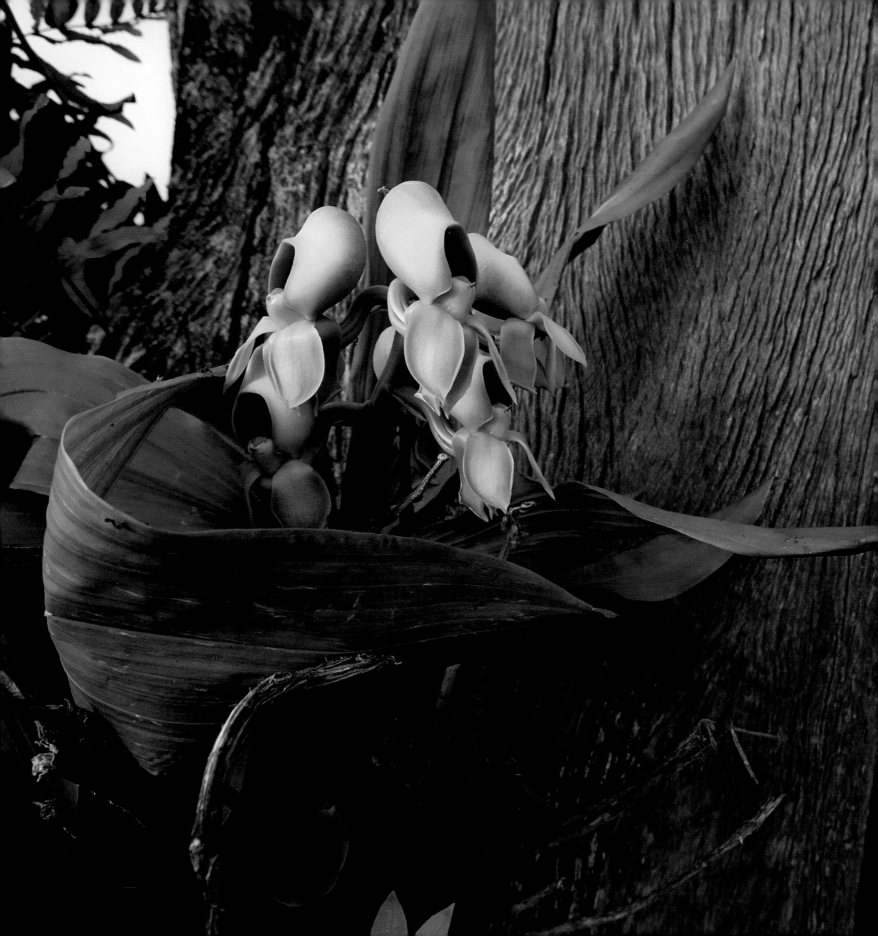

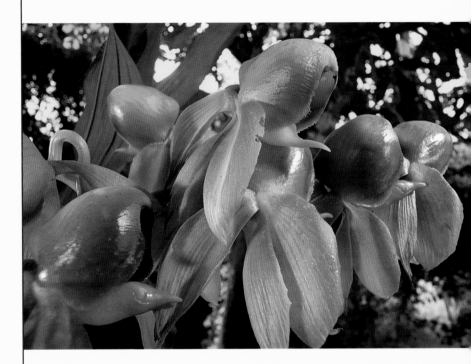

PRECEDING PAGES: Dichaea sp., *a tiny epiphytic orchid, growing on a huge branch 120 feet up in the canopy. Fort Sherman, Caribbean coast of Panama*

LEFT: Catasetum viridiflavum, *its male flowers in bloom, flourishes on a dead tree trunk. Lake Gatun, central Panama*

ABOVE: Catasetum viridiflavum's *female flowers also make a spectacular display in the forest canopy. Both male and female flowers of the species evolved to attract their pollinator, the orchid bee. Barro Colorado Island, central Panama*

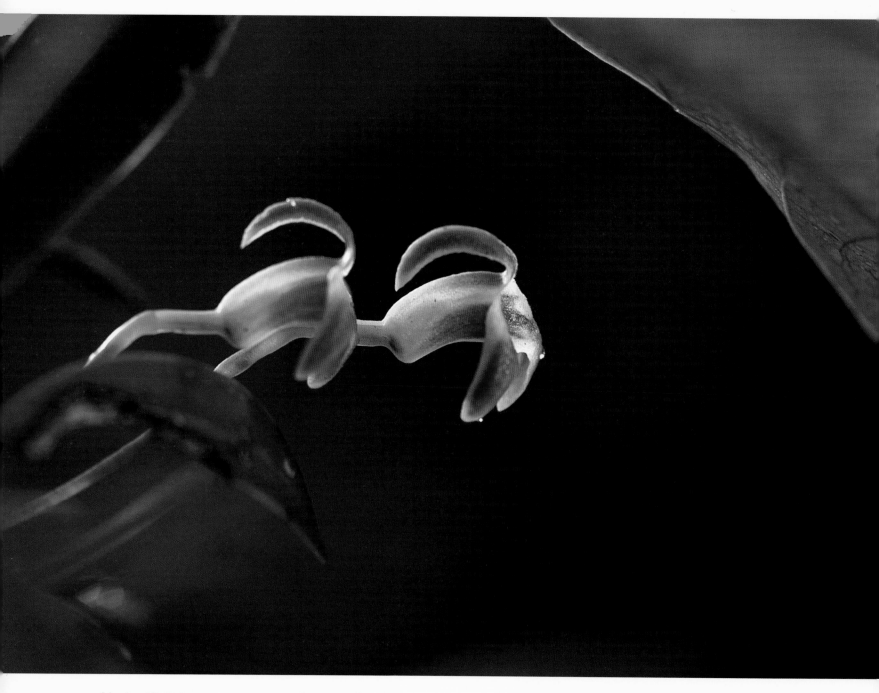

ABOVE: Masdevallia livingstoneana *growing in the canopy of a moist lowland rain forest. Fort San Lorenzo National Park, Panama*

RIGHT: Schomburgkia lueddemannii. *Central Panama*

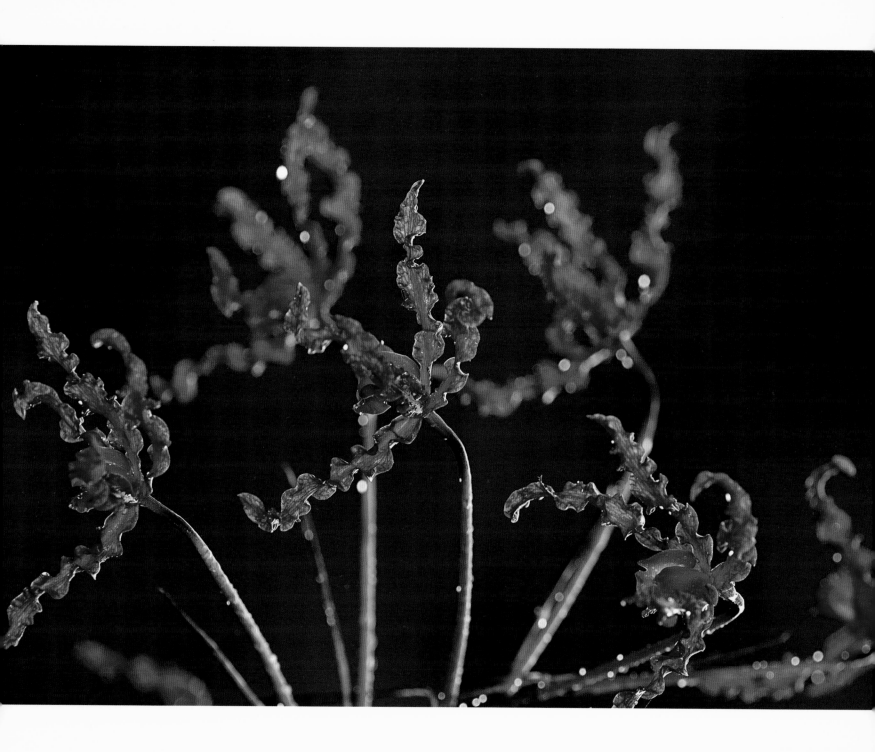

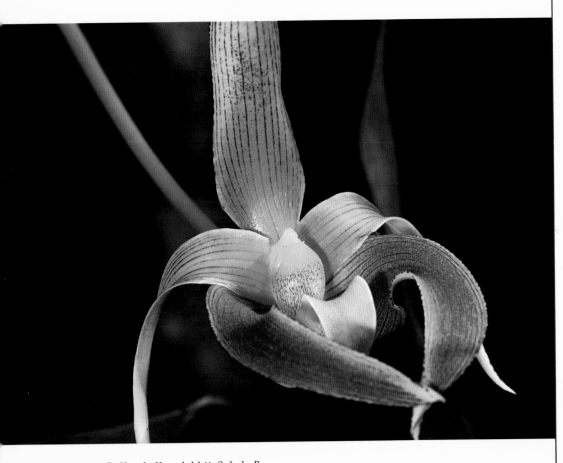

ABOVE: Bulbophyllum lobbii. *Sabah, Borneo*

RIGHT: *A lowland rain forest that once greened this swath of Sarawak was clear-cut to prepare for oil palm plantations. Extensive logging across Borneo has reduced its rich rain forests over the past three decades to a fraction of their former extent. Many orchid species are believed to have gone extinct in the process. Sarawak, Borneo*

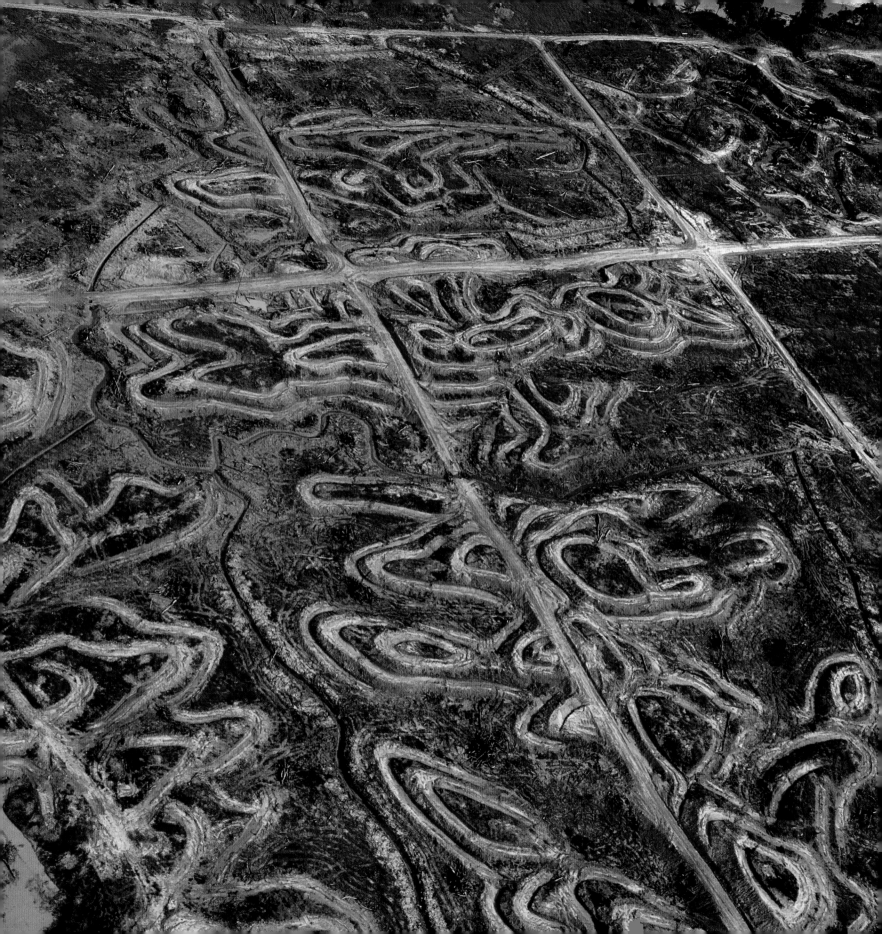

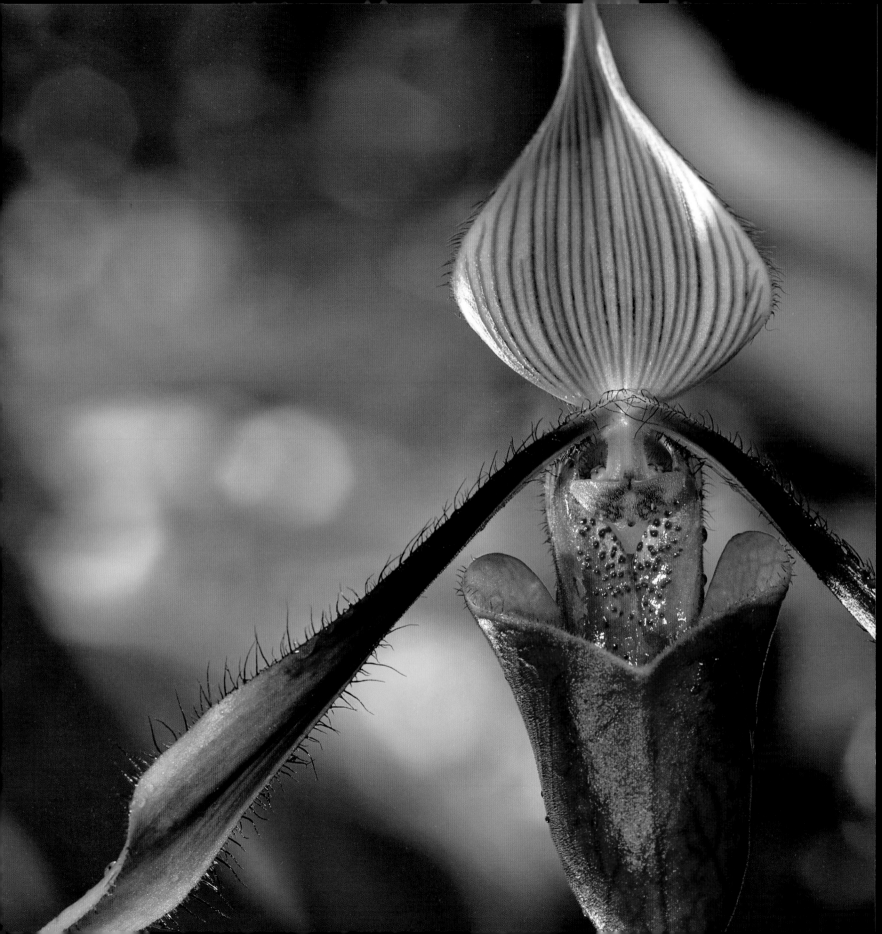

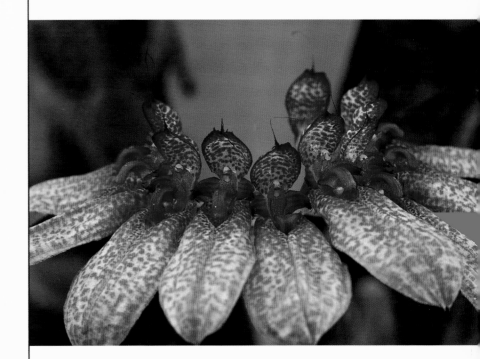

LEFT: Paphiopedilum sp. *(slipper orchid)*

ABOVE: Bulbophyllum longiflorum

Both in Poring Hot Springs, Sabah, Borneo

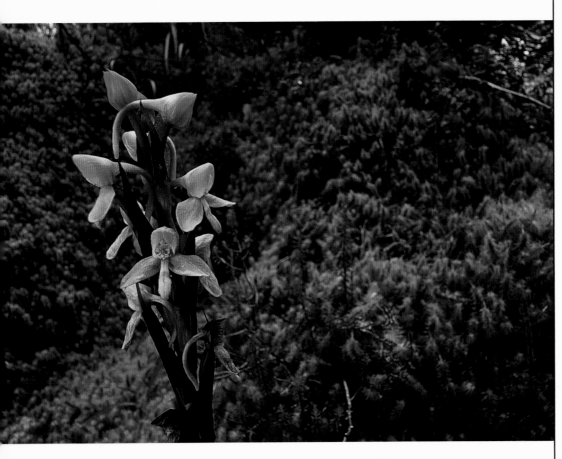

ABOVE AND RIGHT: Disa crassicornis *grow and bloom on mossy pillows at around 10,000 feet (3,000 meters) in the heather forest zone. Rwenzori Mountains, Uganda*

TROPICAL ALPINE HABITATS

The high mountains found in Uganda and Borneo are home to hardy orchid species, some of which can live above 10,000 feet (3,000 meters). Their success in these areas echoes what makes them successful in other high-stress habitats: an ability to tolerate and even flourish under conditions of high radiation and little water or nutrients.

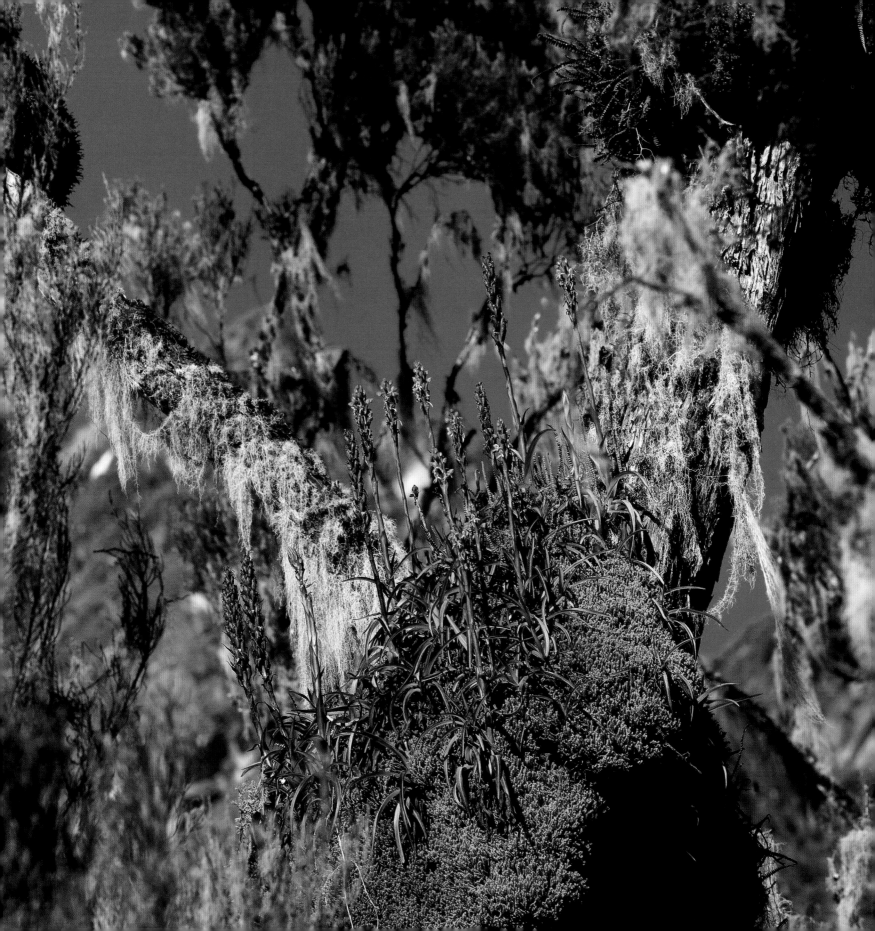

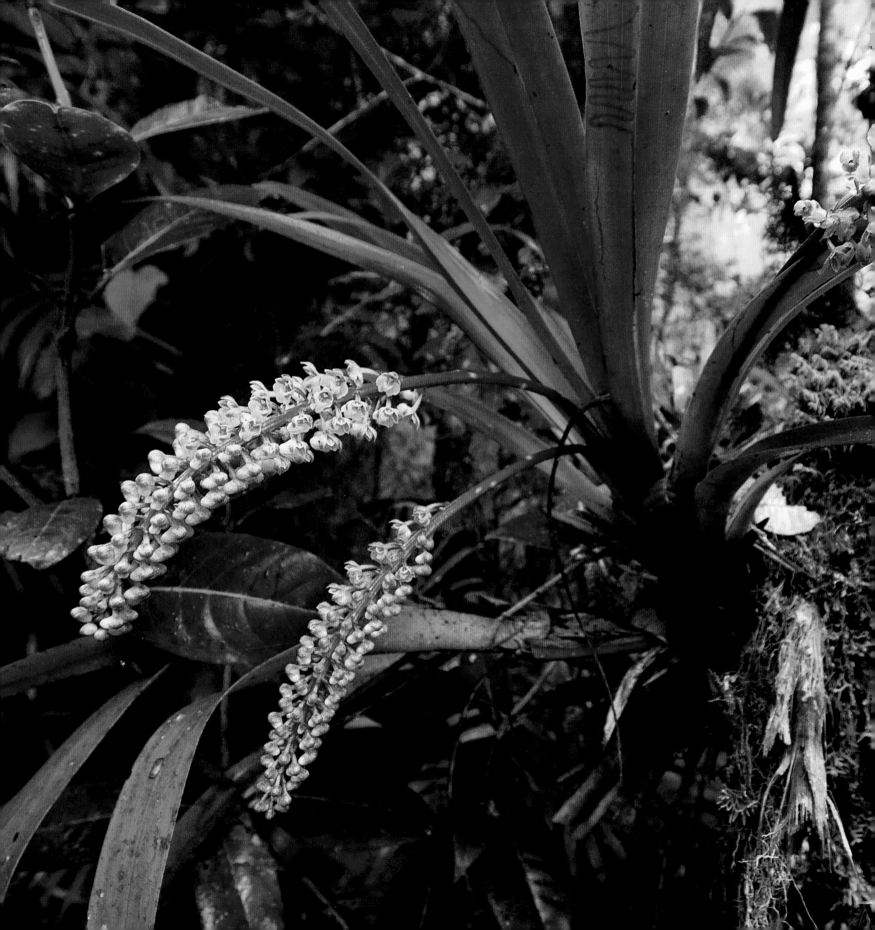

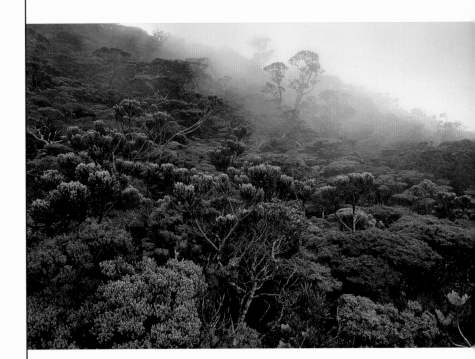

LEFT: Eria sp. *gives off plumes of color in a 10,000-foot (3,000-meter) elfin forest that is a rich orchid habitat.*

ABOVE: *A view down on the elfin forest*

Both on Mount Kinabalu, Sabah, Borneo

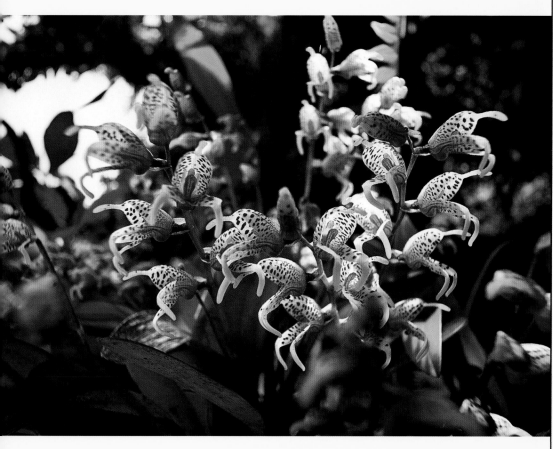

ABOVE: Masdevallia caloptera, *a fly-pollinated high cloud forest species.*
Finca Dracula Orchid Sanctuary, western Panama

RIGHT: Masdevallia regina's *rotting aroma is perfume to its pollinator,*
a tiny carrion fly. Cerro Punta, Panama

Tropical cloud forests

Tropical montane and cloud forests provide
ideal orchid habitats and are consequently
the areas in the world with the greatest
diversity of orchid species. The high rainfall
and radiation, coupled with low nutrients,
are conditions under which orchids thrive,
mostly as epiphytes.

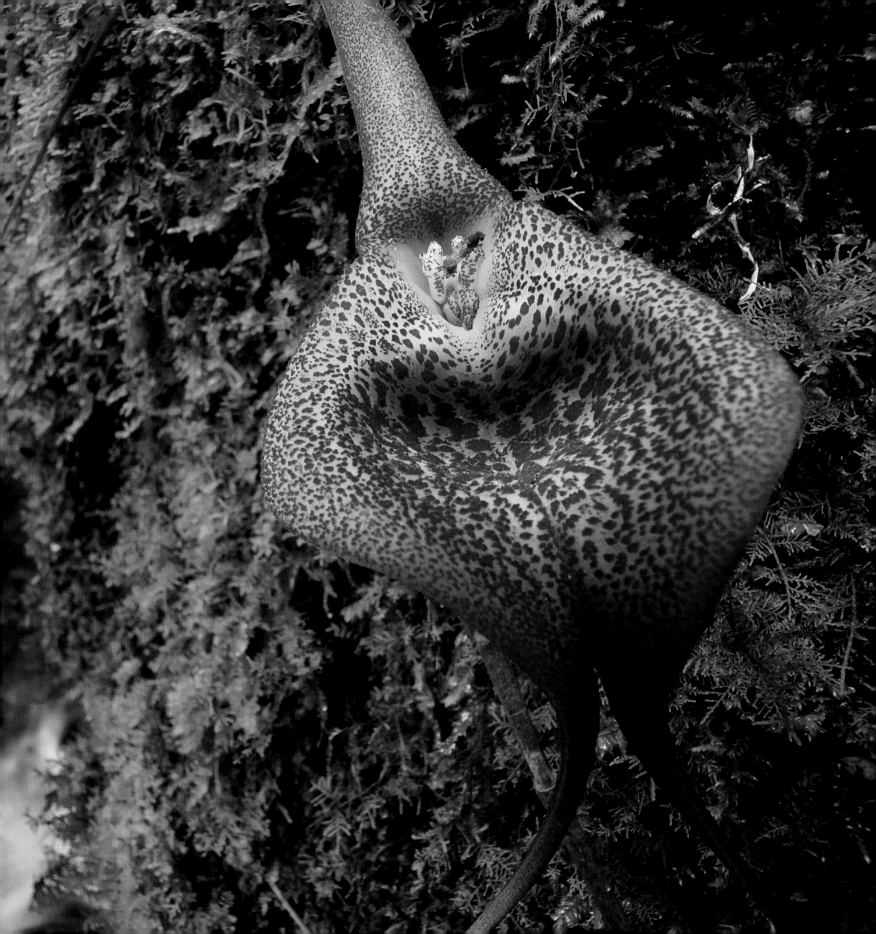

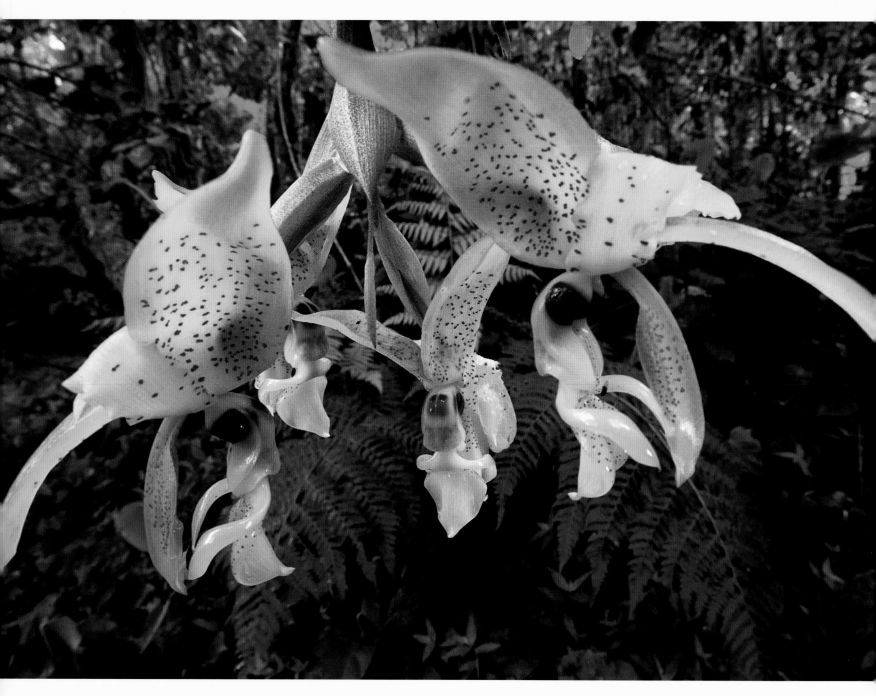

Stanhopea wardii, *a species pollinated by orchid bees and found only in the highlands of Panama. Finca Dracula Orchid Sanctuary, western Panama*

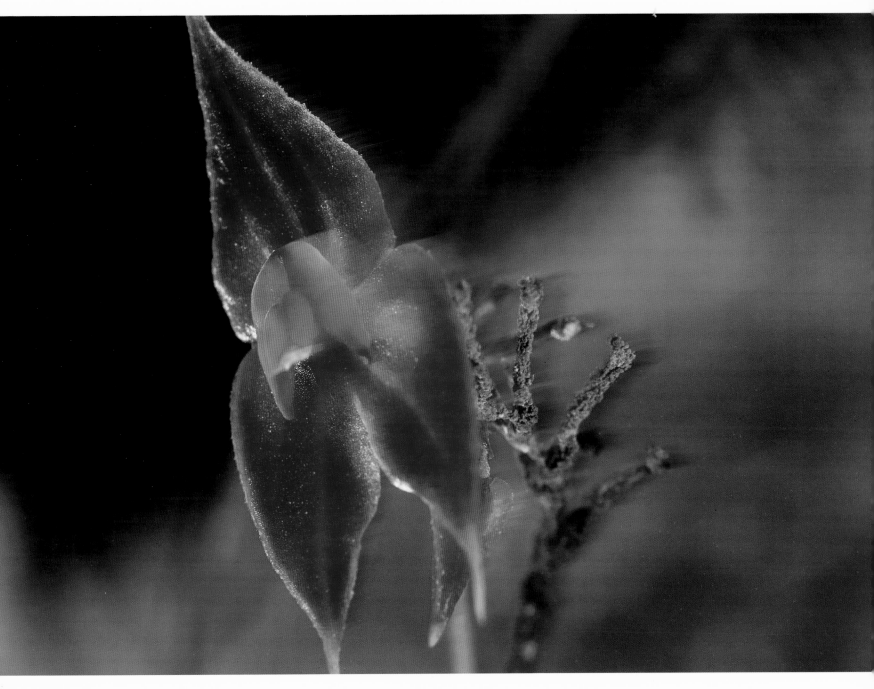

Lepanthes sp. blossoms, less than half an inch long, use sexual deception to lure male fungus gnats for pollination. Finca Dracula Orchid Sanctuary, western Panama

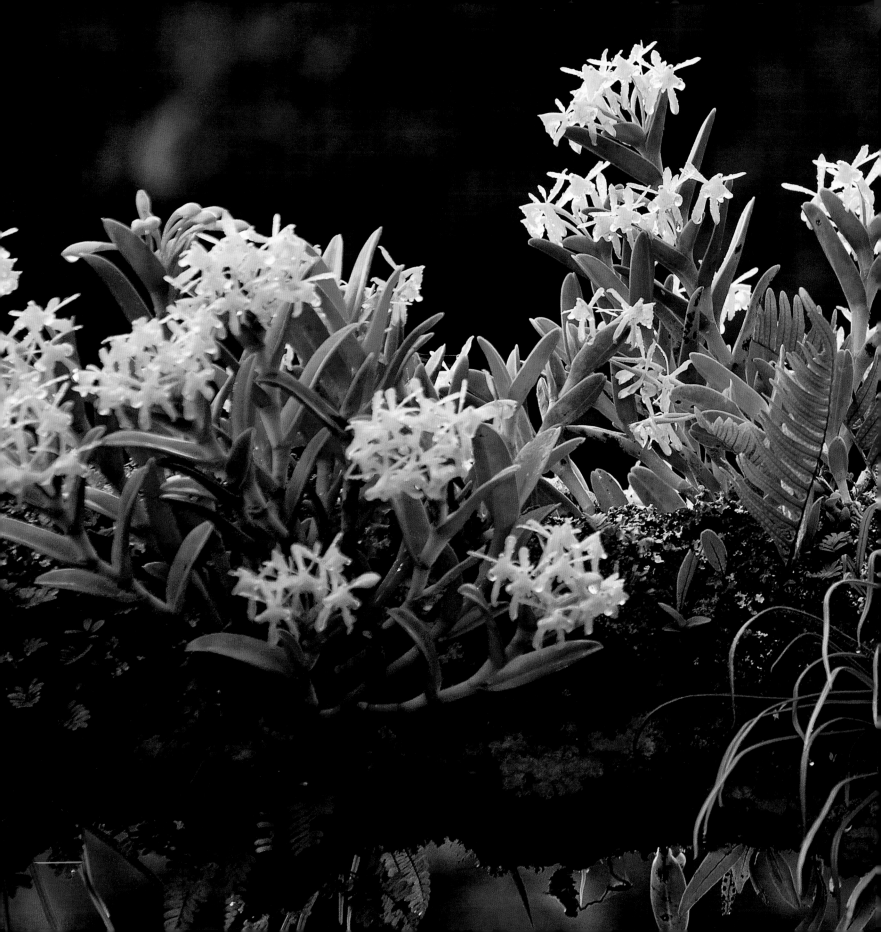

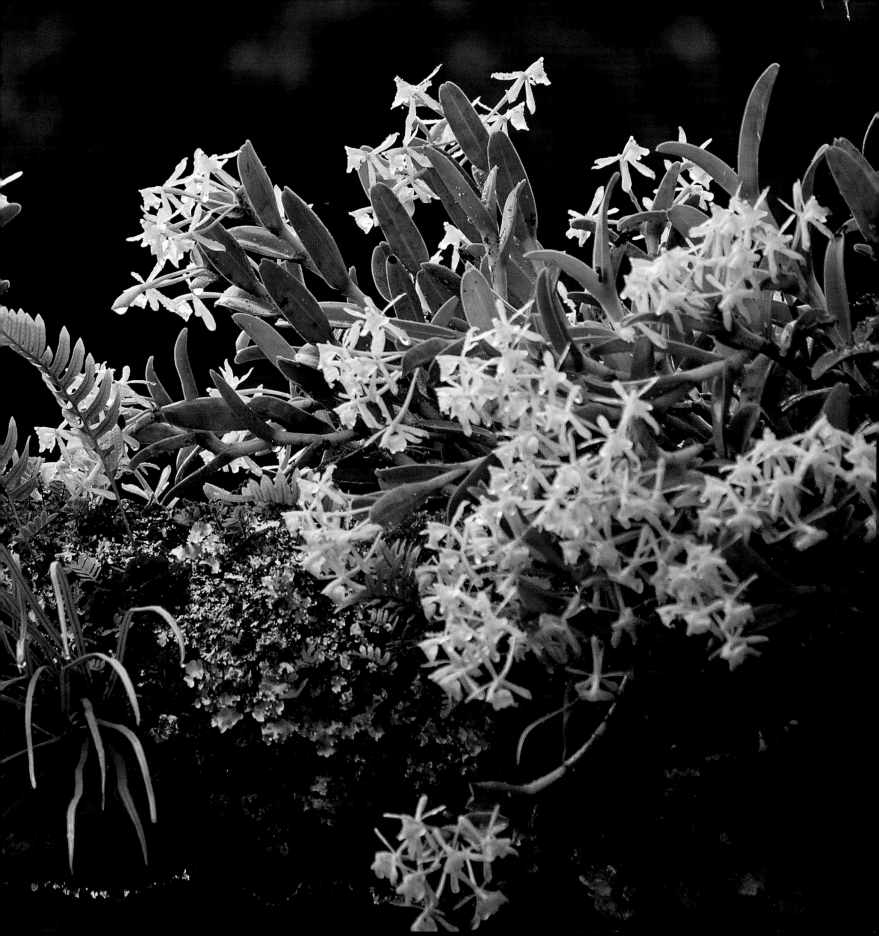

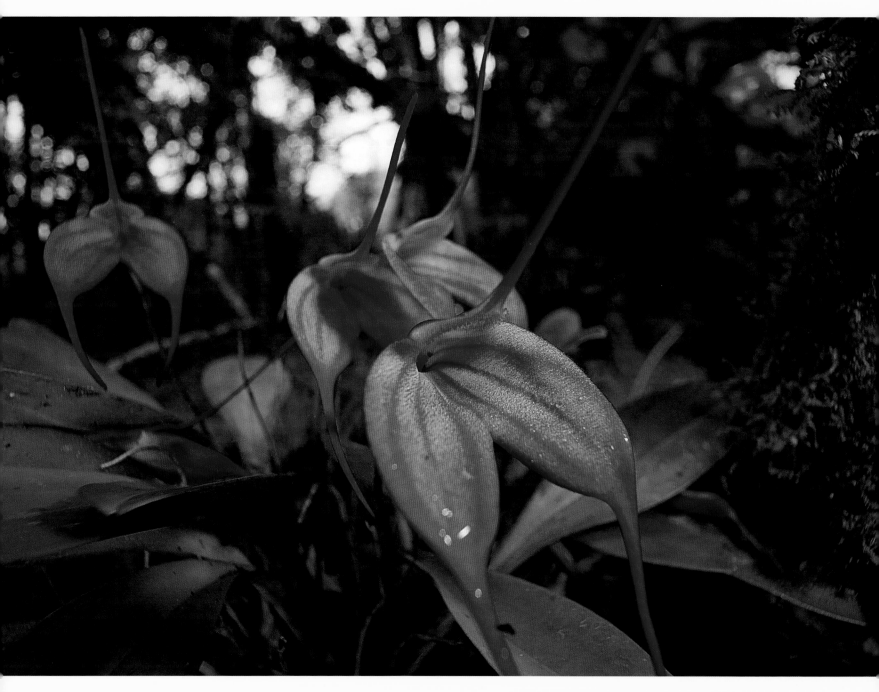

PRECEDING PAGES: Epidendrum sp. *cover a large branch*
high up in the cloud forest. Near Cerro Punta, Panama

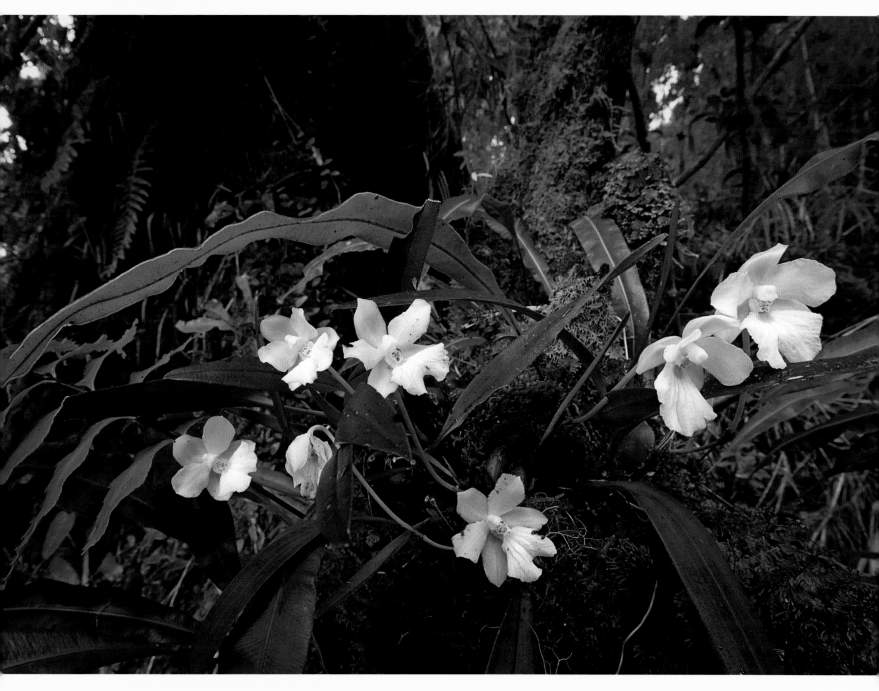

LEFT: Masdevallia sp., *another cloud forest orchid.*
Finca Dracula Orchid Sanctuary, western Panama

ABOVE: Ticoglossum oerstedii *flowering at the feet of giant oaks.*
La Amistad National Park, western Panama

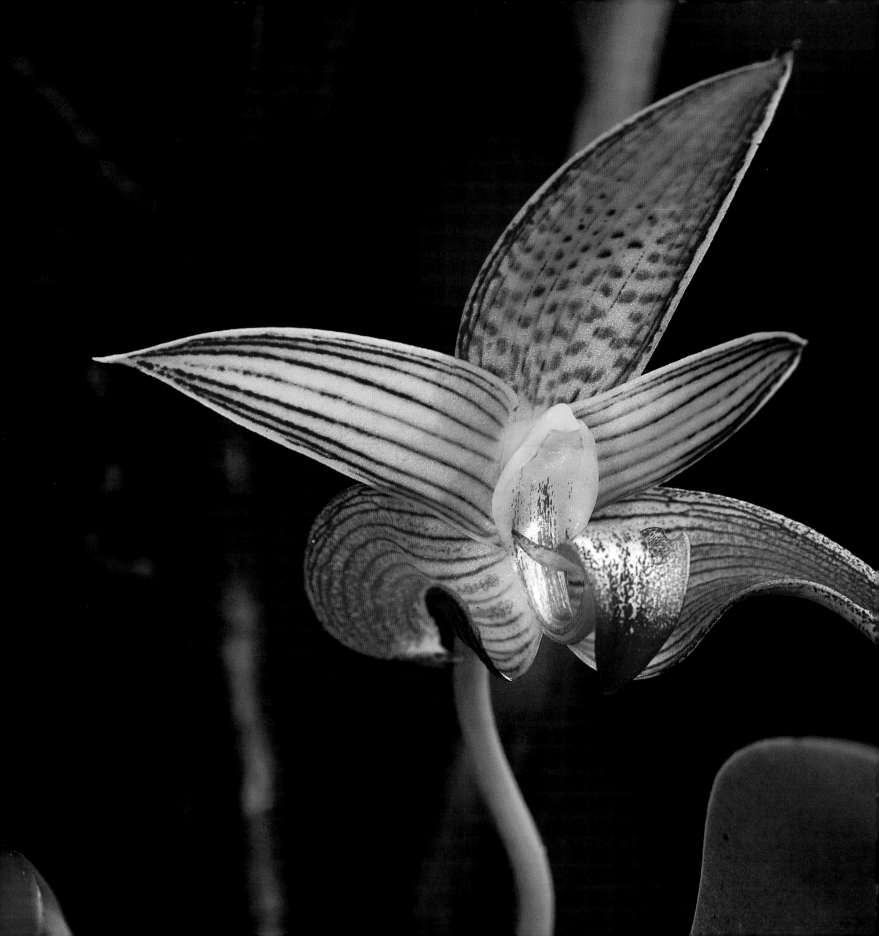

CHAPTER 2

DIVERSITY

For plants that are relatively rare, orchids are spectacularly diverse, with 25,000 wild species to their credit—twice as many as birds and four times as many as mammals. That diversity expresses itself in what Darwin called their "beautiful contrivances," the mesmerizing colors and sensual shapes that make orchids irresistible.

Bulbophyllum lobbii. *Poring Hot Springs, Sabah, Borneo*

ECLECTIC EVOLUTION

The species richness of the orchid family is staggering and unprecedented in the plant world—an estimated 25,000 known species in 725 genera. And every year, some 200 new orchid species are described, generally from tropical areas. It's not unusual to find 50 or more different orchid species in a single tropical tree crown and densities of a hundred or more species within a couple of acres (a hectare) of forest. The amount of physical variation among all these species is striking. Robert Dressler, a world authority on orchids, said the appearance of their blooms ranges from "slightly odd lilies" to "structures that practically transcend the concept of flowers."

Yet all orchid flowers share certain characteristics and a basic pattern: Every blossom contains exactly three sepals and three petals, one of which is always modified and enlarged to form what is called the lip, or labellum, of the flower. This often serves as a landing pad for pollinators—and attracting and accommodating pollinators is, as we'll see in the next chapter, a major reason for the great diversity found in orchid flowers. Also, except for a small number of very primitive species, every flower has a central column unique to the orchid family; in it, the sex organs—the male stamens and female pistils—are fused. Pollen, too, is uniquely handled in orchids. Instead of being loose, as it is in most plants, it's bundled in pollinia sacs that always occur in even numbers (two, four, six, or eight). And finally, all orchids have a bilateral (also called zygomorphic) symmetry as opposed to the radial symmetry of a daisy or a sunflower. Radial symmetry appears to be more conservative and harder to break out of over evolutionary time, while bilateral symmetry seems to be more conducive to evolving into a larger variety of shapes and forms.

Liparis sp. *Sabah, Borneo*

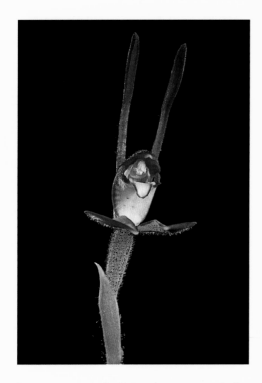

Leptoceras menziesii, *less than a quarter inch in size, is nonetheless a survivor species that may date back some 80 million years.*
Albany, western Australia

EPIPHYTISM—A LIFESTYLE

The almost 70 percent of orchid species that live as tropical epiphytes exhibit much more diversity among species than their terrestrial cousins do. That may be because the total area available in the canopy habitat, which includes the surfaces of branches and twigs, is much larger than the area on the ground. For every ten square feet (one square meter) of forest floor, there are a hundred or more square feet (ten square meters) of canopy surface, a much bigger potential habitat for plants. Also, the canopy habitat is more varied in character, from mossy spots near the trunk and on large branches to airy spots on the thinnest twigs, just fractions of an inch (a few millimeters) across. This kind of habitat variety probably offered more ecological opportunities, more so-called ecological niches that repeatedly encouraged evolutionary changes and radiations in the different groups of epiphytic orchids.

Charles Darwin, in his 1862 book on orchids, used this highly diverse family of plants as an example of the importance and perfection of natural selection. Natural selection is the main process by which species evolve: In each generation, there are typically more offspring than are needed to replace their parents. That means the individuals within each generation are competing for the existing living space. The key difference in their survival chances lies in genetic variation. Only the individuals whose genetic makeup best matches the existing environmental conditions will survive and have offspring of their own. In this way, species track environmental changes through time by means of natural selection.

Darwin speculated that it was solely the interaction of orchids with their pollinators that led to the large variety of orchid species we see today and, until recently, most scientists accepted his theory. Then, in 2006, a wide-ranging study took a fresh look at a broad set of ecological data from more than 200 species worldwide and suggested a different force in the mix. A vast majority of orchids appear to be limited in their reproduction by their access to pollen. The reasons are complex and will be discussed more in the pollination chapter, but in brief the problem for orchids is

that many of them are rare and tend to live in rather low densities. In tropical forest canopies, for example, an orchid plant's nearest neighbor of the same species, whose pollen it needs to reproduce, may be a long distance away. This rarity, in combination with the small number of pollinator species, means many flowers remain unpollinated and never set fruit. It's likely that only a small percentage of individual orchids pass on their genes to the next generation. With genetic variation among offspring limited, natural selection—Darwin's "survival of the fittest," in terms of genetic makeup—can't play the leading role.

So what does account for the great diversity among orchids? Scientists now believe it's probably genetic drift in combination with natural selection. Genetic drift occurs when only a small number of individuals participate in the reproduction of a generation and thus the genetic variation is low. It seems mere coincidence as to which plants get lucky, participate in pollen exchange, and reproduce offspring.

Here's how genetic drift could work for an orchid: Through the serendipitous exchange of pollen among individual plants, the characteristics of the flower in a local population of orchids could change, making the flower less attractive to its original pollinator but at the same time more appealing to a new pollinator species. Once these orchids have switched pollinators, they are genetically disconnected from their former conspecifics, making them a new subspecies. Over a long period of time, a combination of genetic drift and natural selection can result in the evolution of entirely new species.

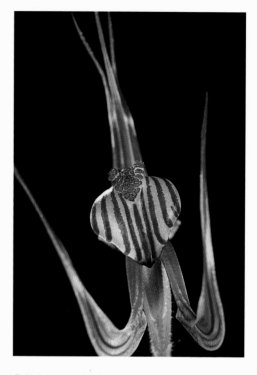

Caladenia multiclavia. *Western Australia*

OF ORCHIDS AND HUMANS

The first written mention of an orchid goes back 5,000 years and is found in a Chinese medical text that lists an orchid as a medicinal plant. Some 4,500 years later Confucius called the orchid "king of fragrant plants." In the Western world, the initial reference to orchids appeared around 350 B.C. in ancient Greek medical texts, when some species were described as useful in the treatment of sexual diseases. And our

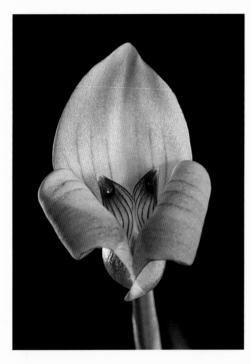

Trigonidium egertonianum. *Central Panama*

very name for this plant family comes from the Greeks via two channels—first, the mythological Orchis, the son of a satyr and a nymph, was turned into a flower after his death; and in classical Greek, the word *orchis* means testicle, referring to the shape of the tubers of many Mediterranean orchid species.

Orchids were known and cultivated in the Americas as well, and when the conquistador Hernán Cortés rolled through Mexico in 1519, he enjoyed a vanilla-flavored cacao drink served by the Aztec leader Moctezuma. *Tlilxochitl*, as the Aztecs called the *Vanilla planifolia* orchid, had been grown in the region for a long time for food, medicine, and perfume.

Several centuries later, in Victorian England, a New World orchid sparked what became known as orchidelirium. During that era, as the British Empire pushed at the boundaries of the "known" world, English salon society grew more and more captivated by the reports of explorers and naturalists like Darwin and Joseph Banks, who returned from remote corners of the globe with exotic plants and animals. The less adventuresome Englishmen wanted a way to partake of this exoticism vicariously, and in 1824 an orchid offered them that way: An unremarkable bulb, shipped from the New World, sprouted an amazing flower. John Lindley, the leading orchid specialist of his time, named it *Cattleya labiata*, after its owner Sir William Cattley, a plant trader and hothouse specialist. Sir William's celebrity flower started a frenzied fashion that would last for decades. Expeditions were mounted by individuals and companies to collect new species, and rare or unique orchid plants changed hands for hundreds, even thousands, of pounds. Orchidelirium, as the excessive orchid-keeping was called, became an elitist hobby that many society gentlemen participated in with a passion rarely seen in that time and place.

The fascination with orchids continues to this day, with naturalists and botanists, both amateur and professional, seeking them out in the wild. Other orchid lovers express their passion for these strangely compelling flowers by growing and propagating them. Hybridization has lead to even greater diversity in the

orchid family, producing larger flowers and hardier, more affordable plants. Today, domesticated orchids have escaped the confines of the English gentry, finding their way onto tabletops and windowsills in homes across the world.

But while hybrids are flourishing, wild orchids face an uncertain future. Some species have suffered from over-collection in the wild, and many wild orchid species have been lost forever as huge tracts of rain forest have been felled in the last 40 years, sometimes affecting the orchids directly and sometimes the pollinator species on which they rely. Global warming holds similar perils. Since orchid species often have a very narrow habitat range, they may be unable to evolve and adapt to changing conditions or to move fast enough to escape extinction. This is especially true for mountaintop species, which have nowhere to go. Conservation biologists, looking for ways to help perpetuate threatened orchid species, are experimenting with "assisted colonization," transporting orchids or their seeds into new areas that meet their ecological requirements.

The extinction of any species is a tragedy, but the demise of members of this elegant plant family, with its "beautiful contrivances," as Darwin wrote, and its lush and intoxicating diversity of scents, shapes, and behaviors, seems an unimaginable loss.

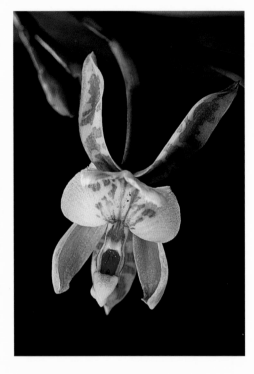

Aspasia epidendroides. *Chilibre, central Panama*

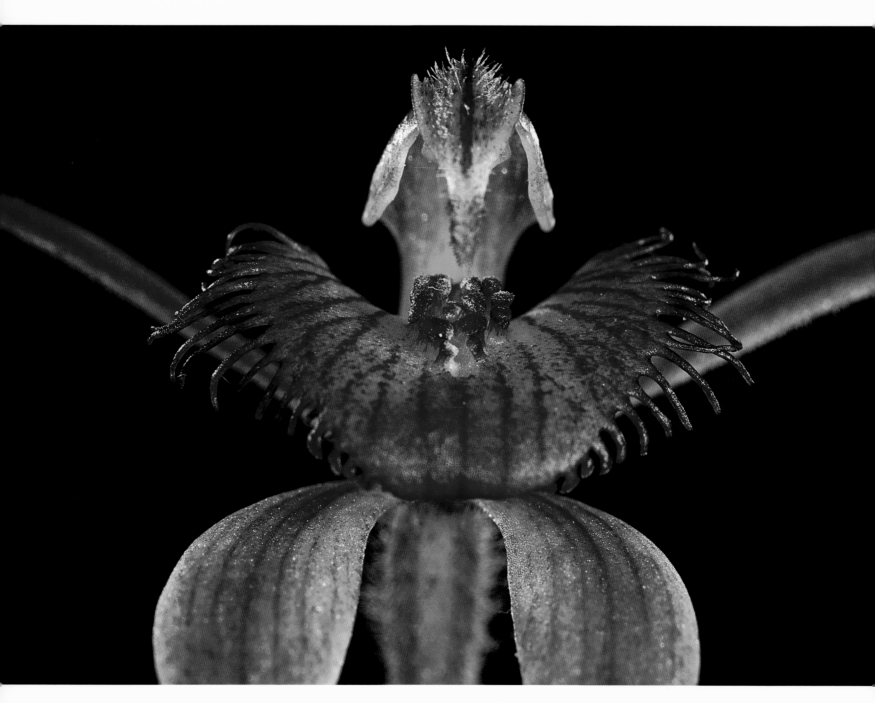

ABOVE: Caladenia discoidea, *one of the bee orchid species*

RIGHT: Caladenia pectinata *(king spider orchid)*

Both in western Australia

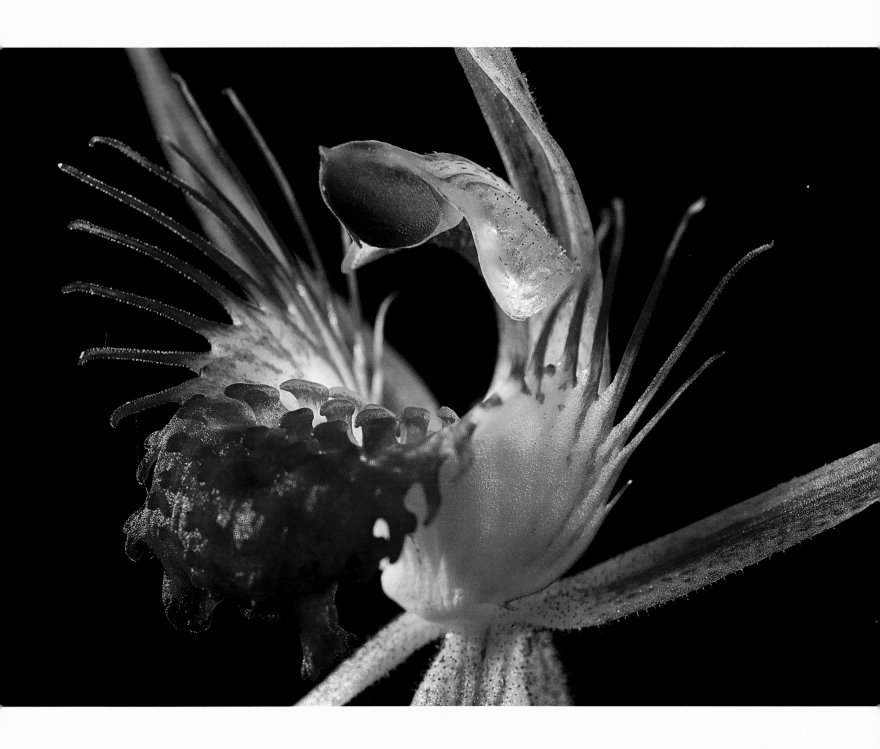

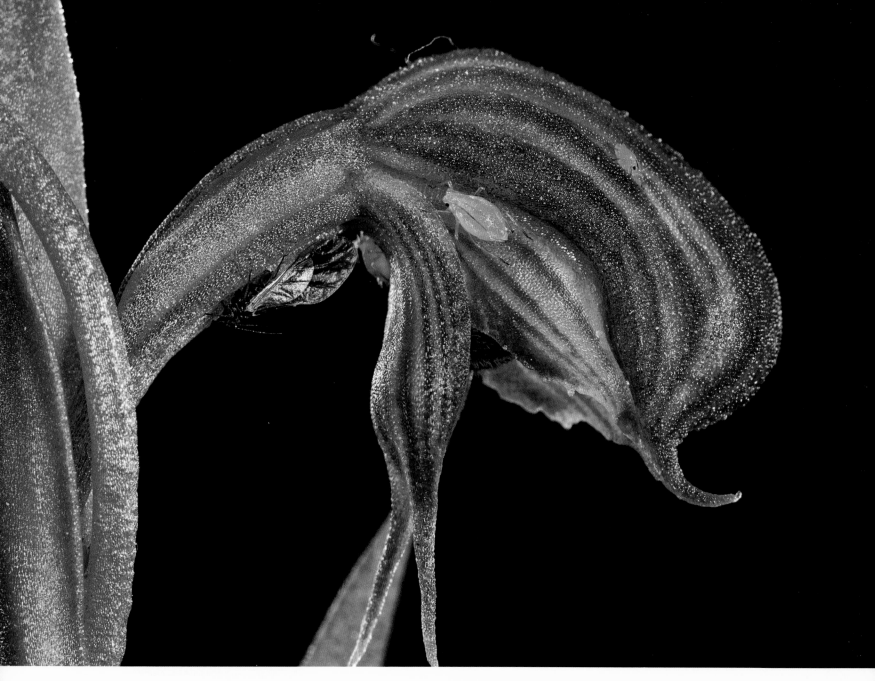

ABOVE: Pterostylis sargentii (*frog greenhood orchid*)

RIGHT: Pterostylis sp. (*snail orchid*)

FAR RIGHT: Pterostylis aff. barbata (*long-beaked bird orchid*)

All in western Australia

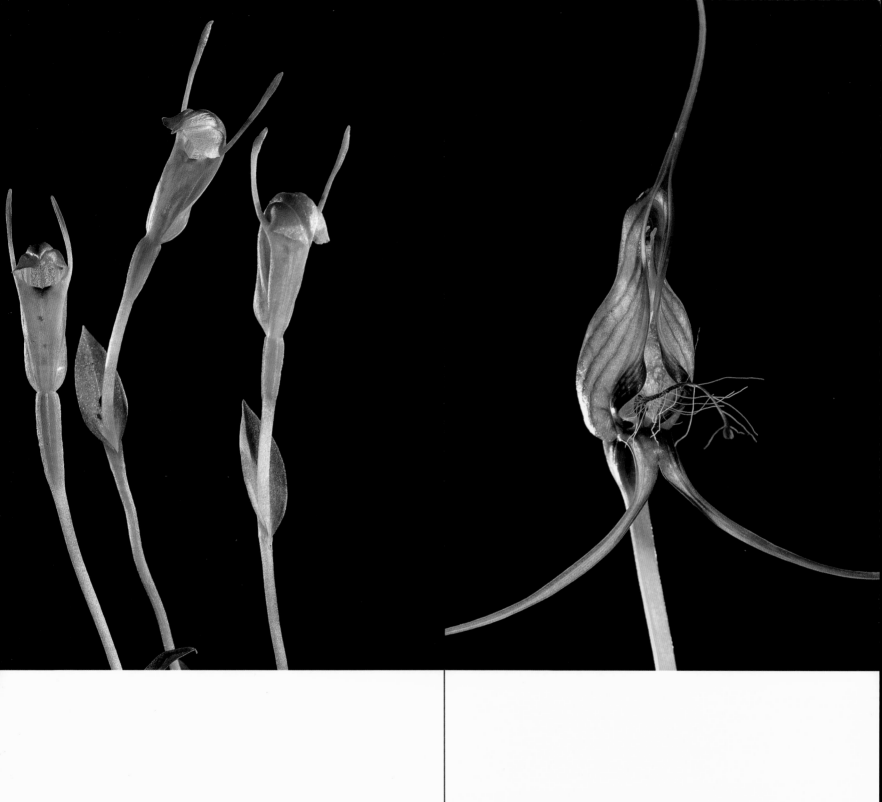

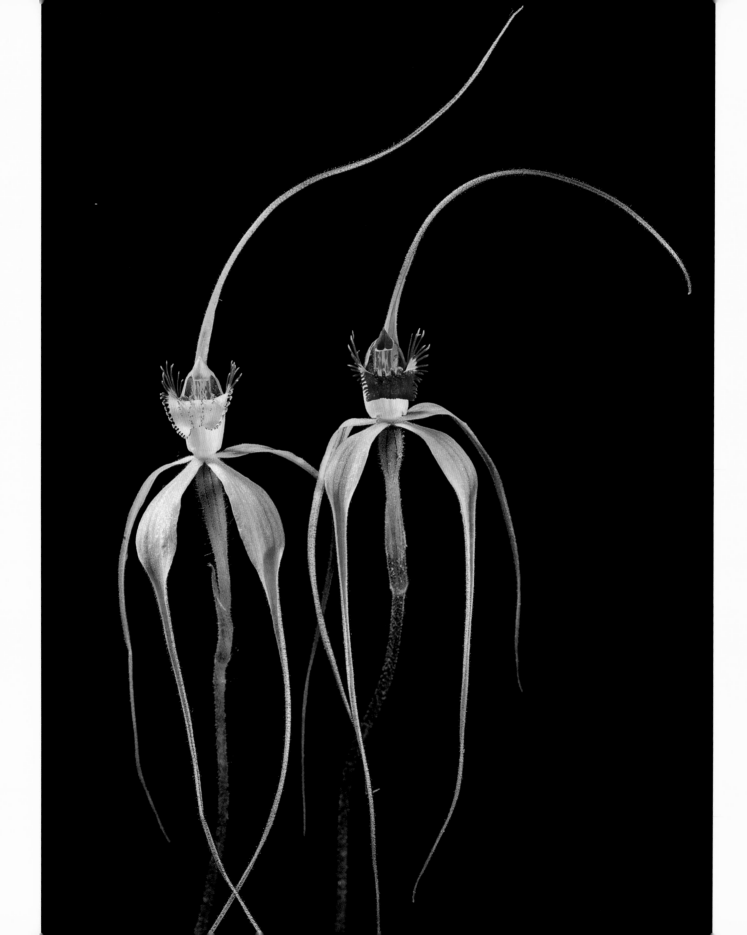

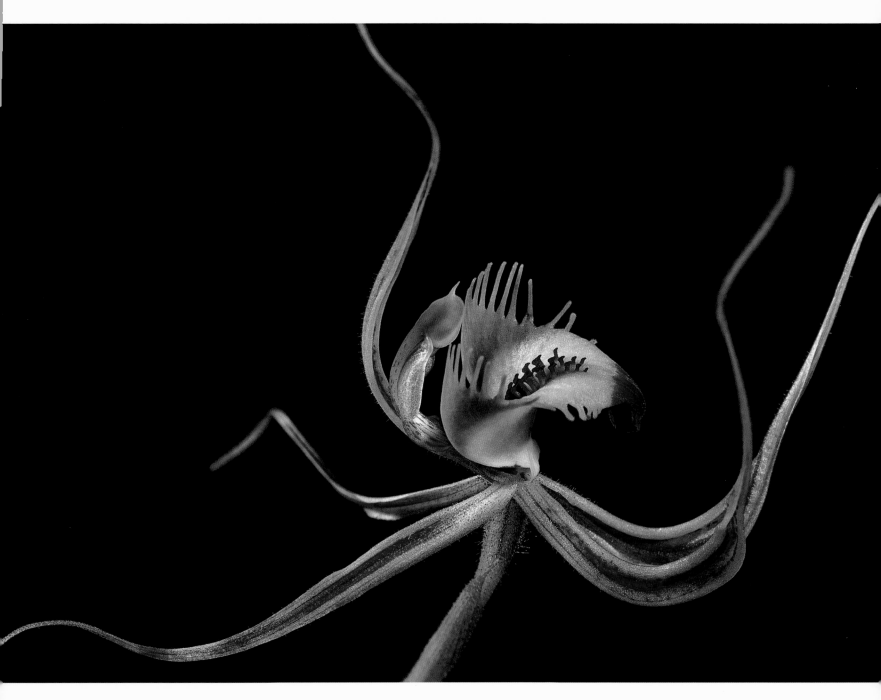

LEFT: Caladenia splendens *hybrid*

ABOVE: Caladenia splendens (*splendid spider orchid*),
with a natural hybrid to its right

Both in Albany, western Australia

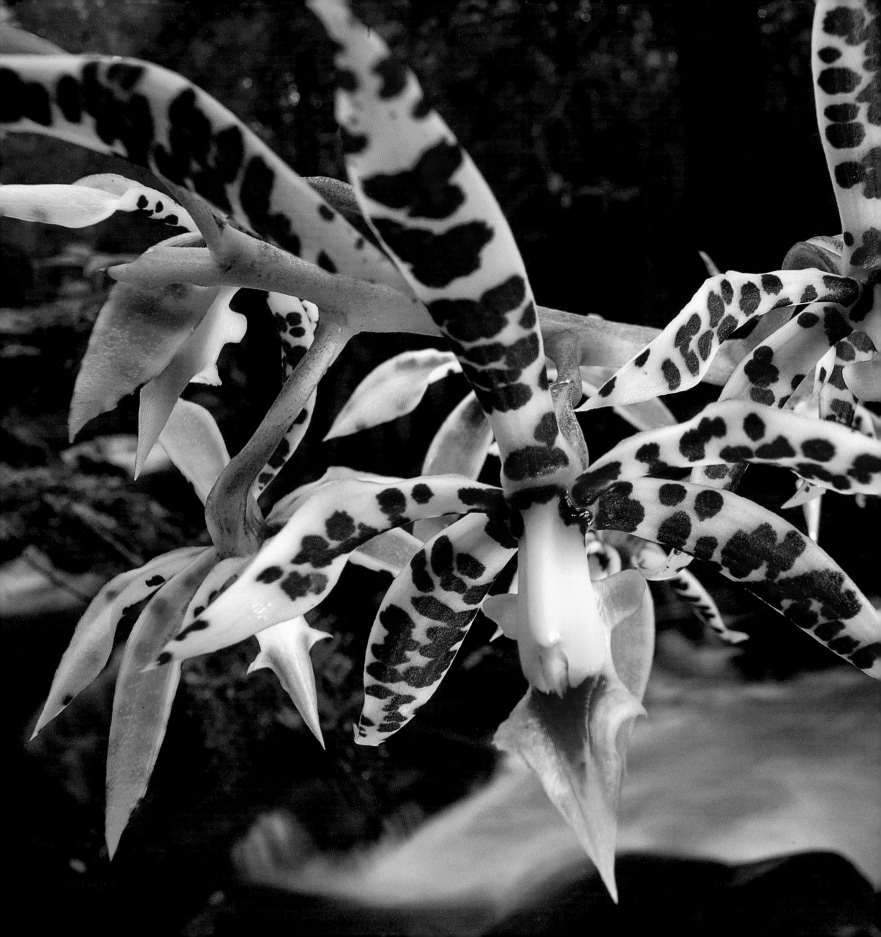

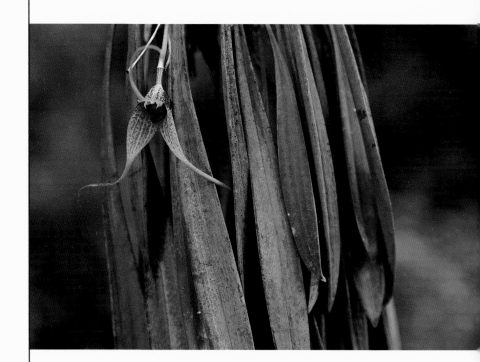

LEFT: Encyclia prismatocarpa

ABOVE: Masdevallia caesia *flowering in the highlands*

Both in La Amistad National Park, western Panama

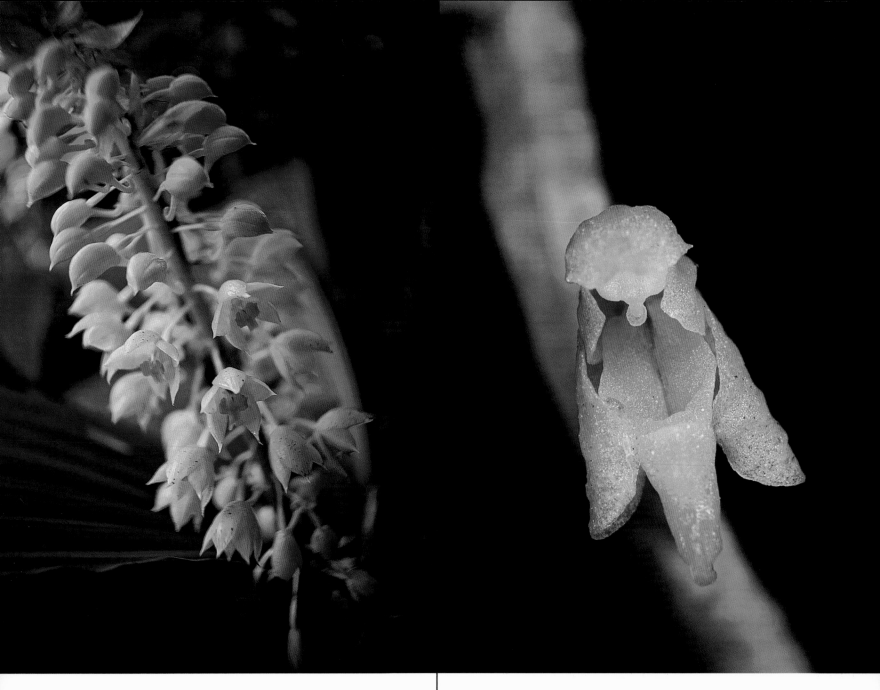

LEFT TO RIGHT:

Calanthe pulchra

Unidentified tropical montane species

Bulbophyllum blumei

Bulbophyllum corolliferum

All in Sabah, Borneo

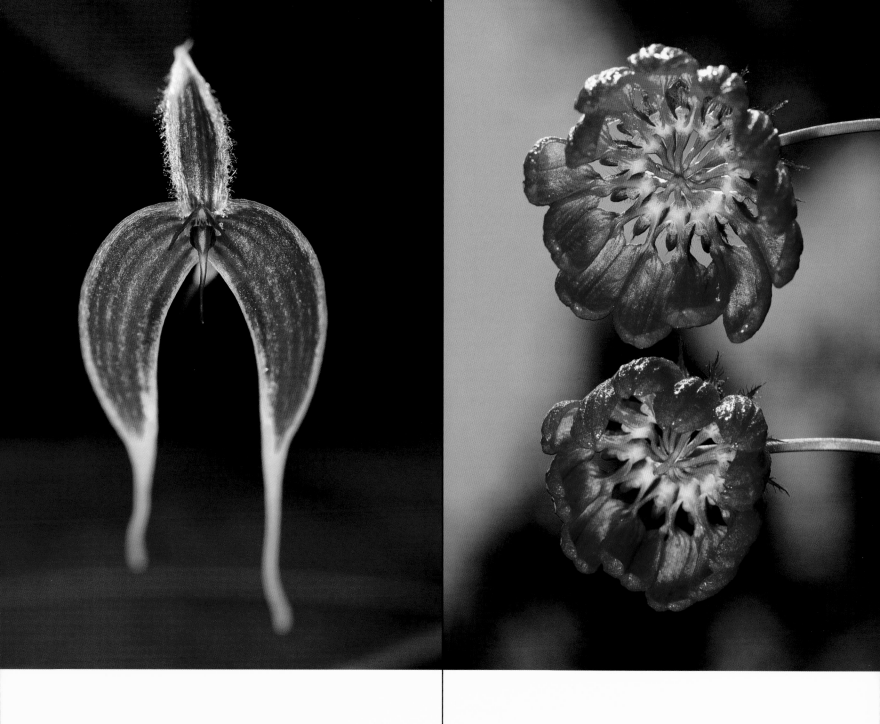

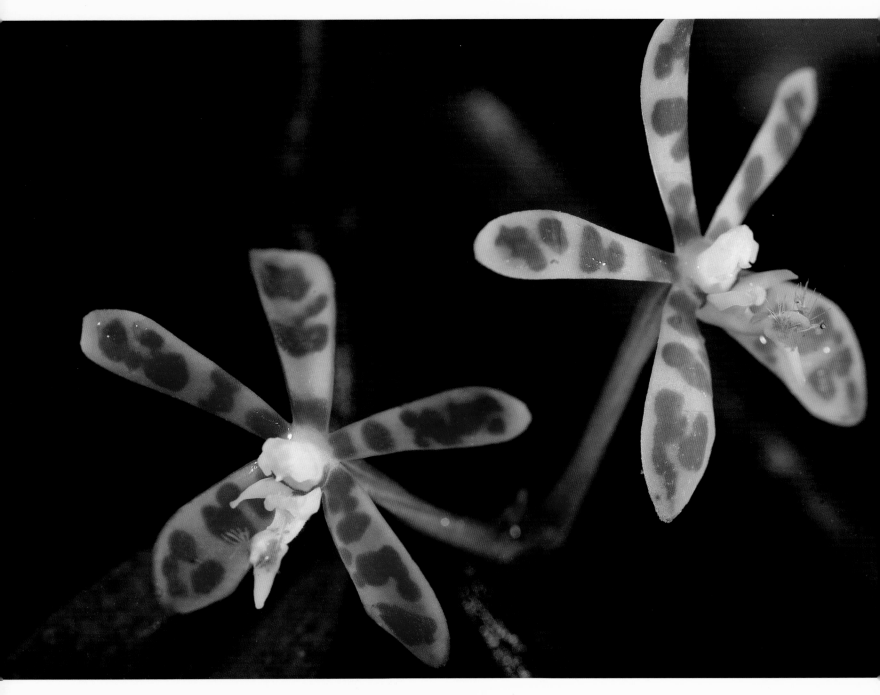

ABOVE: Phalaenopsis doweryensis. *Poring Hot Springs National Park, Sabah, Borneo*

RIGHT: Renanthera matutina. *Penang Botanical Garden, Malaysia*

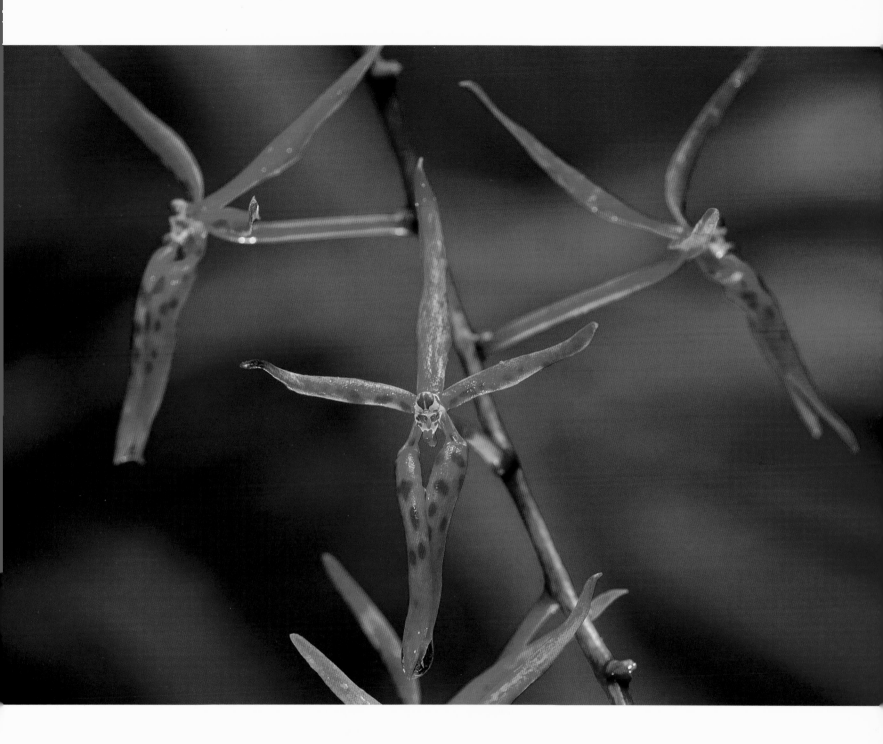

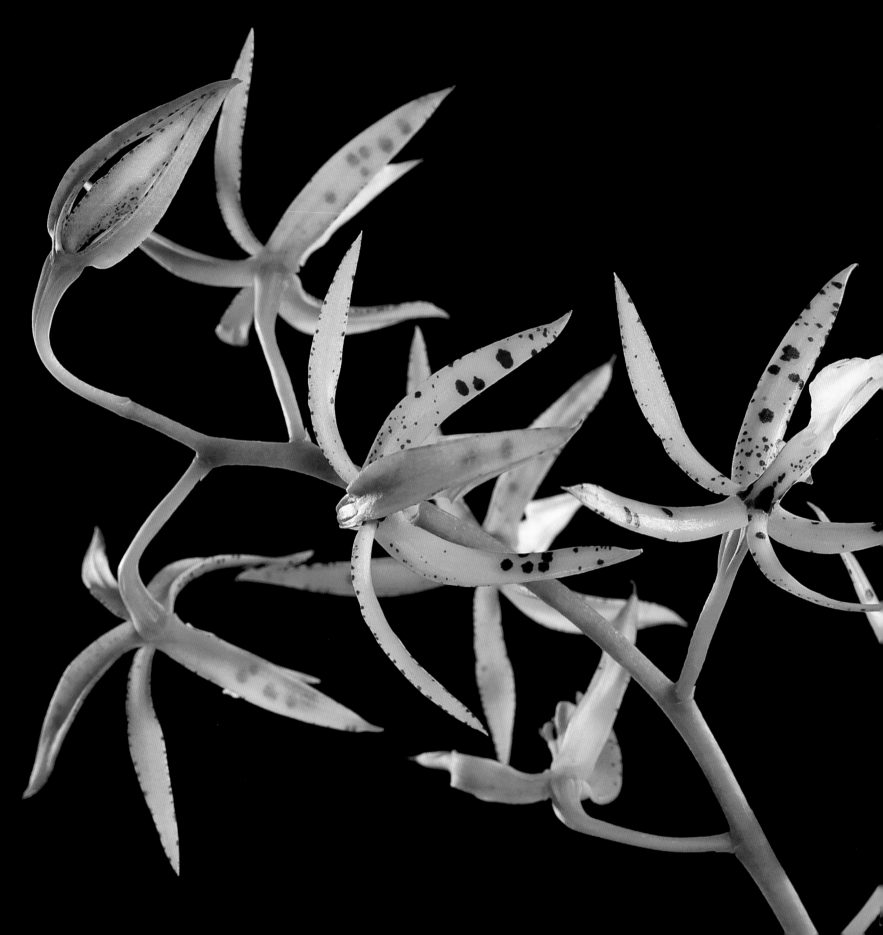

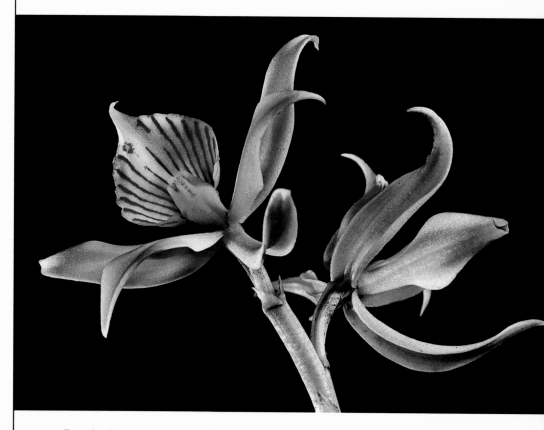

LEFT: Prosthechea prismatocarpa. *Chilibre, central Panama*

ABOVE: Prosthechea chacaoensis. *Santa Rosa National Park, Costa Rica*

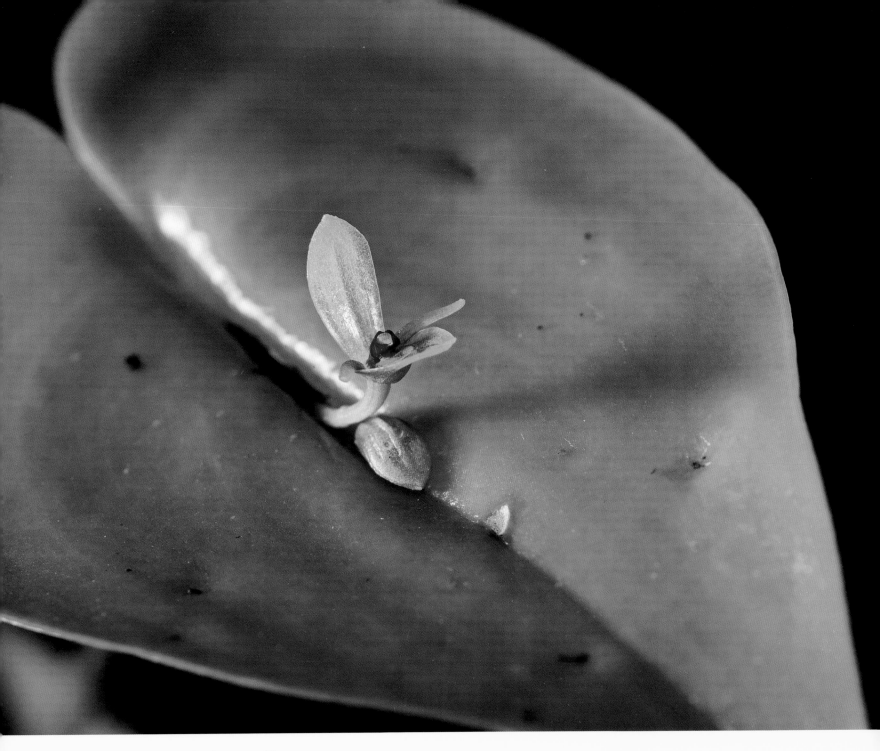

ABOVE: Pleurothallis sp. *Gamboa, central Panama*

RIGHT: Lepanthes sp. *Finca Dracula Orchid Sanctuary, western Panama*

FAR RIGHT: Epidendrum schlechterianum. *Central Panama*

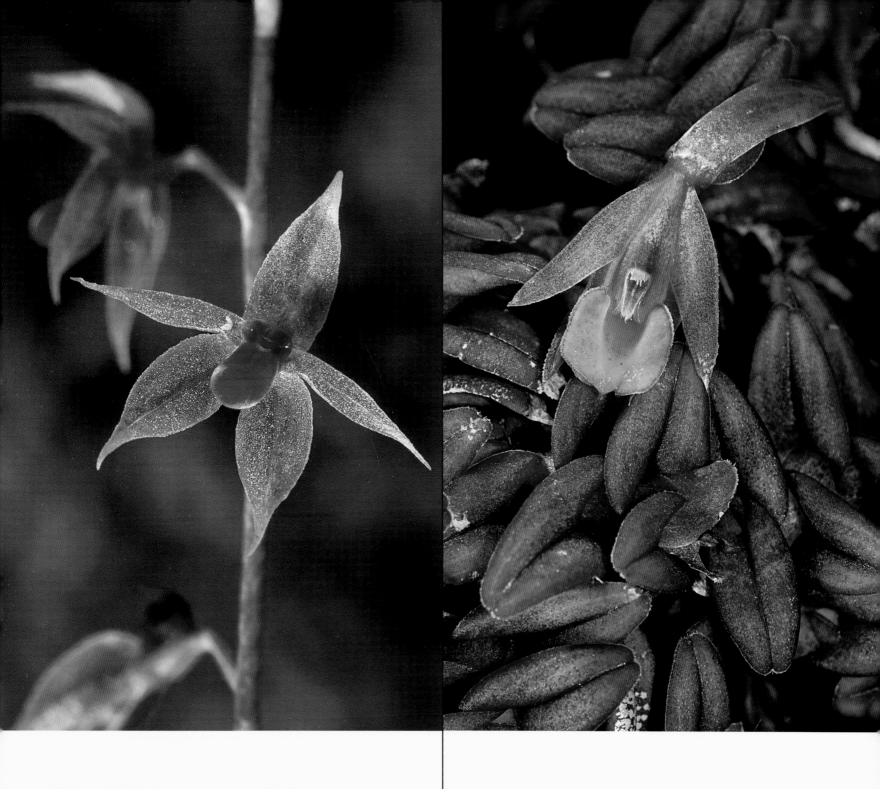

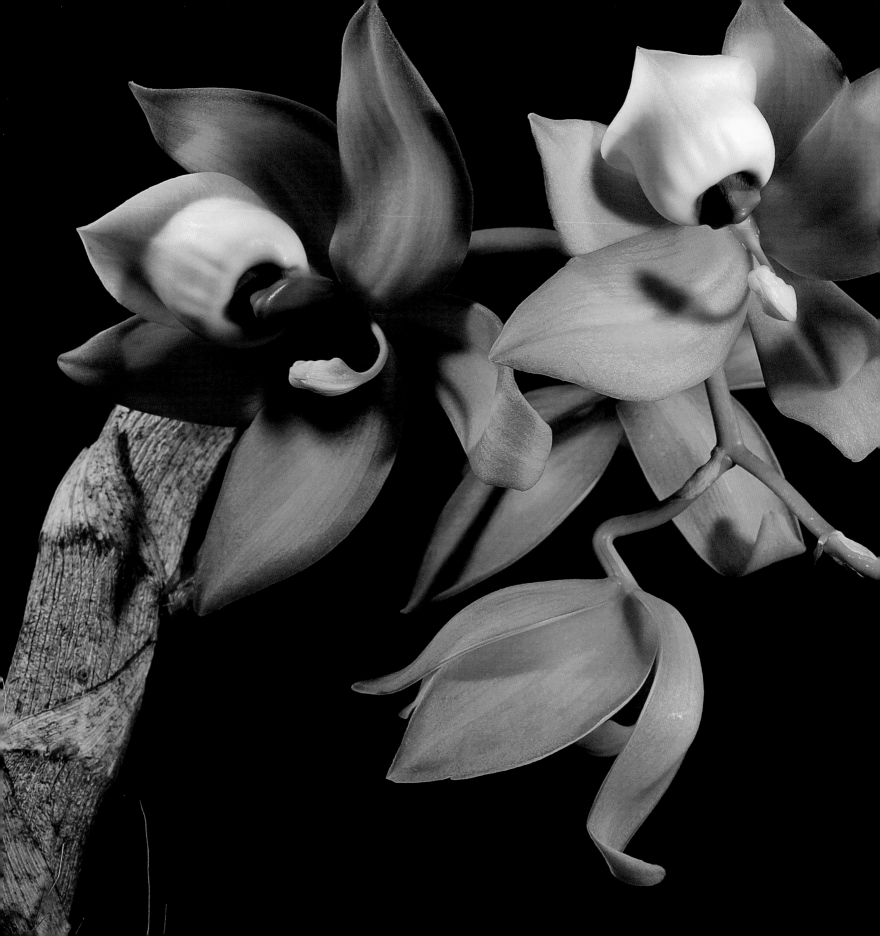

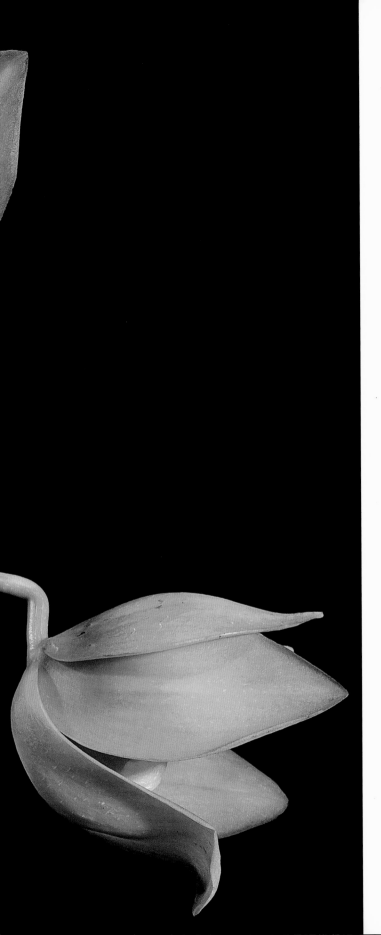

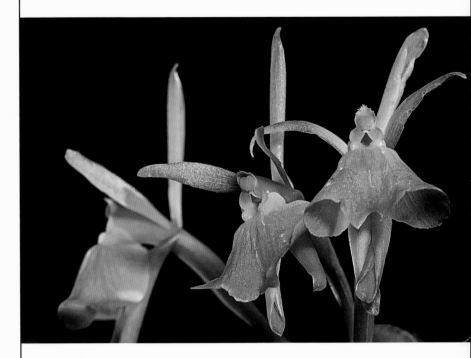

LEFT: Cychnoches warscewiczii

ABOVE: Epidendrum schlechterianum

Both in Chilibre, central Panama

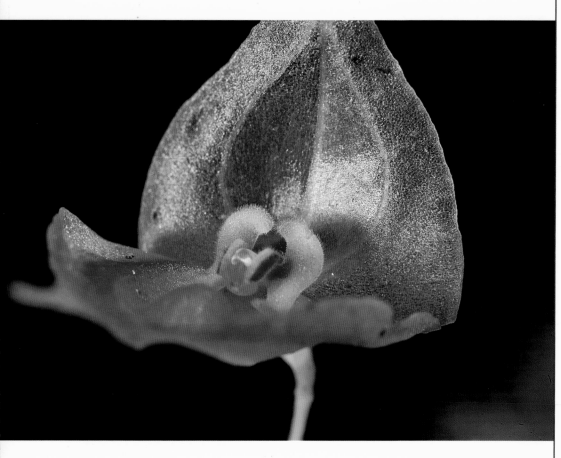

ABOVE: Lepanthes sp.

RIGHT: Brassia arcuigera

Both in Finca Dracula Orchid Sanctuary, western Panama

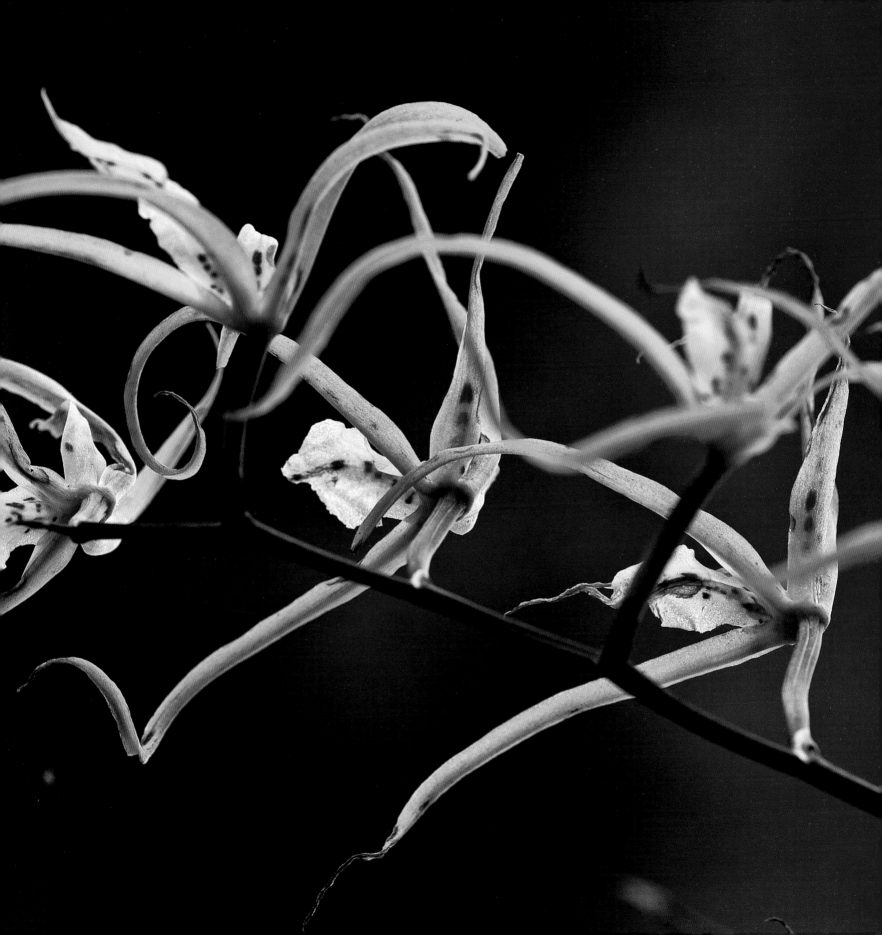

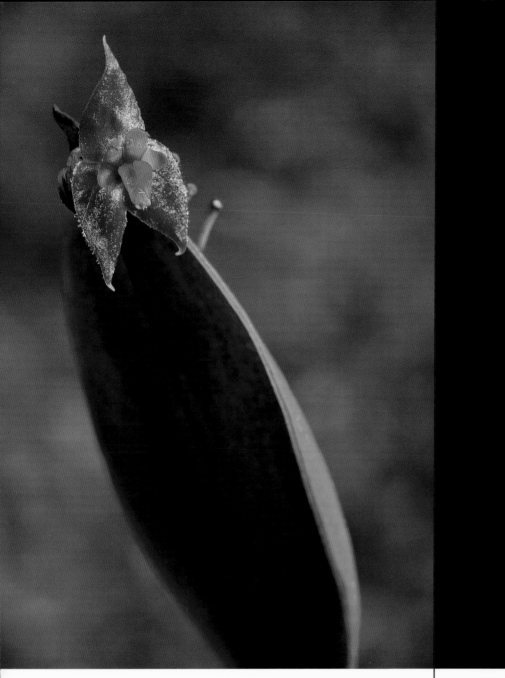
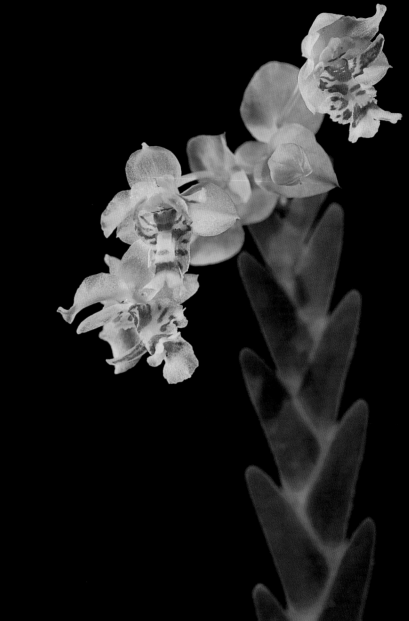

LEFT TO RIGHT:

Pleurothallis sp.
Finca Dracula Orchid Sanctuary, western Panama

Lockarthia amonena. *Panama*

Masdevallia coccinea.
Finca Dracula Orchid Sanctuary, western Panama

Bletia purpurea. *Sian Kaan, Yucatan*

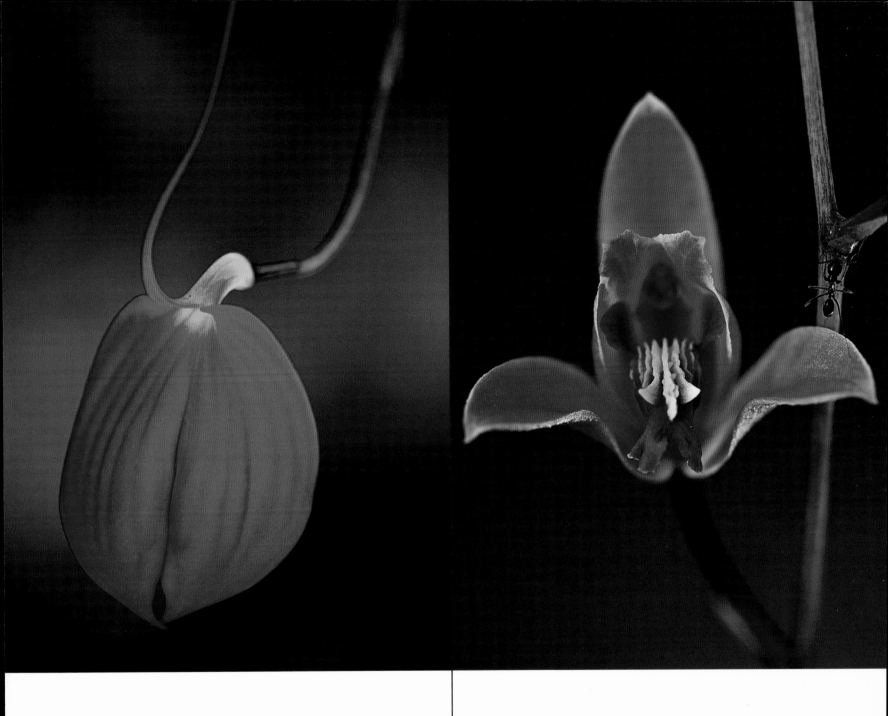

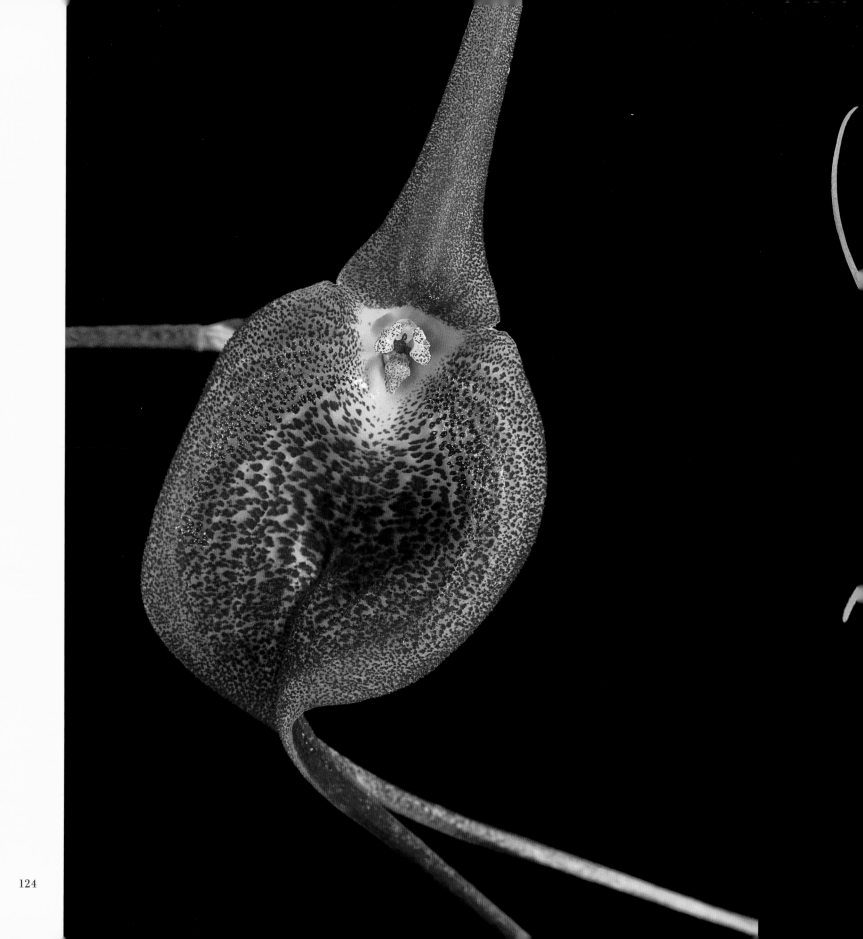

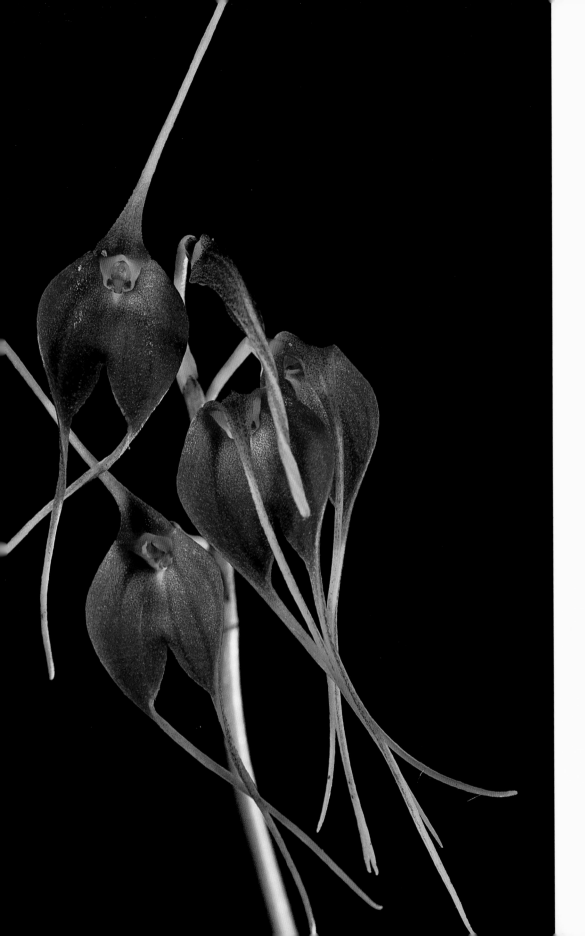

FAR LEFT: Masdevallia sp. *with its pollinator, a carrion fly*

LEFT: Masdevallia excelsior

Both in Finca Dracula Orchid Sanctuary, western Panama

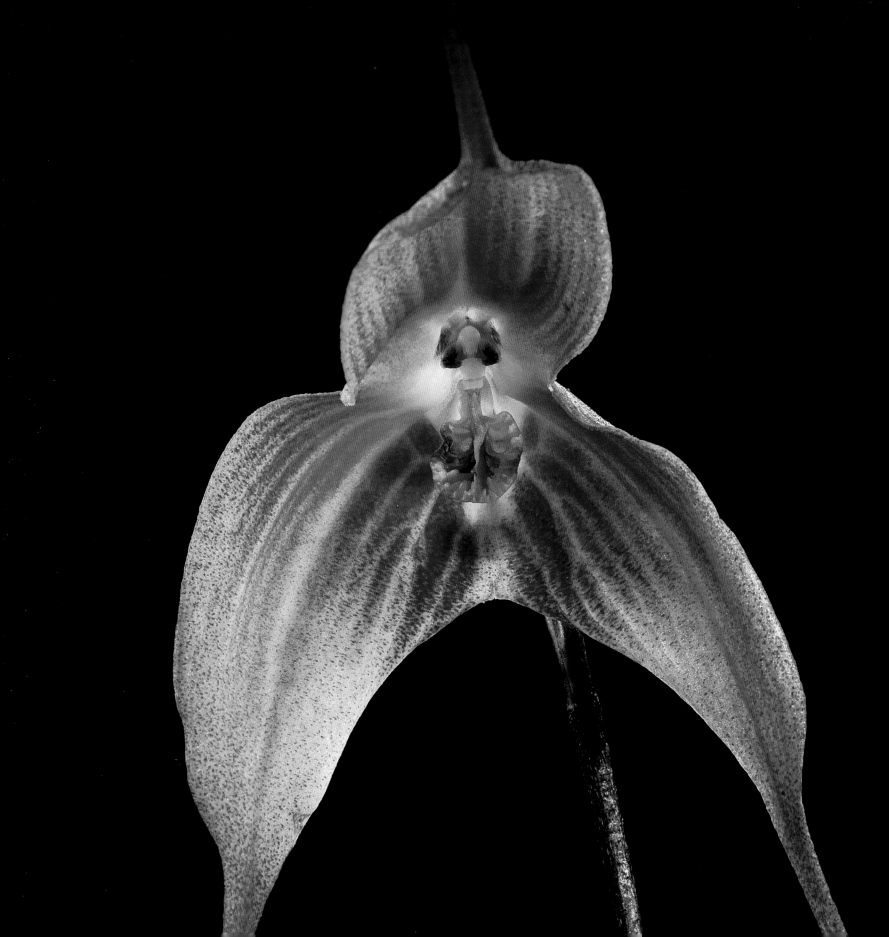

LEFT: Dracula venefica. *Finca Dracula Orchid Sanctuary, western Panama*

ABOVE: Trisetella sp. *Chilibre, central Panama*

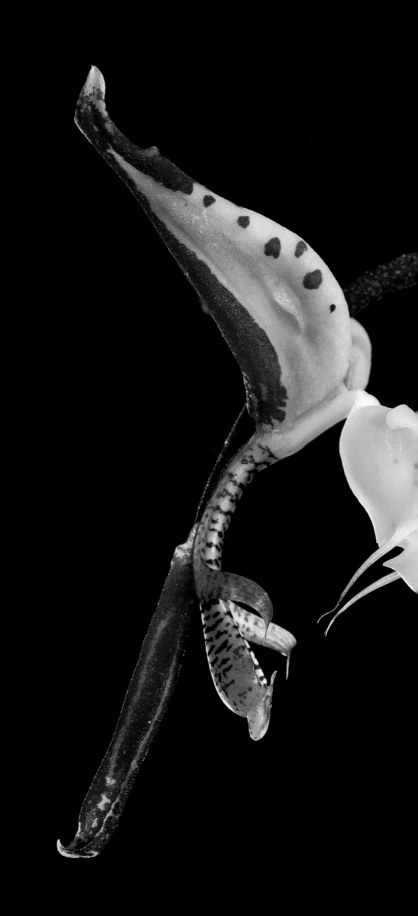

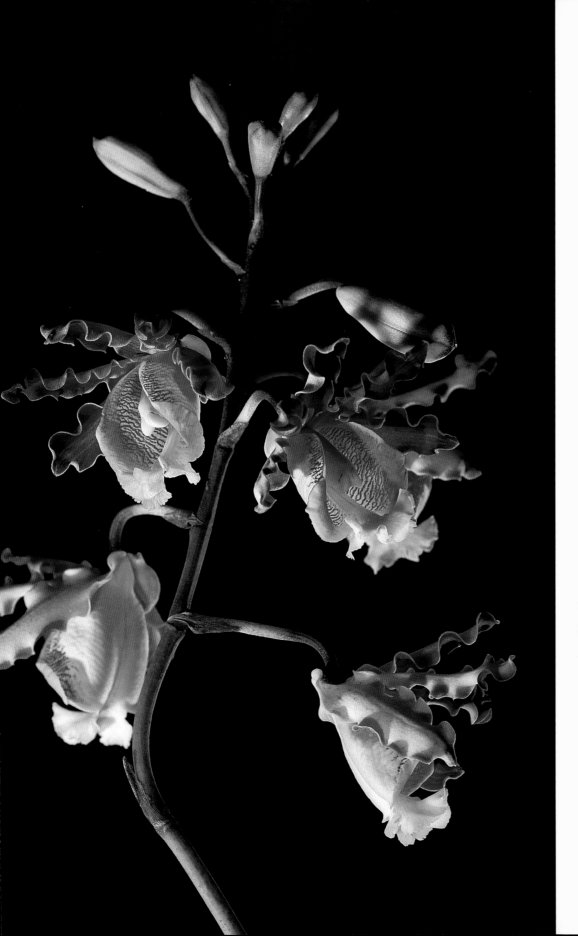

FAR LEFT: Gongora sp.

LEFT: Myrmecophila sp.

Both in Chilibre, central Panama

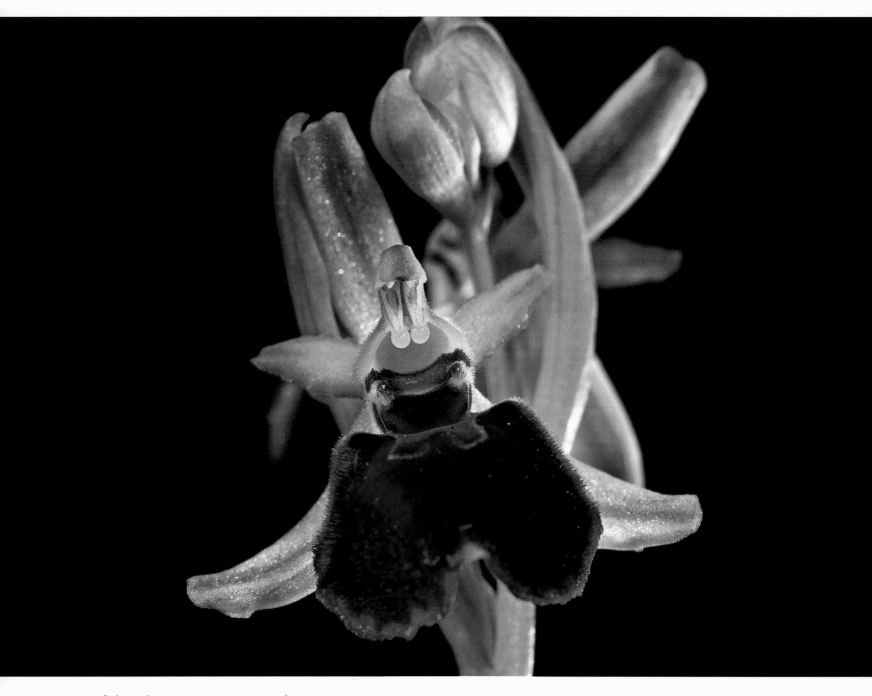

ABOVE: Ophrys chestermanii, *a very rare, endemic species*

RIGHT: Ophrys speculum

Both in southern Sardinia, Italy

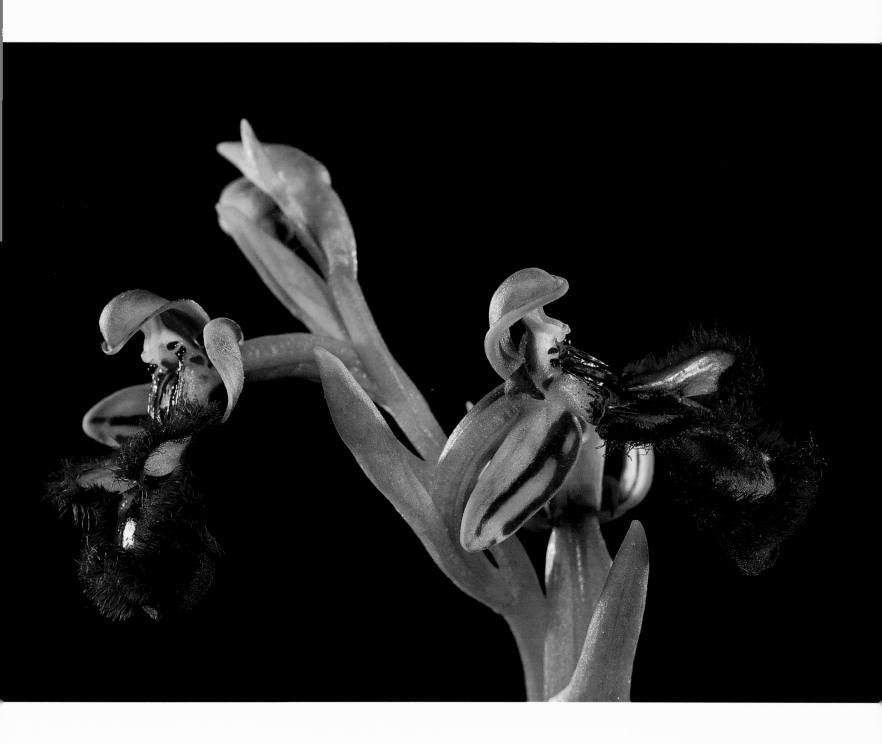

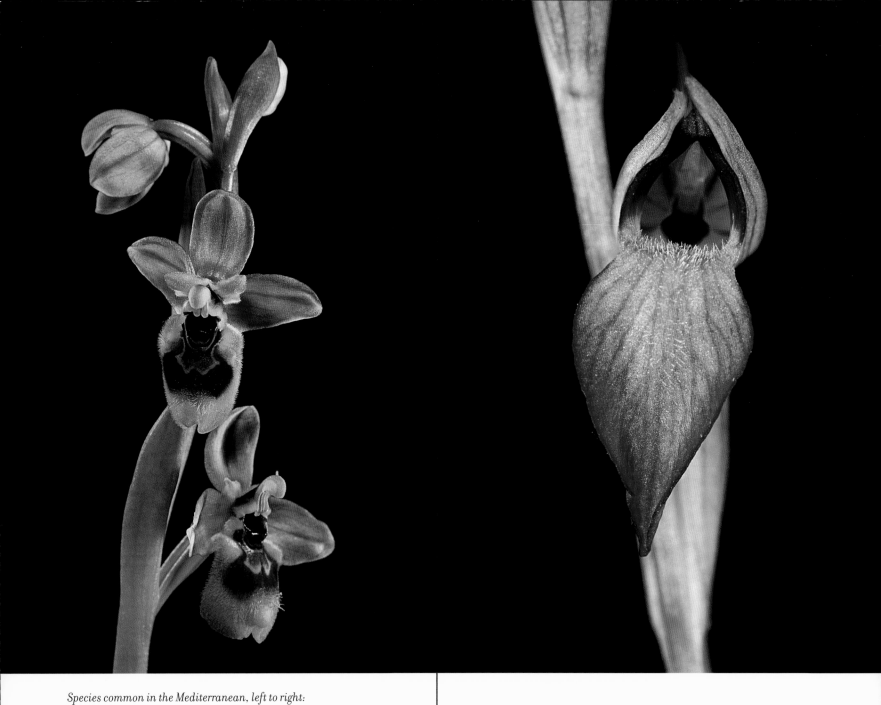

Species common in the Mediterranean, left to right:

Ophrys tenthredinifera *(sawfly orchid)*

Serapias lingua *(tongue orchid)*

Aceras anthropophorum *(man orchid)*

Serapias lingua, *from a different vantage*

All in Sardinia, Italy

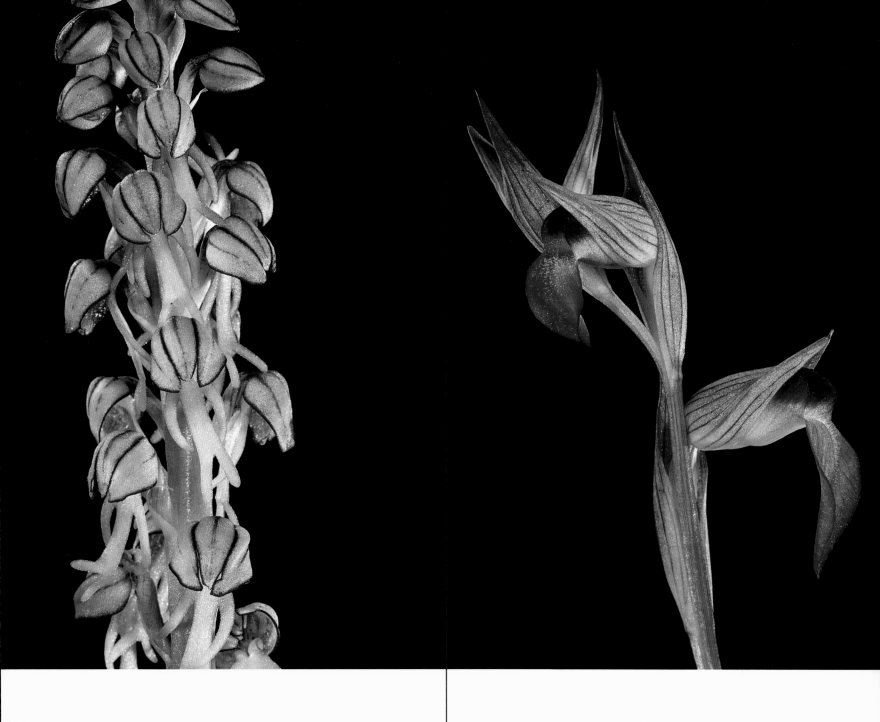

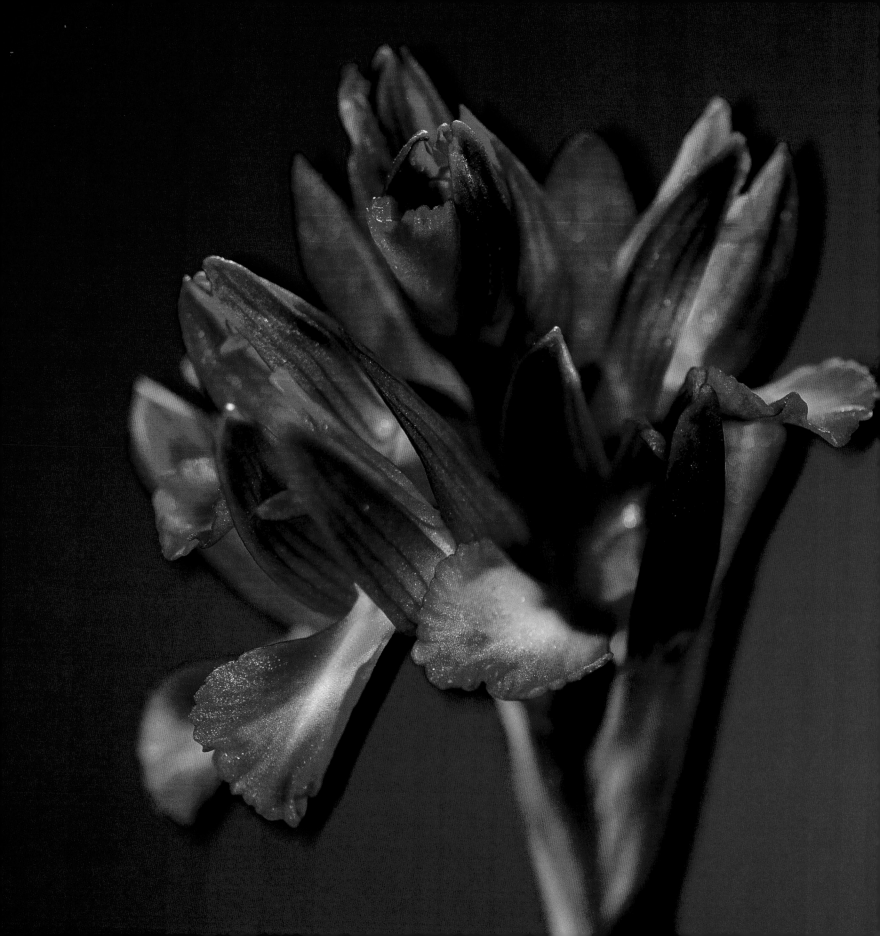

LEFT: Orchis papilionacea (*pink butterfly orchid*)

ABOVE: Ophrys incubacea

Both in Sardinia, Italy

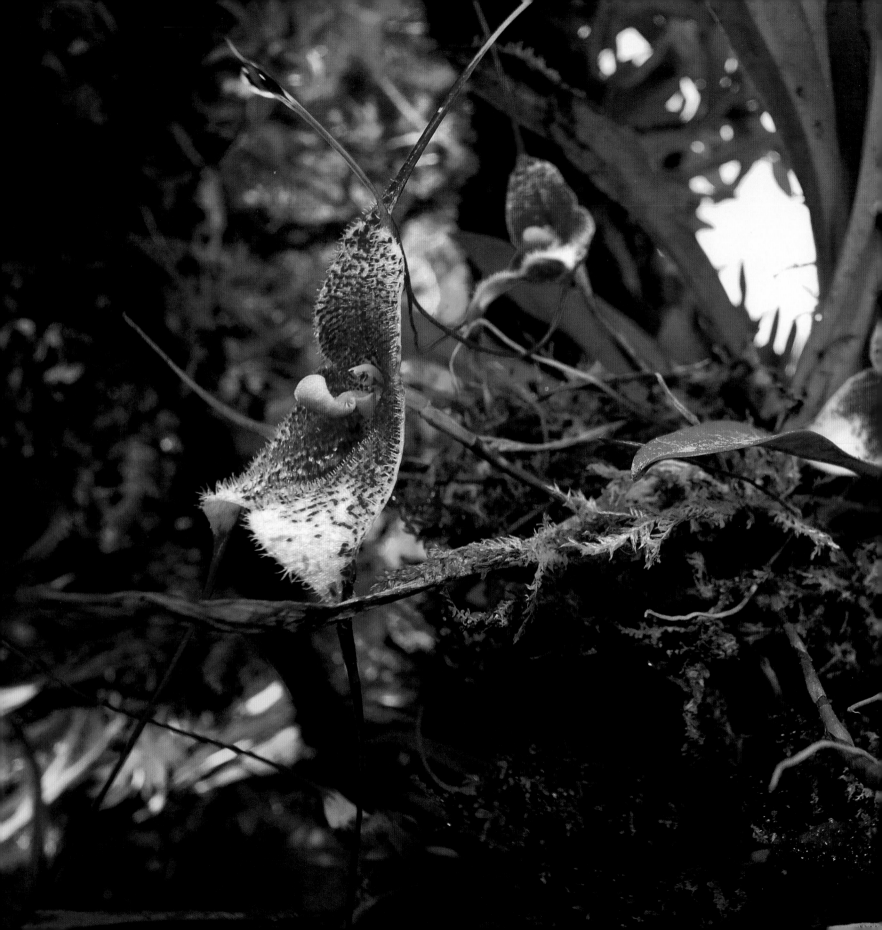

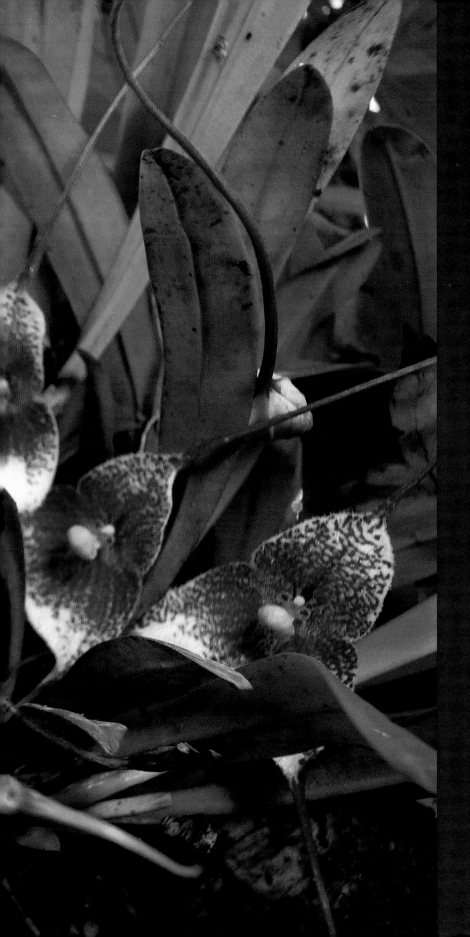

chapter 3

POLLINATION

Masters of deception, fully a third of all orchids promise their pollinators far more than they deliver. With flower shapes and scents designed to lure insects with the enticement of food or sex, orchids often provide neither. But they still get what they want—a messenger to deliver their pollen to another orchid of their own species.

Dracula erythrochaete.
Finca Dracula Orchid Sanctuary, western Panama

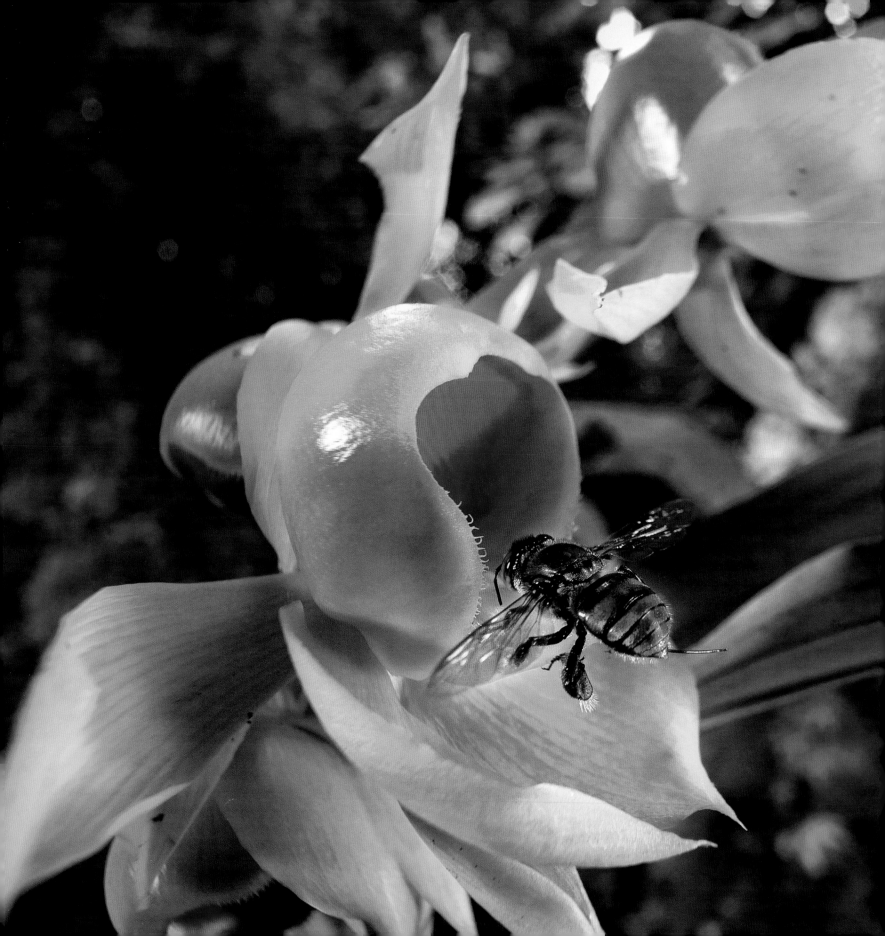

LOVE AND LIES

Pollination is the plant world's version of mating, and like all mating rituals, it entails strategies and variations that have evolved over time. The most obvious of these variations can be seen in the plants' mating organs—their flowers. In the case of the orchid family, that particular variation has led to the breathtaking and endless variety of shapes, colors, and scents that captivates us humans almost as much as it does the orchids' natural pollinators.

But mating is not the only way to reproduce. The first life on the planet, the bacteria and other simple organisms of 3.5 billion years ago, reproduced asexually, by division—an elegant and energy-efficient method of propagation. The first known evidence of sexual reproduction on Earth comes from fossils of a red algae called *Bangiomorpha*, recovered in artic Canada. At first glance, sexual reproduction seems impractical and wasteful. Why go to the trouble of finding a mate, courting, and raising babies if simple division is so easy? The answer is as simple: Sexual reproduction allows for adaptation and survival over time. The recombination of genetic material can give rise to new variations in each generation, while reproduction by division produces a clone, an identical copy of the original organism. The only variations that occur in asexual reproduction are by mutation, which is rare and often disadvantageous or dysfunctional.

Constant and novel variation is essential if a species is going to evolve and survive in an ever changing environment. Variation helps ensure that at least some of the newly conceived offspring of each generation will have the genetic, physiological wherewithal to cope with changing conditions and reproduce offspring of their own.

A male orchid bee approaches a sweet-scented Catasetum viridiflavum. *Barro Colorado Island, Panama*

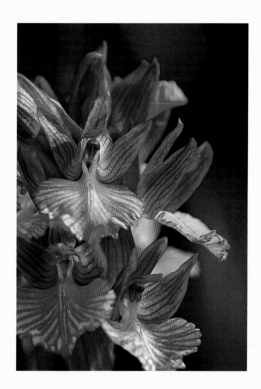

Anacamptis papilionacea (*pink butterfly orchid*), *a species that uses food deception to attract its pollinator. Sardinia, Italy*

In plants, sexual reproduction works this way: The pollen of the male part of a flower is deposited onto the female part of a flower of the same species—no small task for creatures that lack the ability to move. Obviously, plants need help transporting that critical pollen between individuals. Early on in plant evolution, they relied on the wind to move pollen among flowers, and many of the older and more primitive plant groups, like the conifers, still do. But with the emergence of insects on the evolutionary scene, especially flying insects, a new and very effective kind of pollination became possible, and plants took full advantage of it. Soon flowering plants and insects were engaged in a co-evolutionary dance that resulted in a huge radiation of new species for both and in the rich species diversity of these groups we see today.

Some plant species have dozens of generalist pollinators they can rely on, while others have only a single species. If a plant species is very common and clusters together in high densities, a generalist pollinator, like a honeybee or other social bee, is probably best. These bees tend to focus on a single plant species during a foraging trip, thus ensuring cross-pollination. That makes them reliable pollinators for plant species that cluster themselves together. For plants that are fairly rare and live in low densities, with a few scattered here and there, the situation is very different. Relying on a set of generalist pollinators is likely to be a bad strategy, since distances among different plant individuals can easily be longer than a generalist pollinator is willing to travel. Most orchids, especially tropical epiphytic species, live in low or very low densities, with the distance between two individuals of the same species hundreds of feet or even miles apart. To ensure pollen flow in such cases, these plants need a very committed pollinator with a strong fidelity to their species.

So how do orchids achieve this? To start with, they probably hold the world record for evolving the greatest variety in their pollination systems, and some of these systems are among the most sophisticated in the plant world. All the glory, everything we love and admire in orchids—the intricate flower designs, the often unbelievable colors, and the mesmerizing (or sometimes revolting) scents—is directly related to

their pollination and the result of many millions of years of co-evolution with their respective pollinators.

Nectar is the most common reward currency given by plants to their pollinators, and two-thirds of orchids trade nectar for pollen transportation. Often the nectar is positioned in such a way that only the designated pollinating species can reach it, thus cementing the relationship between an orchid species and its pollinator.

Another common reward, pollen in abundance, is not feasible in orchids, because all orchid pollen is stuffed in bundles, the pollinia and typically can't be consumed by insects. A number of orchid species, including some in the *Oncidium* genus, have evolved pseudopollen, a pollenlike substance in appearance and nutritional value that is produced by specialized hairs on the flower's labellum instead of by the stamen. Some *Oncidium* orchids, as well as those in other genera, also reward their bee pollinators with a waxlike substance they can use to construct their nests.

Not all orchids greet their pollinators passively. Some have evolved very complicated flower architectures, with hinges and moving parts, liquid buckets, and directed hairs that constrain visiting pollinators or manipulate their bodies into certain positions. In some cases, the traps simply push the pollinator in the right position either to deliver or receive pollen. As the pollinating insect wiggles, it triggers a mechanism that either attaches the pollen package to its body or detaches it.

Probably the most sophisticated trap flower is the bucket orchid, or *Coryanthes*, of Central and South America. But lady slippers, found around the world, are also trap flowers, mostly for bees and flies. The flowers' slippery inside walls and directed hairs prevent their pollinators from crawling backward, forcing the insects to leave the flowers by an opening other than the entrance. On its way through the flower, the pollinator deposits any pollen it might have brought. Then as it moves through a narrow tube at the end of the flower, the pollinating insect triggers a mechanism that attaches the take-away pollinia to its body. Thus loaded, the pollinator flies off, carrying the cargo the trap flower intended.

Beautiful Cheaters

A good third of all orchids, an estimated 9,000 species, are thought to deceive their pollinators. Rather than rewarding them with nectar or pollen, they imitate the appearance and scent of rewarding flowers or of the insect's potential mate. Some scientists have suggested that deception as opposed to rewards can be advantageous because it reduces the risk of self-pollination: The pollinator tends to be frustrated to find that the first flower on a plant was without reward and is less likely to visit a second flower on the same plant, which, for the plant, would waste valuable pollen.

The most common deception, independently evolved many times in various groups of orchids, is food deception. In these species, the orchid flower mimics a food source, most often a nectar-rich flower, and tricks the pollinator into a visit. These flowers either display the flashy colors, sweet scent, and large size of very nectar-rich flowers, or they may mimic specific plant species that are often visited by pollinators. Victims of these orchids typically are naïve individual pollinators, often freshly hatched insects that fall for the deceptions of these super stimuli a few times before they learn to avoid them.

Some more exotic cases of food deception are found in orchids of the *Dracula* genus in the American tropics: They have flower parts that look and smell like little mushrooms and tempt pollinators, mostly small flies called fungus gnats, to deposit their eggs on the fake fungi. While laying the eggs, the female flies are forced to get into just the right position inside the flower to pick up or deposit the pollen. In a similar way, a number of *Masdevallia* orchids trick carrion flies into pollinating their bad-smelling flowers; African and Asian *Bulbophyllum* orchids have evolved a comparable deception.

Probably the most curious case of food deception was just discovered in 2009 when scientists working on the Chinese island of Hainan found that the *Dendrobium sinense* orchid mimics the alarm pheromone of the honeybee to attract the bee's worst predator, the hornet, as a pollinator.

Then there are the seducers. In the plant world, only orchids seduce their pollinators with overt sexual deception, mimicking the appearance and the pheromones

of female insects in order to lure males to them. Instead of copulating with their female counterparts, the males wind up pollinating the orchids. Clever, and unlikely, this adaptation seems to have evolved a number of times independently and is now common and widespread among orchids. A recent study found that both of the well-known sexual deception complexes, one in southern Europe and the other in Australia, evolved from ancestors that first used food-deception pollination. Presumably, that evolved over time into their evolving the sexual deception technique.

Sexual deception has the huge advantage of attracting extremely loyal pollinators. Because the chemical attractant is aimed at a single insect species only, no other species is ever interested in the orchids. This allows a tight fine-tuning of the relationship between the orchid and its pollinator and has led to some orchids evolving amazingly accurate imitations of female insects, particularly their pheromones. In all cases of sexually deceptive orchids, the plants exploit situations in which there are many more male insects of the species than females, so that the males, competing with one another, can't be choosy and have to take advantage of any female they encounter. Once an orchid flower has evolved a chemical resemblance to that particular insect, the fine-tuning seems to happen pretty quickly. In an ironic twist, many of these orchids become more attractive to male insects than females of their own species, in part because the orchids often produce more of the attracting pheromone than the female insect.

Bees, Wasps, and Butterflies

Bees and wasps were probably the orchids' original pollinator groups, and even today an estimated 60 percent of all orchids, at least 15,000 orchid species, are bee- or wasp-pollinated. The flowers in these species are often yellow or blue, colors that are especially attractive to bees, and the architecture is accommodating, with a large lip as a landing pad and an often globular shape. There are also many odd co-dependencies among these orchids and their pollinators. In southern Europe, orchids of the *Ophrys* genus—the bee orchids described in Michael Pollan's introduction—include many

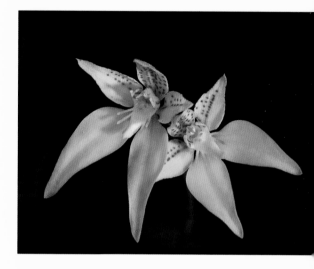

Caladenia flava *(cowslip orchid). Western Australia*

Male orchid bees from Surinam, in the collection of the Smithsonian Tropical Research Institute. These bees are key pollinators for many orchid species in the American tropics.

paired species that share an extremely similar or even identical-looking flower, but the flowers produce different pheromones and thus attract different pollinating insect species. The evolutionary scenario to explain this could be simple: If a single mutation happened in the genes responsible for the flower scent, it could change the faux pheromone to the point that it no longer attracted the males of the pollinating insect. Most such mutations would make the orchid individual unrecognizable to its pollinator, and thus lead to an evolutionary dead end. But every now and then, in one out of many millions of such events, the mutation might create a new scent that was actually the pheromone of another insect, typically that of a close relative of the original pollinator. This individual plant would be visited exclusively by the new pollinator species and its offspring would perpetuate a new subspecies.

Evolution is always full of surprises, and appearances are not always the best way to judge taxonomic relatedness. Take the example of two bee orchid species from the same area of Sardinia. The *Ophrys* "sisters" are almost look-alikes, and they share the same pollinator species, a species of cuckoo bumblebee. But genetic analysis has shown that the two orchids are not close relatives at all. It seems that over evolutionary time, their interaction with their common pollinator has led to their similar appearance.

If Europe has bee orchids, the American tropics have orchid bees. Forested areas there can be home to as many as 50 species of the spectacular, metallic-looking euglossine bees, and the several hundred species of orchids that have co-evolved with them. Each of these orchid species now depends on a male bee of a particular euglossine species for pollination. The orchids' flower shapes can be extremely different from one another…depending on the size of their pollinating bee species and the way in which the bees are manipulated into the right position to deposit and pick up the pollen packages. But all of these orchids have a strong aromatic, mostly sweet scent that attracts the bees, and that scent is the linchpin of the relationship.

The bees need the orchid's scent substances to make their own courtship perfume. In a rather romantic display, male euglossine bees create a certain species-specific scent for their females, who choose a partner based on its scent. Each orchid bee

species has its own specific ideal scent, and the more accurately a male bee can match it, the higher his mating chances are. It can take several months for the males to assemble the perfume, and they spend hours each day locating flowers, resins, and other sources from which to collect the components they need. These ingredients get mopped up with brushlike structures on the bees' front legs, then transferred and stored in a set of large pouches located on the bees' back legs. Eventually, these essences are mixed together to form the perfume.

Once the scent is complete, each male sits on a special perch site, extracts some of the perfume from his pouches, and fans it off with his wings. The complexity and difficulty of this process explains a bizarre-seeming behavior called grave robbing: If a male orchid bee dies, other males will soon wrestle over the body and try to squeeze out as much of the valuable scent from his leg pouches as they can get.

From the orchids' perspective, euglossine bees are the perfect pollinators: The male bees' need for the scent substances makes them highly committed and very specific orchid visitors, frequently flying long distances in their quest for the right perfume. In fact, observations and experiments with radio transmitters have confirmed that an individual male may forage as far afield as six miles (ten kilometers). In order to avoid pollination with the wrong pollen, orchids that share a pollinating orchid bee species with other orchid species will attach their pollinia to different body parts of the male bee. A single male can be laden with two or more pollinia from different orchids sticking to him on different body parts.

Because male orchid bees are such reliable pollinators, scientists have been using them to study orchids in the tropical canopy—not the easiest place for human researchers to do an orchid census. The researchers use essential oils to attract the bees, then study the color, shape, and position of pollen packages on their bodies to determine the presence of an orchid species in the forest, as well as its flowering season and relative abundance.

Relying so heavily on the euglossine bees has some serious risks for orchids. In recent decades forest fragmentation caused by logging and development in Central

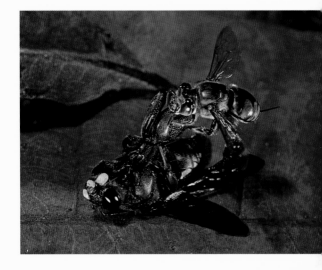

A male orchid bee approaching a dead male of a different species in a behavior called grave robbing. Because it takes male bees weeks or even months to collect the scents they need for courtship, they will steal these oils from dead males they encounter. Barro Colorado Island, Panama

and South America has affected this specialized pollination system. A recent study showed that the amount of pollen removed from orchids was reduced by 50 percent in fragmented forests. One of the world's leading tropical ecologists, Dan Janzen, foresaw this problem some time ago and thinks that it will likely lead to the extinction of some orchid species.

In Australia, the *Caladeniinae* orchids are another well-documented case of sexual-deception pollination. These orchids rely on a family of parasitic wasps called *Thynninae*, which lay their eggs into the larvae and pupae of beetles and other insects. While the male wasps are good fliers, the wingless, short-lived females are only able to crawl. Right after hatching, the females climb up a tall grass plant to an exposed spot and start emitting their pheromones. Male wasps rush in and try to be the first to grab a female, carry her to a flower for food, then mate with her. Under such a scenario, with intense competition and very little opportunities, the male wasps can't afford to be picky and will approach anything that seems like a female wasp. So the orchids have exploited the males' desperation, evolving to take on the appearance of the female wasps.

While bees and wasps are major orchid pollinators, other insects also play a role in the life of various orchid species. At higher elevations in the tropics, fungus- and nectar-eating flies are key pollinators, but butterflies and moths have also co-evolved as the pollinators of some orchid species. The particular shape of their extremely long, rolled-up, and hollow proboscises has shaped flower architecture, resulting in long spurs where the nectar is located. The most famous of all long-spurred orchids, *Angraecum sesquipedale*, is also called Darwin's orchid, because when a horticulturist sent Darwin the flowers of this Madagascan orchid, he predicted its pollinator would be a large hawk moth with a very long proboscis. Twenty-one years after his death, his prediction was verified when a large moth with an 18-inch-long proboscis was observed visiting this spectacular flower in the jungles of Madagascar. Both butterfly- and hawk-moth-pollinated orchids typically offer a nectar reward to their pollinators and have

specially shaped, rather small pollinia, which easily attach to an insect's proboscis without getting in the way of its rolling up.

Some of the most spectacular orchid pollinators are nectar-feeding birds, including the hummingbirds of the American tropics and the sunbirds of Africa and Asia. They play an especially important role in higher elevations, often in montane cloud forests above 5,000 feet (1,500 meters), where insects become less reliable as pollinators. They often have to stop foraging during rainfall or in cooler temperatures, but birds can stay active because of their relative strength and warm-bloodedness. This seems to be a powerful selective pressure; bird pollination of orchids has independently evolved in all montane tropical areas of the world.

The bird-flower syndrome is not unlike the butterfly one—the orchid flowers typically are red, orange, or pink, often with a longer spur, but they mostly lack the sweet scent that butterfly flowers have. One particular characteristic of bird-pollinated orchids is that the pollen packages usually have a dark color, often a gray or dark purple. If they were yellow, as they are in most other orchid species, they would be too obvious to the bird and would probably be preened off right away.

Perhaps the most unusual pollinator-orchid relationship, at least to the human eye, occurs in Australia, where *Rhizanthella gardneri*, the western underground orchid, flowers belowground and attracts termites as its pollinators. In truth, though, we still know very little about the strange and wondrous dance that orchids and their pollinators do. The future is bound to uncover all kinds of new and alluring ways orchids have evolved to play the mating game.

Bulbophyllum corolliferum. *Sabah, Borneo*

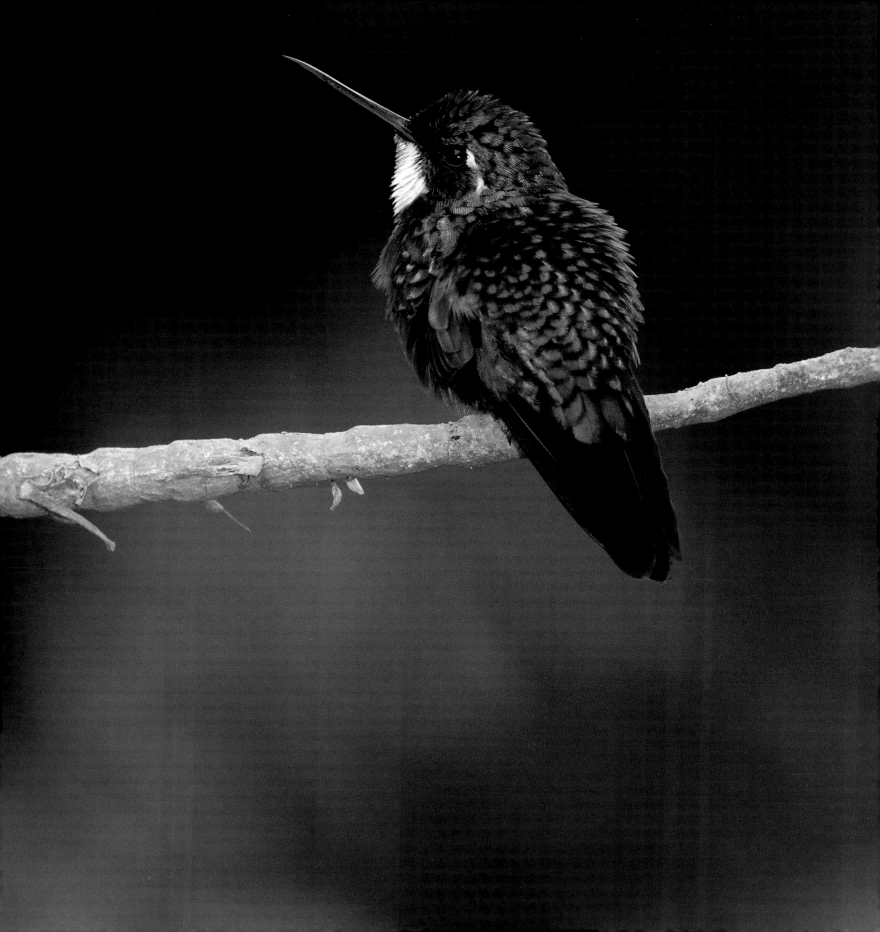

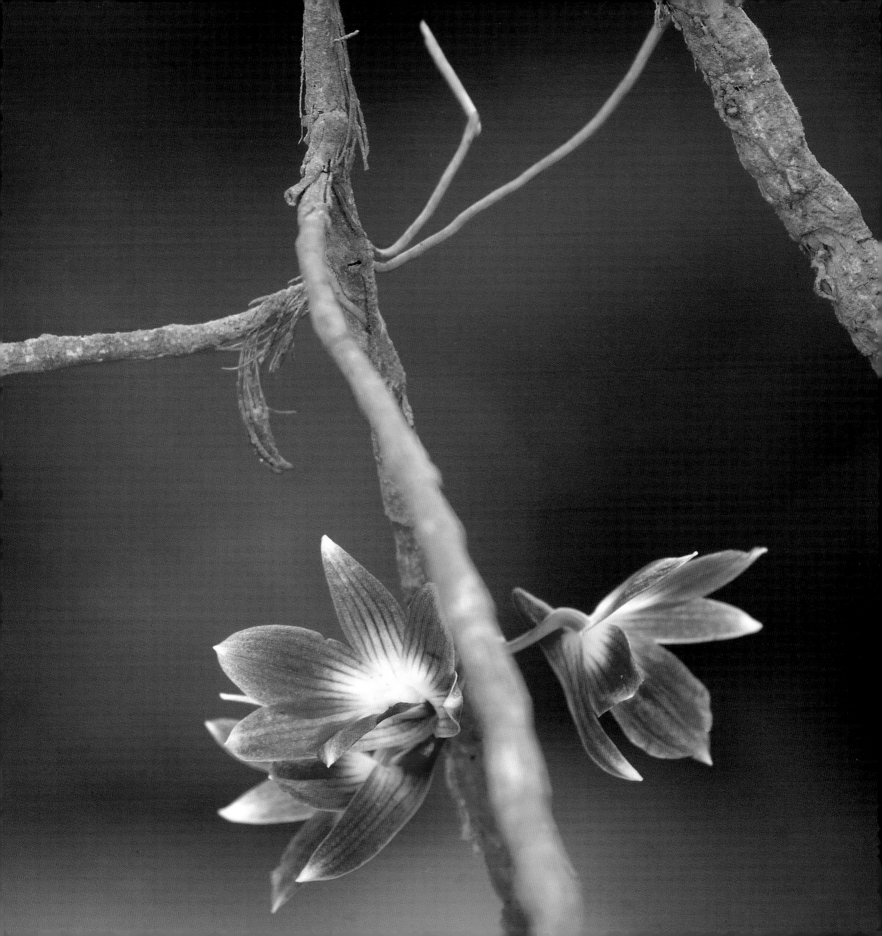

PRECEDING PAGES: *A female White-throated Mountain Gem*
hummingbird pollinates Dendrobium victoria-reginae,
originally from the Philippines where it is pollinated by sunbirds.
Finca Dracula, Panama

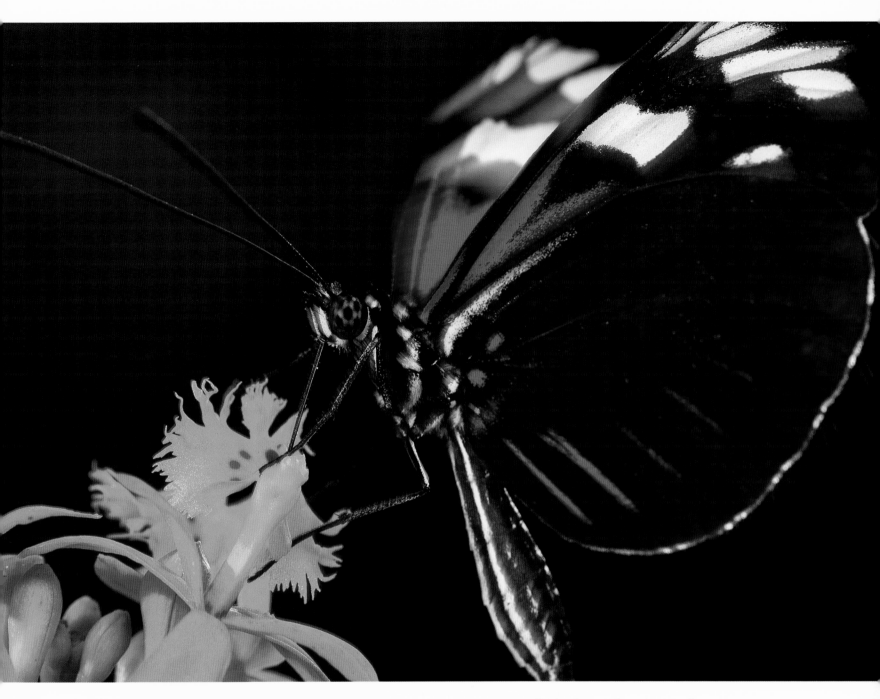

LEFT AND ABOVE: Epidendrum radicans *mimics the appearance of milkweed to attract its butterfly pollinator. Gamboa, central Panama*

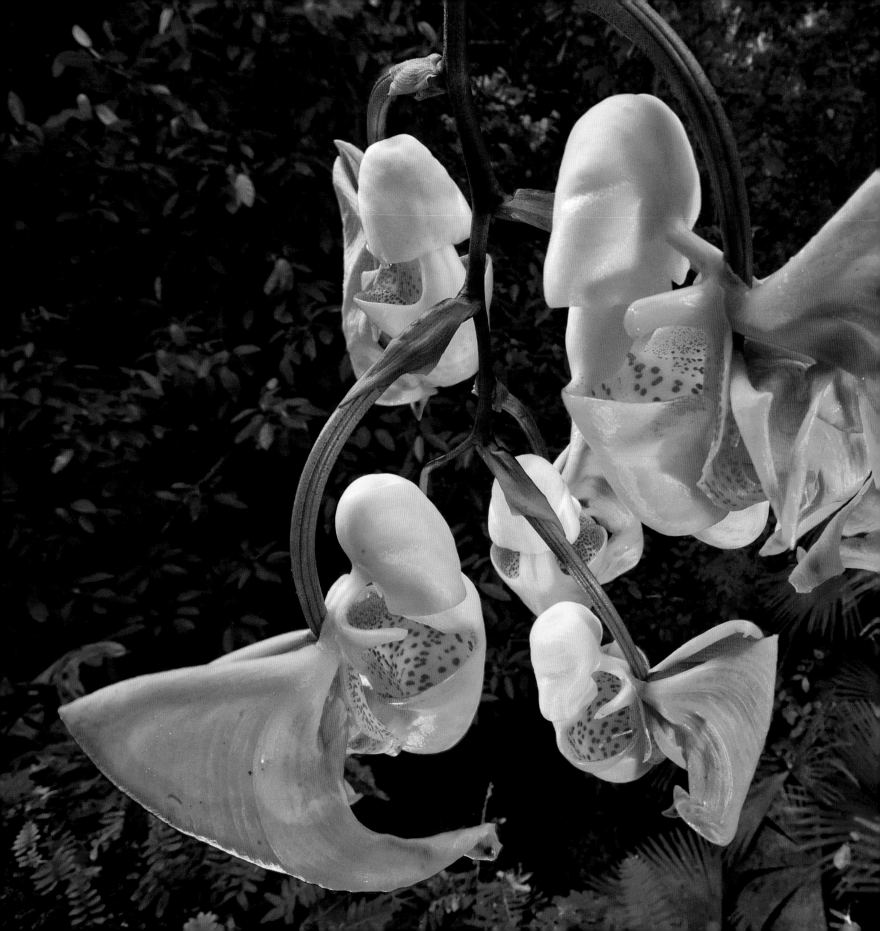

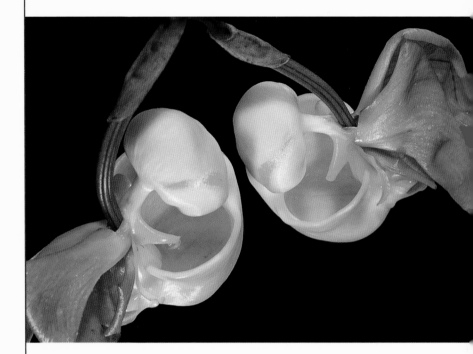

LEFT AND ABOVE: Coryanthes panamensis *(bucket orchid) blooming in the canopy of a lowland rain forest. Gamboa, central Panama*

FLOWER TRAPS

The intricately designed flower of this variety effectively functions as a bee trap: As a male bee tries to collect the flower's scent, it slips down the inner walls of the blossom, eventually ending up in the sticky liquid at the bottom of the "bucket." Unable to fly with wet wings, the bee tries to crawl up the inner wall. The only area with traction leads right to the entrance of a narrow tunnel. As the bee squeezes through the far end, pollinia are attached to its back that when inadvertently delivered by the bee to another bucket orchid, will complete the process of pollination.

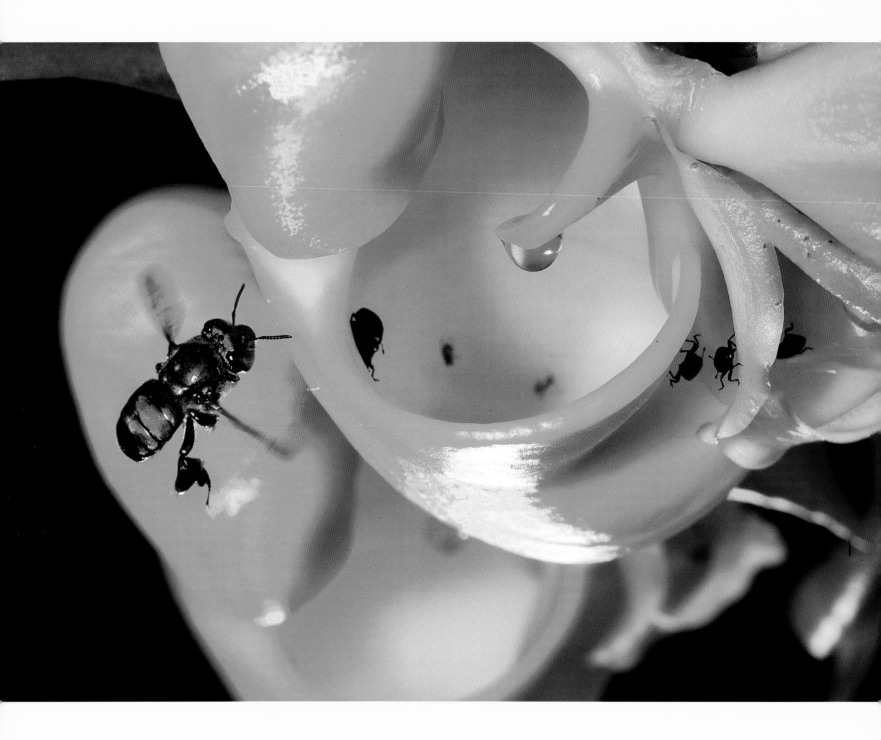

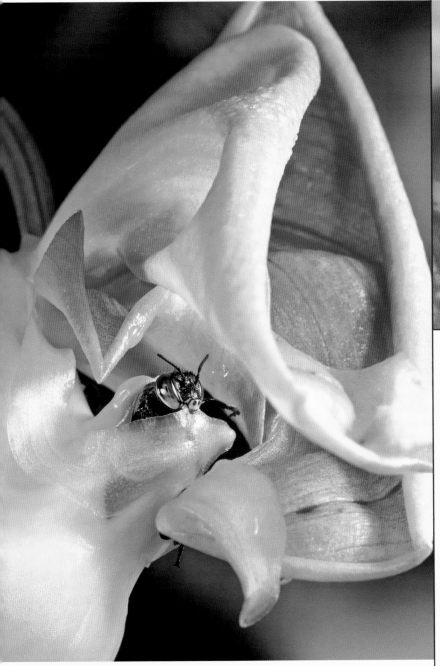

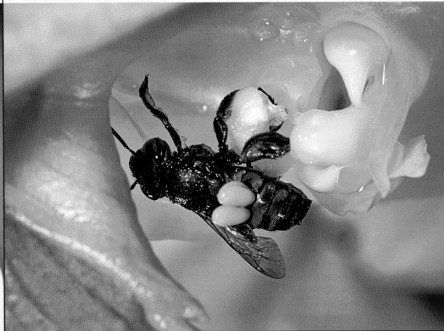

LEFT TO RIGHT: *Male euglossine, or orchid, bees gather at the blossom of a* Coryanthes panamensis *(bucket orchid), one of a number of bucket orchids that offer euglossine bees some of the scents they use to create a perfume needed to attract a female bee. Having been trapped by the orchid, one of the bees squeezes out the end of the tunnel leading from the flower's "bucket," then dries off its wings, wet from the flower's nectar; the orchid's yellow pollenia is visible on its back. Gamboa, central Panama*

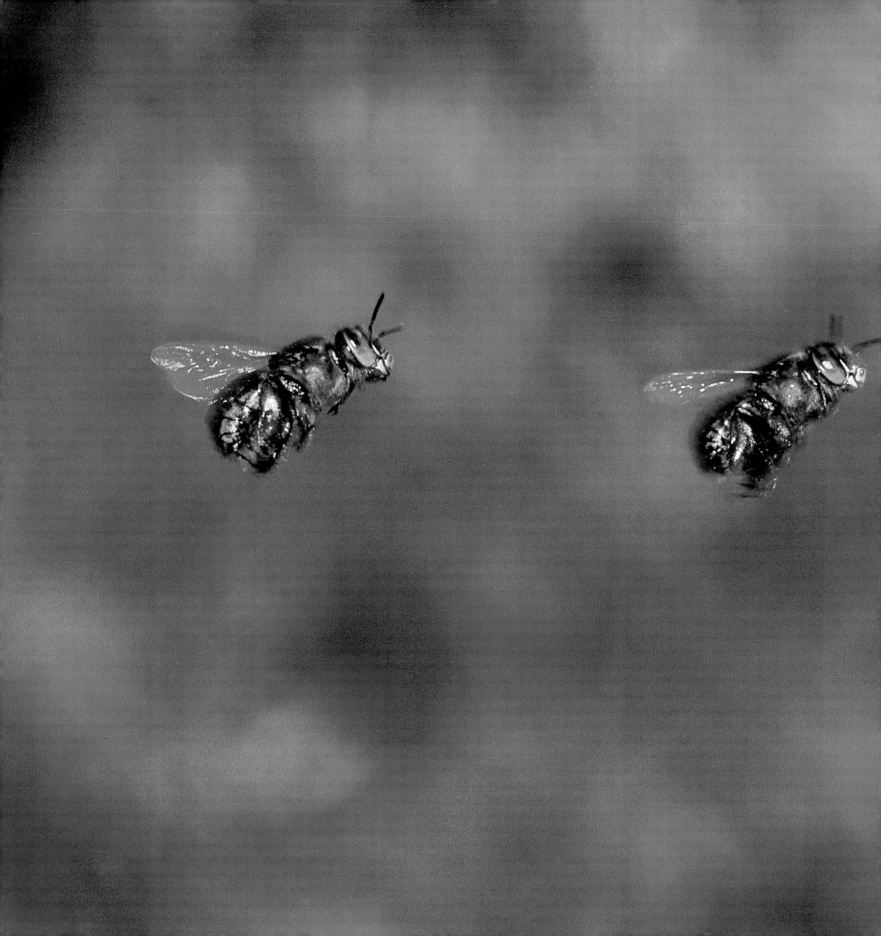

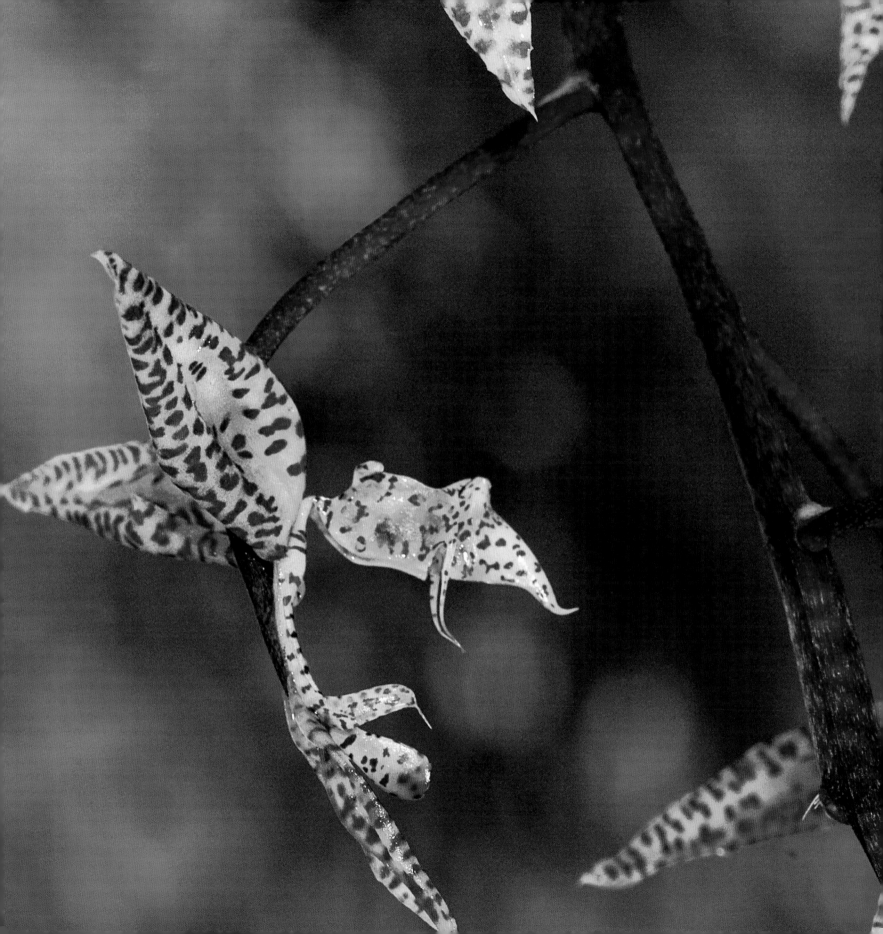

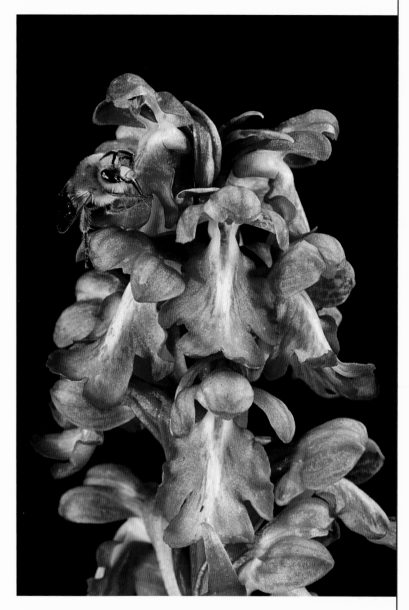

PRECEDING PAGES: Gongora powellii *with euglossine bees approaching its bucket blossom. Gamboa, central Panama*

ABOVE: Himantoglossum robertianum (*giant orchid*), *an "honest" orchid, offers a nectar reward to its bee pollinators. Sardinia, Italy*

RIGHT: Diuris magnifica (*pansy orchid*), *a food-deceptive species, mimics the scent of a nectar-rich legume. Perth, western Australia*

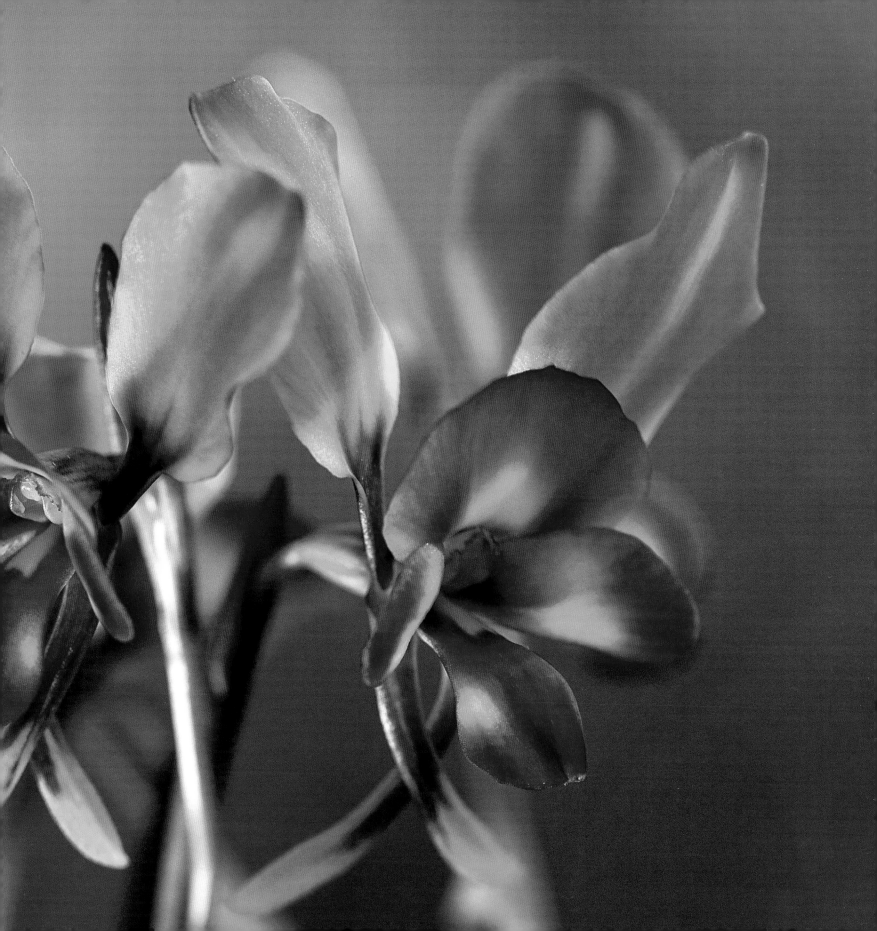

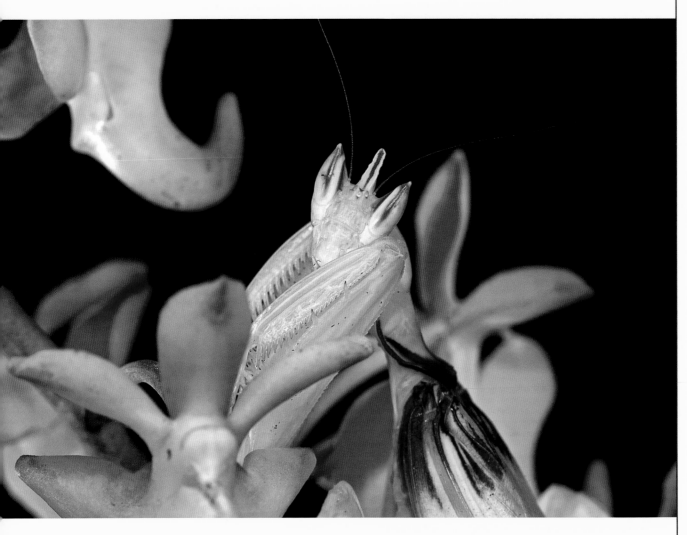

ABOVE: Aerides lawrenceae, *with the impressively camouflaged orchid mantis, an anti-pollinator, poised on a petal and waiting for a victim. Penang, Malaysia*

RIGHT: Gongora tricolor *hides a crab spider hoping to catch a bee or other insect. Gamboa, central Panama*

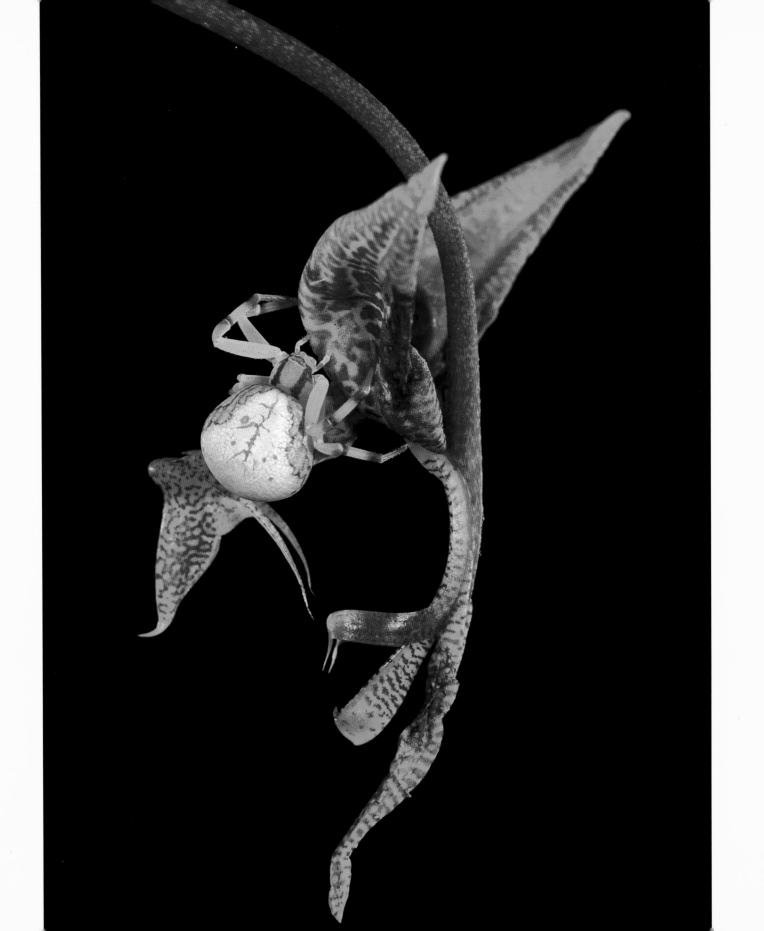

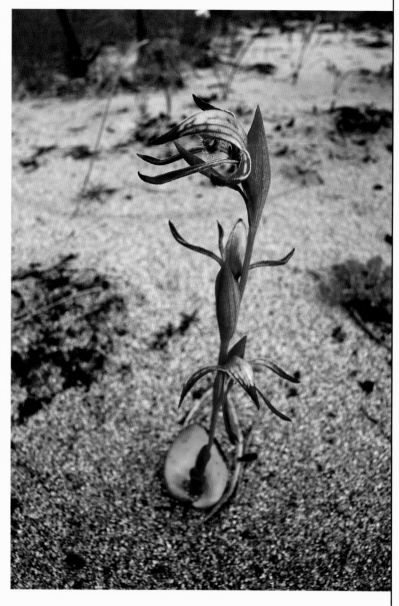

ABOVE: Pyrorchis nigricans *(red beaks orchid)*

RIGHT: Caladenia caesarea

Both in western Australia

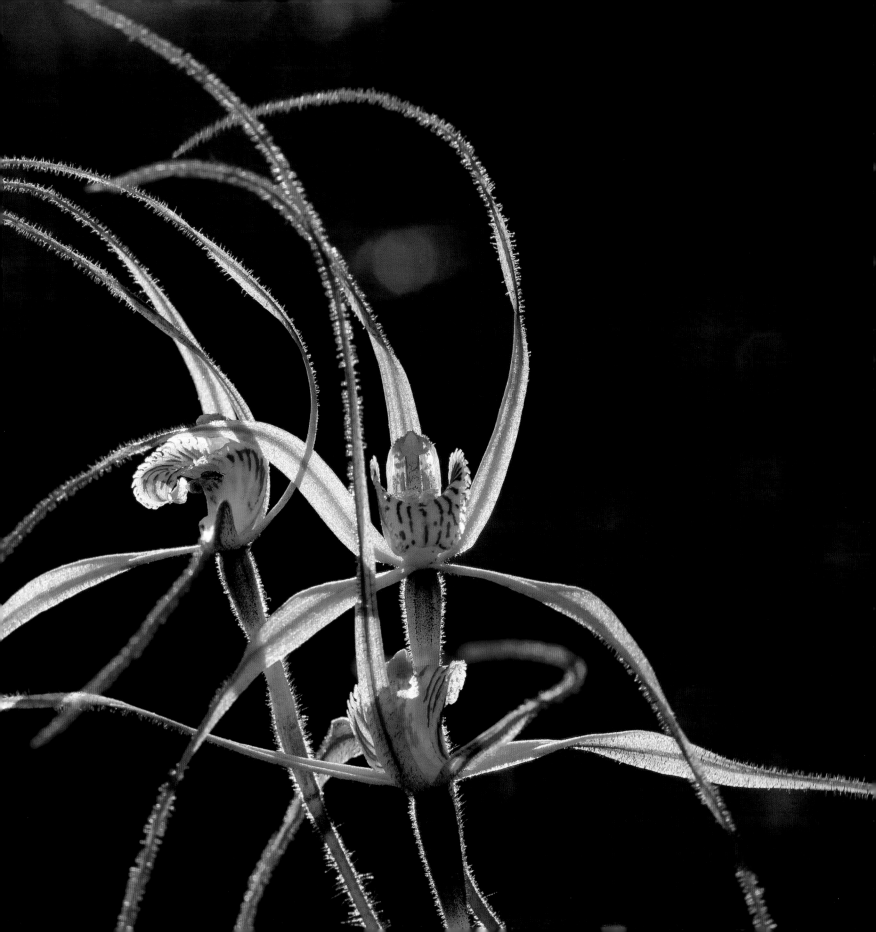

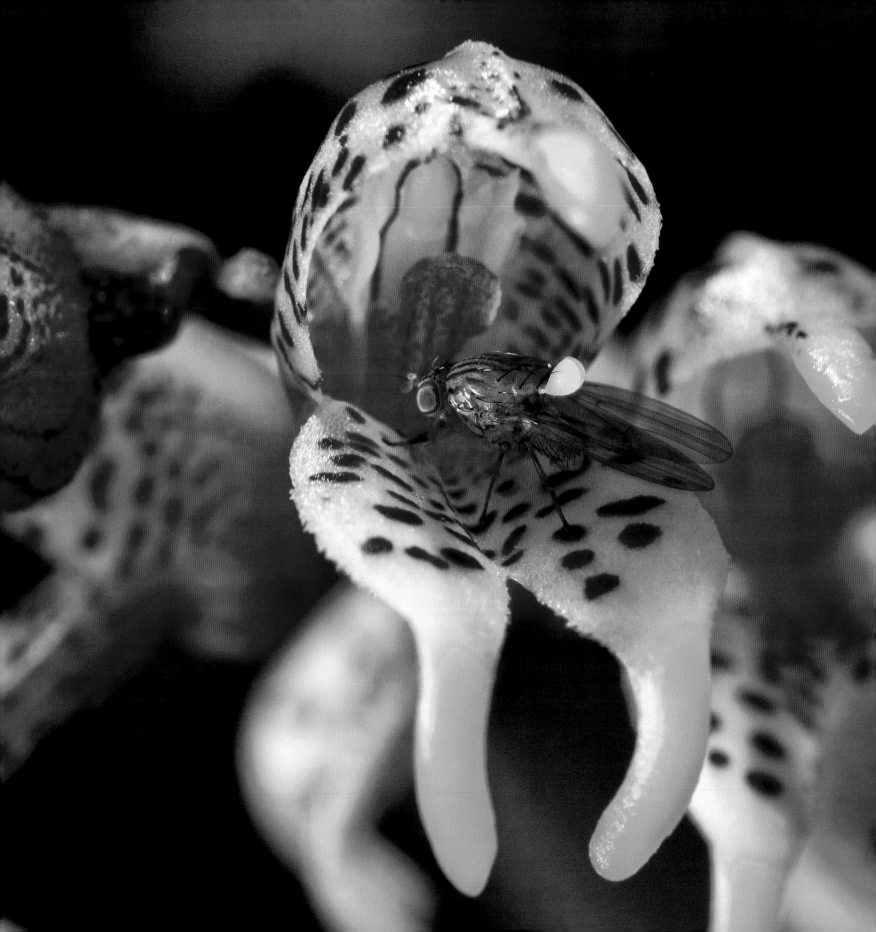

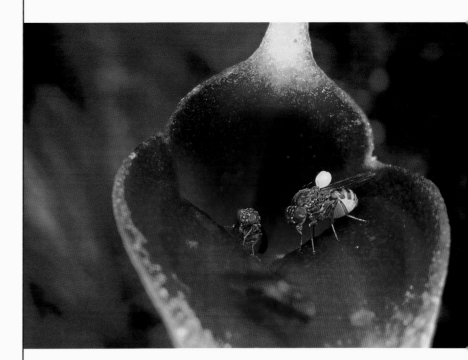

LEFT: Masdevallia caloptera *seems to swallow its pollinator, a small carrion fly carrying a yellow pollinium on its back.*

ABOVE: Masdevallia sp. *being pollinated by tiny carrion flies, one of which has a small pollinium on its back. The flower's blood red color, texture, and rotting odor, all mimic decomposing flesh to attract the flies.*

Both in Finca Dracula Orchid Sanctuary, western Panama

FOOD DECEPTION

Among the elaborate hoaxes that orchids perpetrate to attract pollinators, food deception is a big one. While two-thirds of orchids actually offer their pollinators a nectar reward, some only mimic the look and smell of nectar- or pollen-rich flowers— or, like the *Masdevallia*, of rotting flesh— to attract insects.

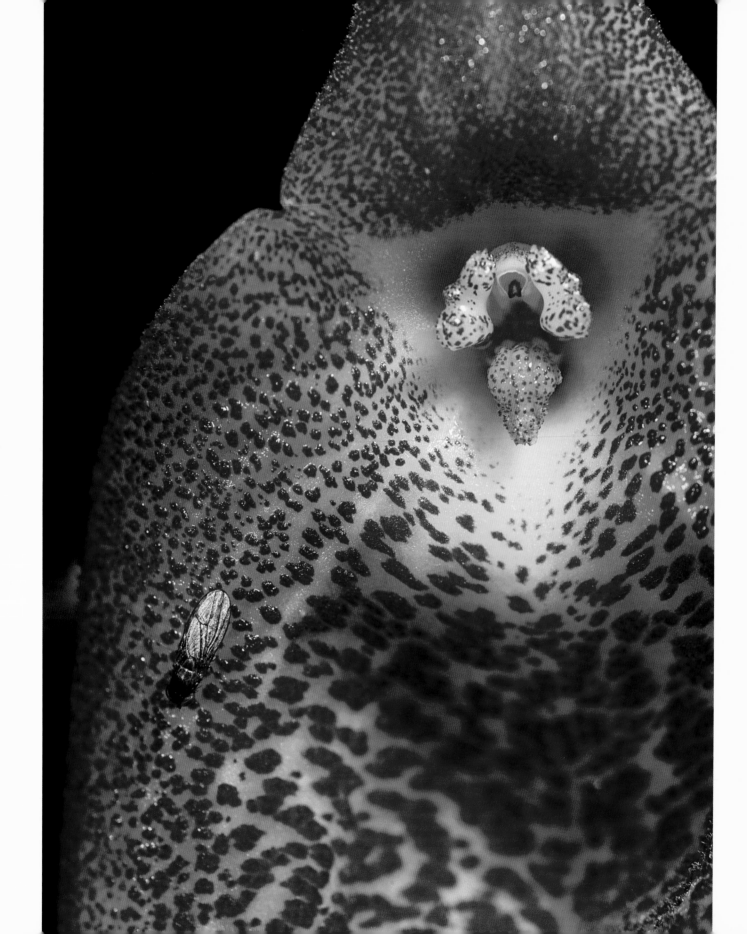

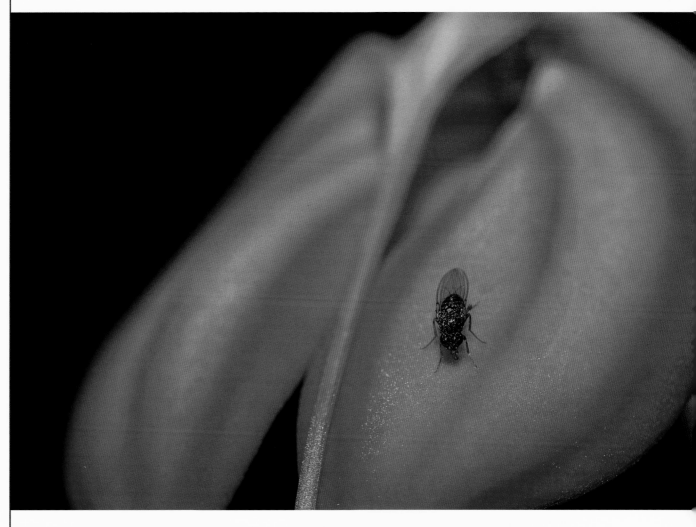

LEFT: Masdevallia regina *and a tiny carrion fly*

ABOVE: Masdevallia ignea *also with its minuscule fly pollinator*

Both in Finca Dracula Orchid Sanctuary, western Panama

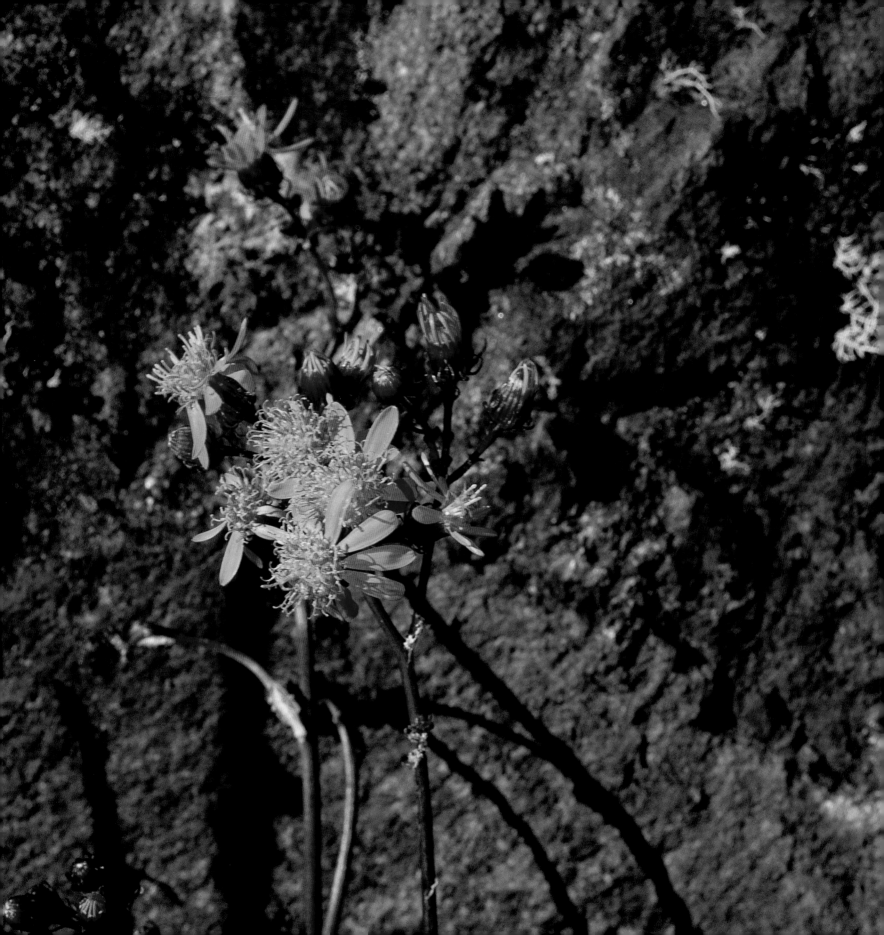

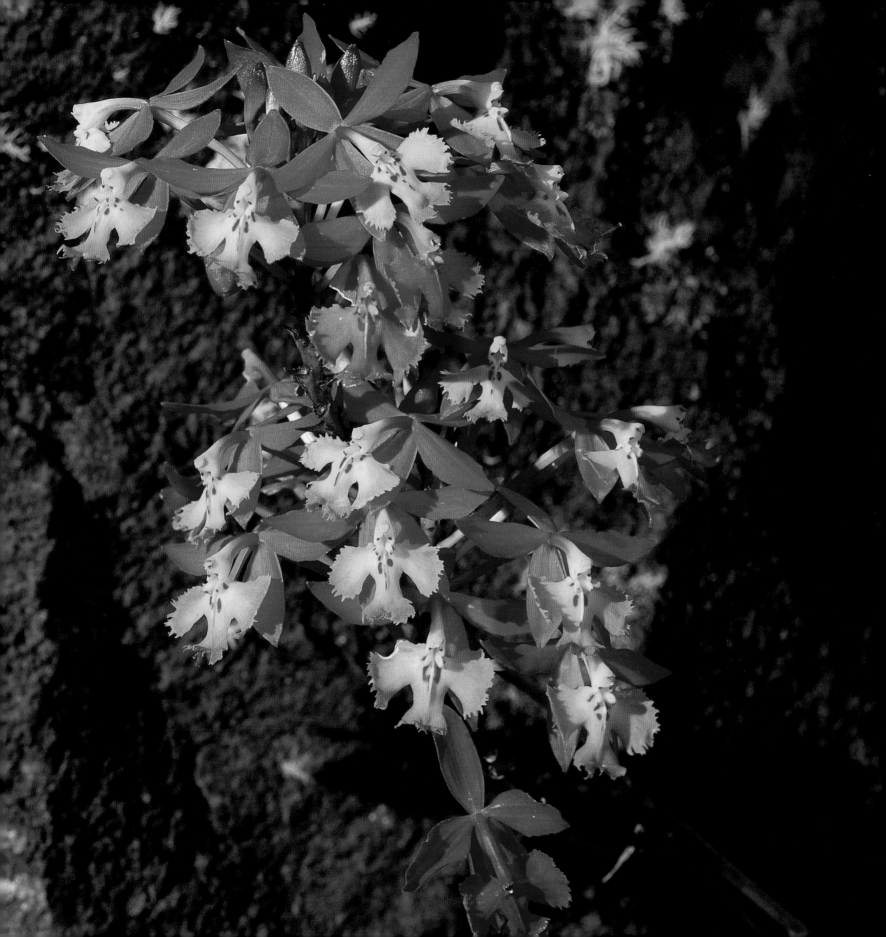

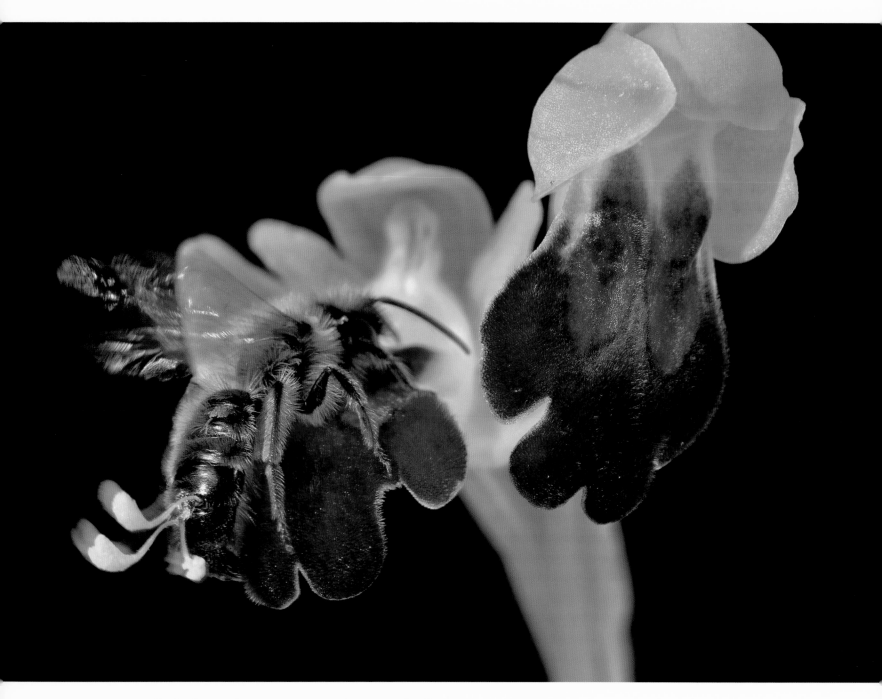

PRECEDING PAGES: Epidendrum radicans *growing next to the nectar-rich milk-weed that the orchid is thought to mimic. Vulcan Baru National Park, Panama*

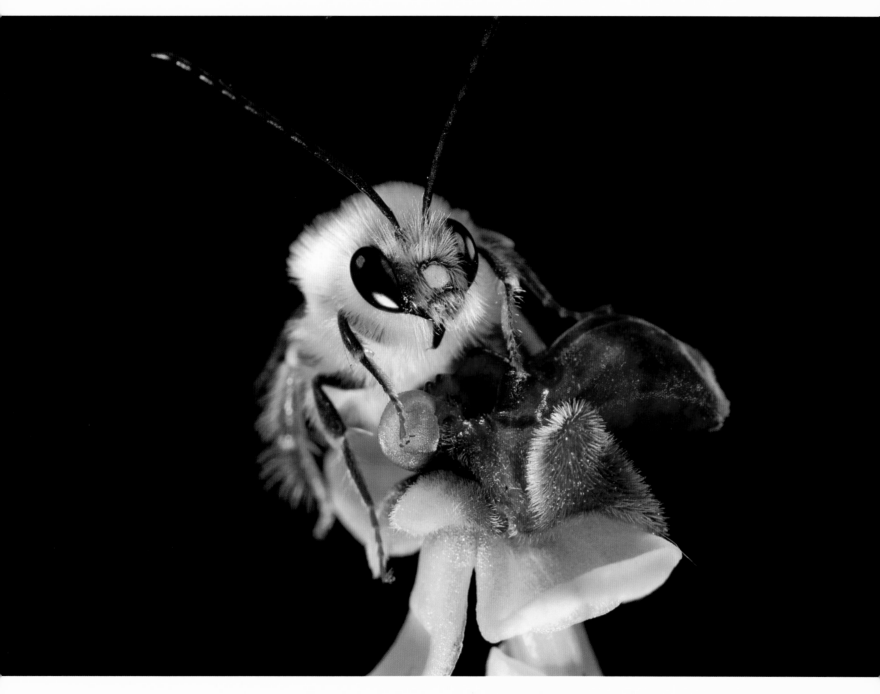

LEFT: Ophrys eleonorae *and* Ophrys lupercalis, *a wild hybrid, whose pollinator, a male solitary bee, is engaged here in pseudocopulation. Such hybrids occur naturally, and both species share the same pollinator.*

ABOVE: Ophrys bombyliflora *with its pollinator, a male solitary bee.*

Both in Sardinia, Italy

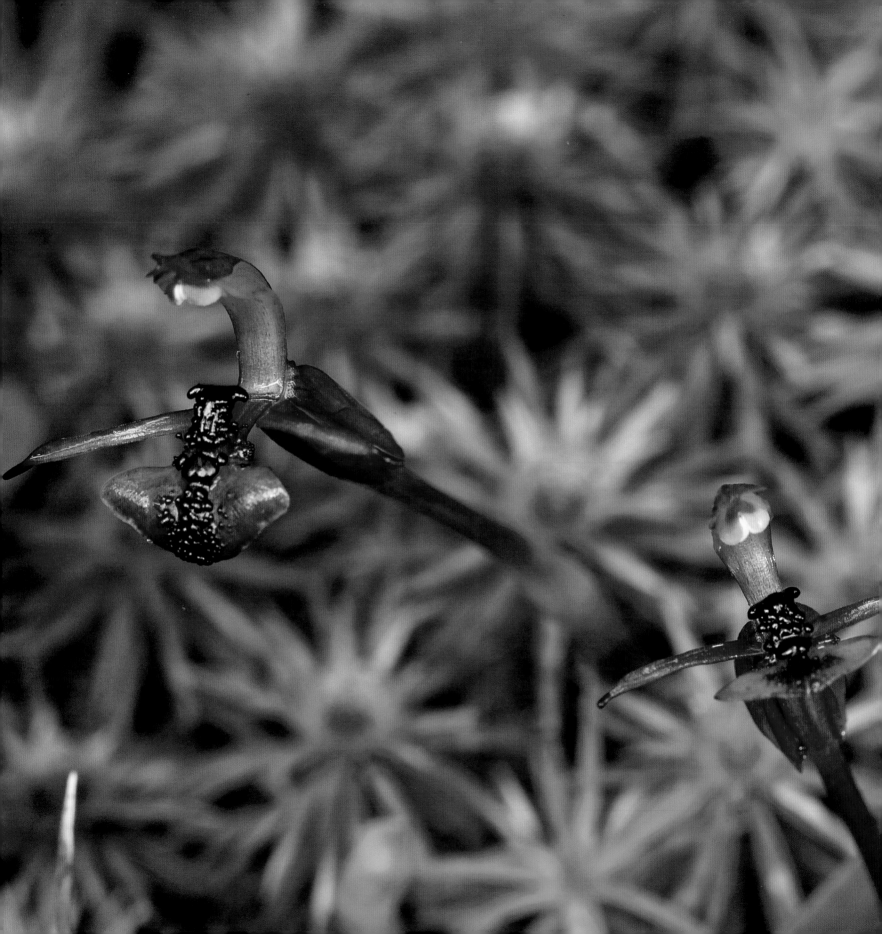

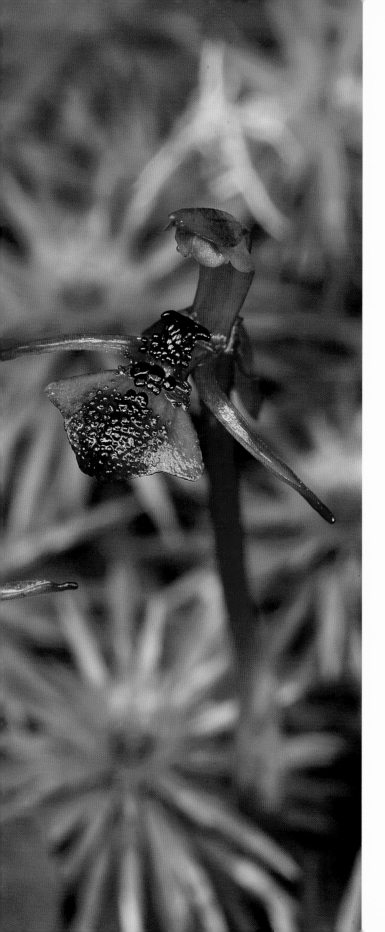

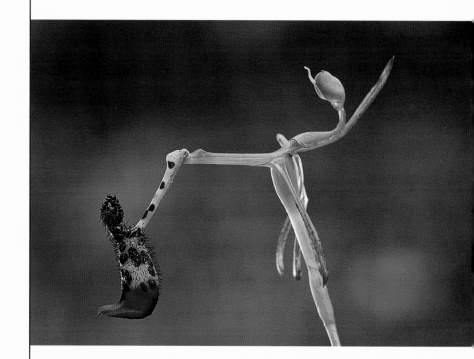

LEFT: Chiloglottis formicifera. *New South Wales, Australia*

ABOVE: Drakaea livida *(warty hammer orchid) is pollinated by sexual deception. The flower has a hinge mechanism designed to manipulate its pollinator into just the right position to receive its pollen. South of Perth, western Australia*

SEXUAL DECEPTION

Brilliant imitators, sexually deceptive orchids have evolved to imitate the smells and looks of female insects to seduce male insect pollinators. This technique is limiting because the orchids only attract a very specific pollinator species—but the mimicry ensures that the pollinator is a loyal lover, unable to resist the flower's wiles. Sometimes the hapless males become more attracted to the orchids than to the females of their own species because the flowers produce more of the sexually alluring pheromone.

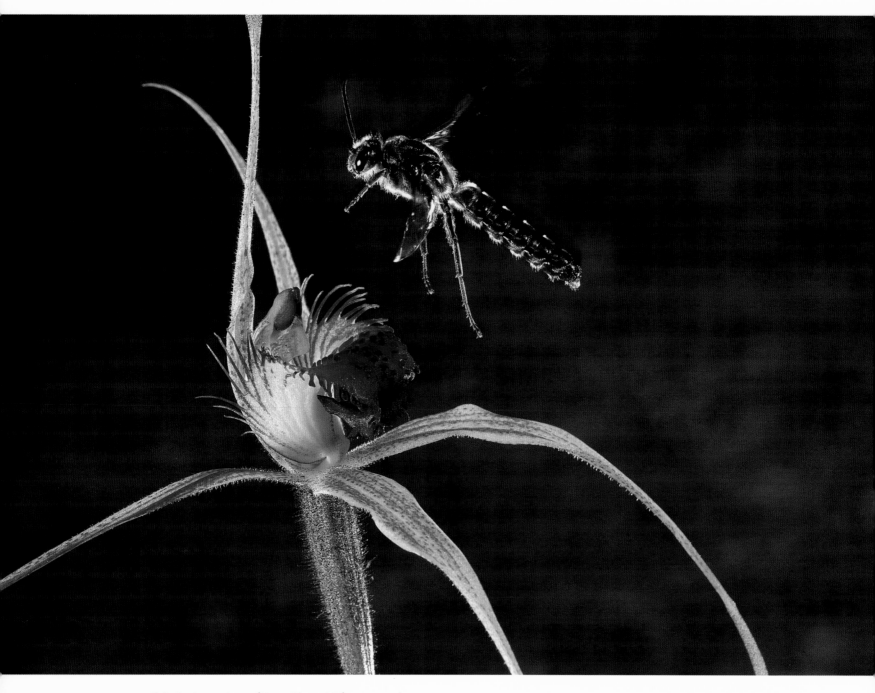

ABOVE AND RIGHT: Caladenia pectinata *(king spider orchid) uses sexual deception to attract male parasitic wasps. Denmark, western Australia*

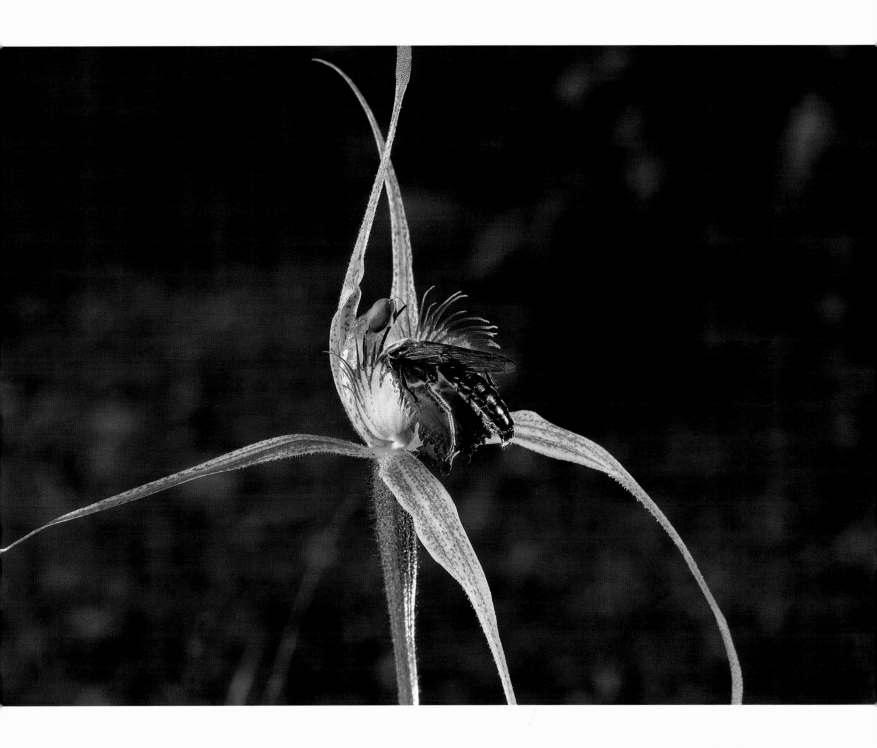

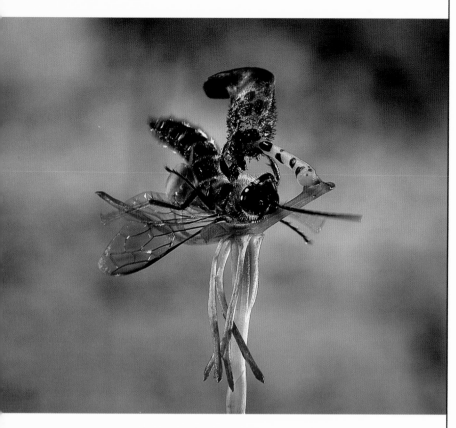

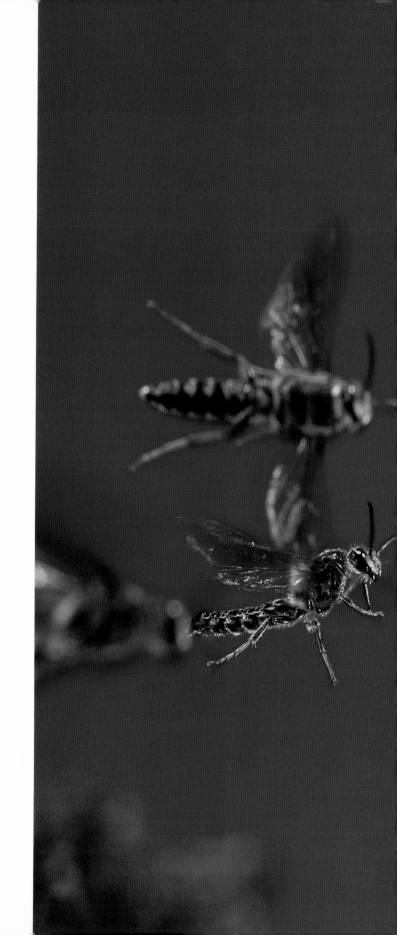

ABOVE: Drakaea livida *draws in male parasitic wasps by producing a faux female-wasp pheromone.*

RIGHT: Caladenia pectinata *swarmed by pollinating male parasitic wasps, who interpret the flower's red lip, or labellum, as a female wasp.*

Both near Denmark, western Australia

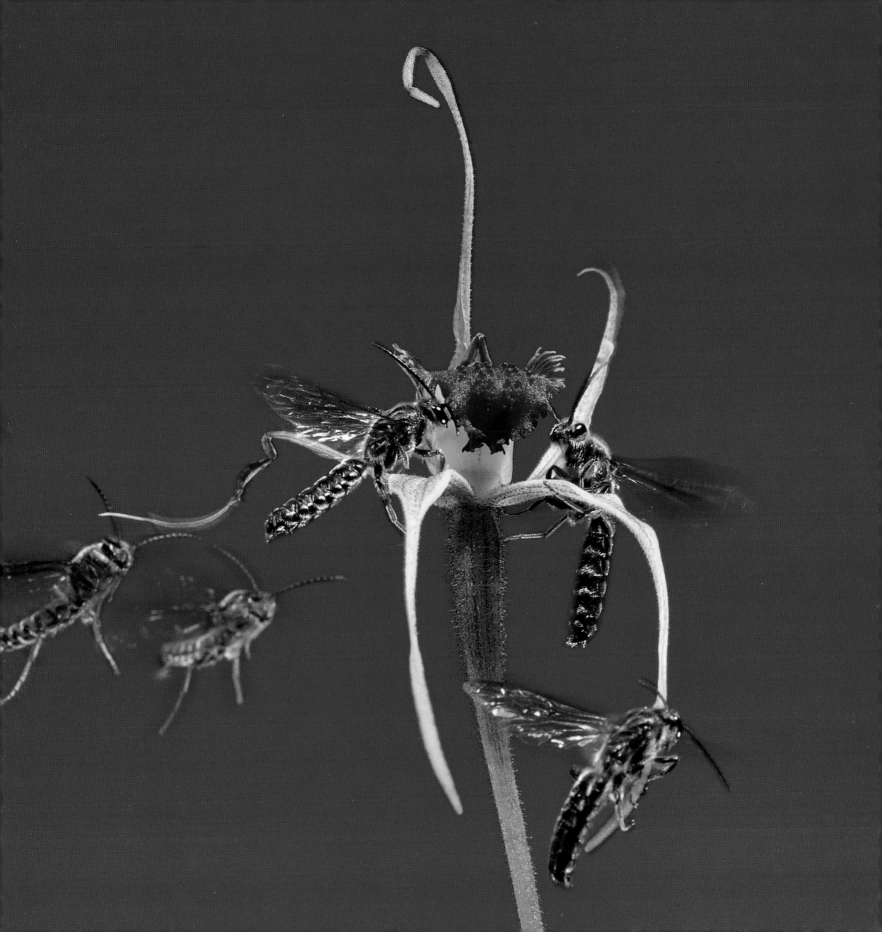

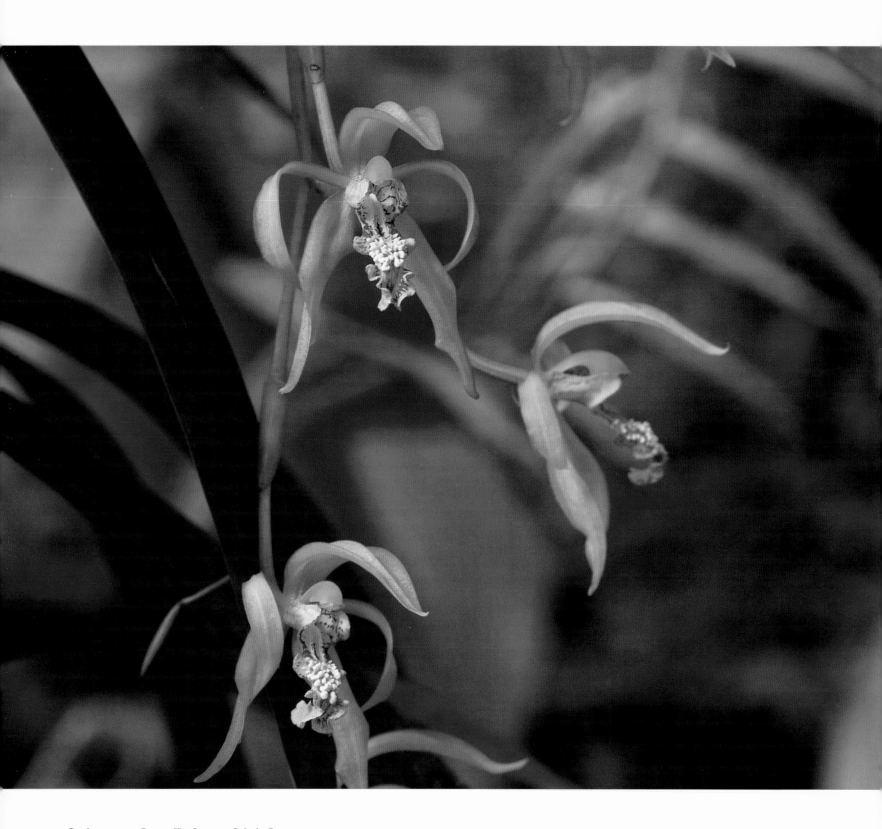

Coelogyne sp. *Poring Hot Springs, Sabah, Borneo*

BIBLIOGRAPHY

Ayasse, Manfred, et al. "Evolution of Reproductive Strategies in the Sexually Deceptive Orchid *Ophrys Sphegodes*: How Does Flower-Specific Variation of Odor Signals Influence Reproductive Success?" *Evolution* 54, no. 6 (2000): 1995-2006.

Benzing, David H. "Major Patterns and Processes in Orchid Evolution: A Critical Synthesis." In *Orchid Biology: Reviews and Perspectives,* ed. Joseph Arditti, vol. 4, 34-77. Ithaca, N.Y.: Cornell University Press, 1987.

Benzing, David H., and D.W. Ott. "Vegetative Reduction in Epiphytic Bromeliacae and Orchidaceae: Its Origin and Significance." *Biotropica* 13, no. 2 (1981): 131-40.

Benzing, David H., et al. "Shootlessness, Velamentous Roots, and the Pre-eminence of Orchidaceae in the Epiphytic Biotope." *American Journal of Botany* 70, no.1. (1983): 121-33.

Chase, Mark W., and Harold G. Hills. "Orchid Phylogeny, Flower Sexuality, and Fragrance-Seeking." *Bioscience* 42, no. 1 (1992): 43-49.

Chase, Mark W., and J.D. Palmer. "Leapfrog Radiation in Floral and Vegetative Traits Among Twig Epiphytes in the Orchid Tribe Oncidiinae." In *Molecular Evolution and Adaptive Radiation*, eds. Thomas J. Givnish and Kenneth J. Sytsma, 331-52. Cambridge: Cambridge University Press, 1997.

Conran, John G., et al. "Earliest Orchid Macrofossils: Early Miocene *Dendrobium* and *Earina* (Orchidaceae: Epidendroideae) from New Zealand." *American Journal of Botany* 96 (2009): 466-74.

Cozzolino, Salvatore, and Alex Widmer. "Orchid Diversity: An Evolutionary Consequence of Deception?" *Trends in Ecology & Evolution* 20, no. 9 (2005): 487-94.

Darwin, Charles. *The Various Contrivances by Which Orchids Are Fertilised by Insects.* Chicago: University of Chicago Press, 1984.

Dressler, Robert L. "Biology of the Orchid Bees (Euglossini)." *Annual Review of Ecology and Systematics* 13 (1982): 373-94.

Dressler, Robert L. *Field Guide to the Orchids of Costa Rica and Panama.* Ithaca, N.Y.: Cornell University Press, 1993.

Dressler, Robert L. *The Orchids: Natural History and Classification.* Cambridge, Mass.: Harvard University Press, 1981.

Eltz, T., et al. "Fragrance Collection, Storage, and Accumulation by Individual Male Orchid Bees." *Journal of Chemical Ecology* 25 (1999): 157-76.

Feinstein, Harold. *Orchidelirium.* New York: Bulfinch Press, 2007.

Fritz, A.L., and L.A. Nisson. "How Pollinator-Mediated Mating Varies with Population Size in Plants." *Oecologia* 100 (1994): 451-62.

Goegler, Julia, et al. "Ménage à Trois—Two Endemic Species of Deceptive Orchids and One Pollinatior Species." *Evolution* 63, no. 9 (2009): 2222-34.

Górniak, Marcin, et al. "Phylogenetic Relationships Within in Orchidaceae Based on a Low-Copy Nuclear Coding Gene, *Xdh*: Congruence with Organellar and Nuclear Ribosomal DNA Results." *Molecular Phylogenetics and Evolution* 56, no. 2 (2010): 784-95.

Gravendeel, Barbara, et al.: "Epiphytism and Pollinator Specialization: Drivers for Orchid Diversity?" *Philosophical Transactions of the Royal Society* 359, no. 1450 (2004): 1523-35.

Griffiths, Mark. *Orchids.* New York: Abrams, 2005.

Hoffman, Noel, and Andrew Brown. *Orchids of South-west Australia.* Nedlands: University of Western Australia Press, 1992.

Janzen, D.H. "Euglossine Bees as Long-Distance Pollinators of Tropical Plants." *Science* 171, no. 3967 (1971): 203-05.

Meléndez-Ackerman, Elvia J., and James D. Ackerman. "Density-Dependent Variation in Breeding System and Reproductive Success in a Terrestrial Orchid." *Plant Systematics and Evolution* 227 (2001): 27-36.

Meléndez-Ackerman, Elvia J., et al. "Reproduction in an Orchid Can Be Resource-Limited over Its Lifetime." *Biotropica* 32, no. 2 (2000): 282-90.

Motomura, H., et al. "The Occurrence of Crassulacean Acid Metabolism in *Cymbidium* (Orchidaceae) and Its Ecological and Evolutionary Implications." *Journal of Plant Research* 121, no. 2 (2008): 163-77.

Neiland, Mary Ruth M., and Christopher C. Wilcock. "Fruit Set, Nectar Reward, and Rarity in the Orchidaceae." *American Journal of Botany* 85 (1998): 1657-71.

Peakall, R., and A.J. Beattie. "Ecological and Genetic Consequences of Pollination by Sexual Deception in the Orchid *Caladenia Tentaculata*." *Evolution* 50 (1996): 2207-20.

Peakall, R., et al. "Pseudocopulation of an Orchid by Male Ants: A Test of Two Hypotheses Accounting for the Rarity of Ant Pollination." *Oecologia* 73 (1987): 522-24.

Pridgeon, Alec, ed. *The Illustrated Encyclopedia of Orchids.* Portland, Ore.: Timber Press, 1992.

Robinson, Harold, and Pamela Burns-Balogh. "Evidence for a Primitive Epiphytic Habit in Orchidaceae." *Systematic Botany* 7, no. 4 (1982): 353-8.

Roubik, David W., and Paul E. Hanson. *Orchid Bees of Tropical America: Biology and Field Guide.* Santo Domingo de Heredia, Costa Rica: Instituto Nacional de Biodiversidad, 2004.

Schemske, D.W. "Evolution of Floral Display in the Orchid *Brassavola nodosa*." *Evolution* 34 (1980): 489-93.

Schiestl, Florian P., and Manfred Ayasse. "Post-Pollination Emission of a Repellent Compound in a Sexually Deceptive Orchid: A New Mechanism for Maximising Reproductive Success?" *Oecologia* 126, no. 4 (2001): 531-34.

Scopece, Giovanni, et al. "Pollination Efficiency and the Evolution of Specialized Deceptive Pollination Systems." *The American Naturalist* 175, no. 1 (2010): 98-105.

Silvera, Gaspar. *Cultivo de Orchideas en Climas Tropicales.* 2010.

Silvera, Katia, et al. "Crassulacean Acid Metabolism and Epiphytism Linked to Adaptive Radiations in the Orchidaceae." *Plant Physiology* 149 (2009): 1838-47.

Smithson, Ann. "Pollinator Preference, Frequency Dependence, and Floral Evolution." In *Cognitive Ecology of Pollination: Animal Behavior and Floral Evolution*, eds. Lars Chittka and James D. Thomson, 237-58. Cambridge: Cambridge University Press, 2001.

Smithson, Ann, and Luc D.B. Gigord. "Are There Fitness Advantages in Being a Rewardless Orchid? Reward Supplementation Experiments with *Barlia Robertiana*." *Proceedings of the Royal Society* 268, no. 1475 (2001): 1435-41.

Tremblay, Raymond L., and James D. Ackerman. "Gene Flow and Effective Population Size in *Lepanthes* (Orchidaceae): A Case for Genetic Drift." *Biological Journal of the Linnean Society* 72, no. 1 (2001): 47-62.

Tremblay, Raymond L., et al. "Ecological Correlates of Rarity in the Epiphytic Orchid *Lepanthes caritensis* (Orchidaceae)." *Biological Conservation* 85 (1998): 297-304.

Tremblay, Raymond L., et al.: "Variation in Sexual Reproduction in Orchids and Its Evolutionary Consequences: A Spasmodic Journey to Diversification." *Biological Journal of the Linnean Society* 84, no. 1 (2005): 1-54.

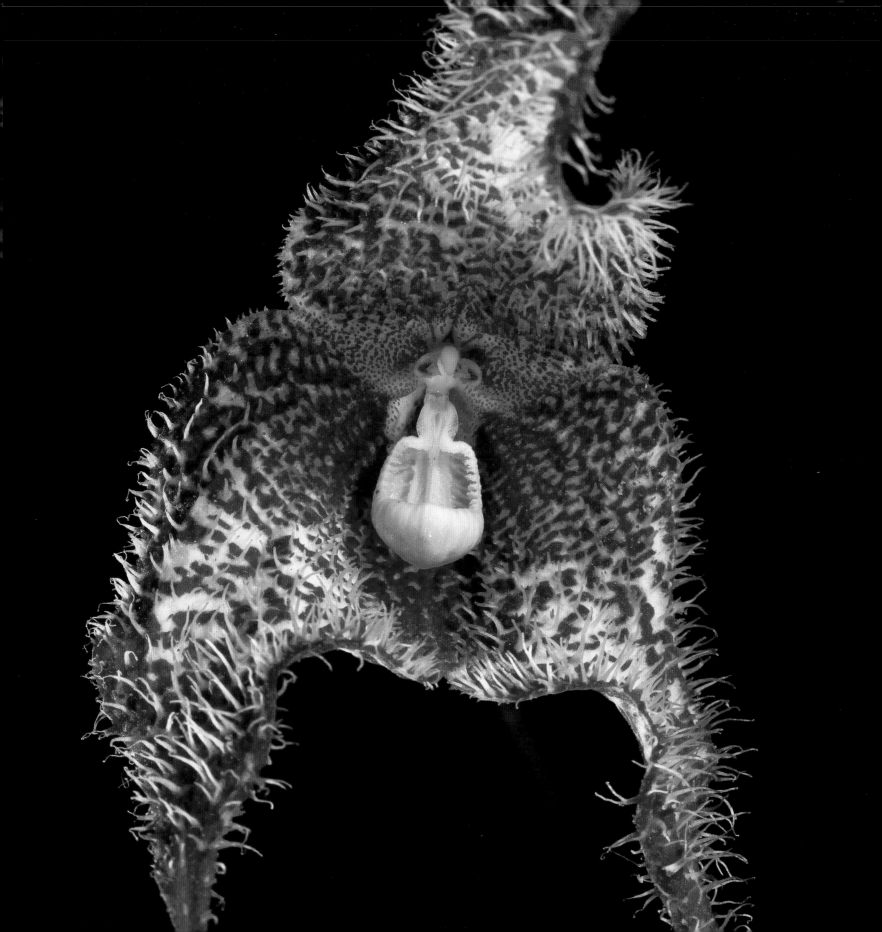

species index

Note: Bold page numbers indicate a reference to the species within the text; all other page numbers refer to species photographs.

Acknowledgments

T he photographs in this book would have been impossible without the generous help of the scientists and orchid enthusiasts around the world who were willing to share their knowledge. I want to thank the following experts for taking the time to advise me about what ought to be included in this project: Peter Raven, Robert Dressler, and Peter Bernhardt (Missouri Botanical Garden); Neal Smith and Dave Roubik (Smithsonian Tropical Research Institute); John Alcock (Arizona State University); Rod Peakall (Australian National University); Kingsley Dixon and Ryan Phillips (Kings Park and Botanic Garden); Manfred Ayasse (University of Ulm); Gerhard Zotz (University of Oldenburg); and Tom Mirenda (Smithsonian Institution).

In the field, I was fortunate to be able to join a number of other scientists and orchid enthusiasts, without whom I would have never been able to find my target species. I would like to thank Gaspar Silvera for sharing his vast knowledge about the wild orchids of Panama on several field trips; Keith Smith and Ryan Phillips for introducing me to the fascinating world of western Australian orchids; Rod Peakall for taking me to a wonderful eucalyptus forest south of Sydney; and Julia Goegler and Pierluigi Cortis for allowing me to accompany them to their field sites in Sardinia.

A number of images in this book were taken in orchid collections, located in their natural habitats where pollinators can visit the plants in flower. I want to express my deep gratitude to Andres Maduro, who welcomed me to his orchid collection, Finca Dracula, in Cerro Punta, western Panama; home to some 6,000 species of orchids, this is one of the biggest collections on the planet. Gaspar Silvera allowed me to photograph his large collection of lowland species in Chilibre, Panama, and Robert Lamb invited me to work in the wonderful orchid garden of the Sabah Agricultural Park in Tenom, Borneo. My home institution, the Smithsonian Tropical Research Institute in Panama,

182

kindly allowed me access to its canopy cranes so that I could visit on eye level epiphytic orchid species that grow 150 feet up.

The vast majority of the material in this book was created for a magazine photo essay for *National Geographic*. Thanks to the magazine's support, I was able to visit four continents and revel in the orchid wonders of Central America, Italy, Borneo, and western Australia. It is a unique privilege to be able to contribute to *National Geographic*, and I want to express my sincere gratitude to my illustrations editor Sarah Leen, who guided me through the orchid jungle, and to former director of photography David Griffin, design director David Whitmore, and editor in chief Chris Johns.

The one person most instrumental in making this book a reality is Lisa Lytton, who helped me shape the vision of this book, who edited the images and designed the book, while taking care of thousands of other details. She always knew what I meant, even when I didn't know that myself.

Karen Kostyal artfully turned my rambling text into nicely flowing English and made this a true book, while Kathy Moran advised us on structure and pacing of the book layout. My sincere thanks to both of them. Several orchid specialists were kind enough to help me identify the orchid species in the book or to give the manuscript a thorough read to eliminate factual mistakes. I want to thank Dr. Robert Dressler, Dr. Manfred Ayasse, Gaspar Silvera, Julia Goegler, and Tom Mirenda for taking the time to do so.

Christie Henry, our editor at the University of Chicago Press, gave us amazing support, liberty, and trust to develop what we had in mind for this book. I want to thank her and her staff very much.

Last but not least, to my partner Janeene Touchton, for her patience during many long trips and her loving support in many ways throughout this project. Thank you. —CZ

Resources

American Orchid Society, www.aos.org

Missouri Botanical Garden, orchid collection
www.mobot.org/press/Assets/FP/orchid.asp

Smithsonian Orchid Collection, www.orchids.si.edu

Marie Selby Botanical Gardens Orchid Programs
www.selby.org/research/orchid-programs-orchidaceae

Finca Dracula, www.fincadracula.com

CHRISTIAN ZIEGLER is a biologist-turned-photographer specializing in tropical natural history. A frequent contributor to *National Geographic*, he has covered topics ranging from tree frogs to ocelots, tropical bats to African primates. He likes to think of his work as translating science, ecology, and natural history into images that make these subjects more accessible to a broad public.

Christian is an associate for communication with the Smithsonian Tropical Research Institute and a founding fellow of the International League of Conservation Photographers. He has received honors in the Wildlife Photographer of the Year, European Wildlife Photographer of the Year, and Picture of the Year International competitions. For more information about Christian's work, please visit his website, www.naturphoto.de.

Deceptive Beauties
The World of Wild Orchids

CHRISTIAN ZIEGLER, *Author and Photographer*
LISA LYTTON, *Project Editor and Packager*
KAREN M. KOSTYAL, *Text Editor*
KATHY MORAN, *Photography Advisor*
JENNA PIROG, *Photography Assistant*
HEIDI ERNST, *Release Editor*

THE UNIVERSITY OF CHICAGO PRESS
CHRISTIE HENRY, *Editorial Director, Sciences*
ELLEN GIBSON, *Publicity Manager*

The University of Chicago Press, Chicago 60637
The University of Chicago Press, Ltd., London

Color separations by Michael Lappin with additional prepress work provided by Prographics, Rockford, Illinois

Printed in China
20 19 18 17 16 15 14 13 12 11 1 2 3 4 5
ISBN-13: 978-0-226-98297-7 (cloth)
ISBN-10: 0-226-98297-1 (cloth)

Library of Congress Cataloging-in-Publication Data
Ziegler, Christian.
 Deceptive beauties : the world of wild orchids / Christian Ziegler ; with an introduction by Michael Pollan.
 p. cm.
 Includes bibliographical references and index.
 ISBN-13: 978-0-226-98297-7 (cloth : alk. paper)
 ISBN-10: 0-226-98297-1 (cloth : alk. paper) 1. Orchids. I. Title.
 QK495.O64Z48 2011
 584'.4—dc22
2011006675

♾ The paper used in this publication meets the minimum requirements of the American National Standard for Information Sciences— Permanence of Paper for Printed Library Materials, ANSI Z39.48-1992.